KU-532-828

ALL ABOUT TECHNIQUES IN
drawing for **animation production**

An indispensable manual for artists

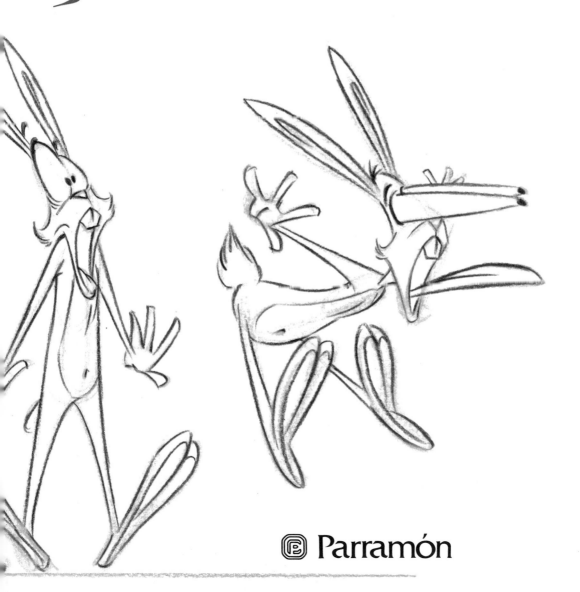

Ⓟ Parramón

Con-
tents

KIRKLEES METROPOLITAN COUNCIL	
250646119	
Bertrams	29.01.08
741.5	£13.99
DE	CUL44063

Bibliography

• Blair, Preston, and Walter, T. *Animation.* Foster Publishing, Laguna Hills, CA, 1949.

• Blair, Preston, and Walter, T. *How to Animate Film Cartoons.* Foster Publishing, Laguna Hills, CA, 1980.

• Finch, Christopher. *The Art of Walt Disney.* Abrams Books, New York, 1995.

• García, Raúl. *La magia del dibujo animado.* Mario Ayuso, Ed., Madrid, 1995.

• Johnston, Ollie, and Thomas, Frank. *Disney Animation: The Illusion of Life.* Abbeville Press, New York, 1981.

• Salesas, Florenci. *Apuntes y notas del curso de narrativa cinematográfica que impartió en el Centre de la imatge de Barcelona en 1989.*

• Taylor, Richard. *The Encyclopedia of Animation Techniques.* Running Press, Philadelphia, 1996.

• Thomas, Bob. *Maravillas de los dibujos animados*. Ediciones Gaisa, Valencia, 1968.

• White, Tony. *The Animator's Workbook.* Watson & Guptill, New York, 1986.

• Williams, Richard. *The Animator's Survival Kit.* Faber & Faber, London, 2001.

Acknowledgments

My special gratitude to my nanny, Lola, to my wife, Lluïsa, to my children, Gerard and Júlia, and to my parents, Santi and Nuri.

To my entire family, whom I love and with whom I share my best moments: my parents-in-law César and Luisa, Idoya, Josefina, Ana, José Luis, Cristina, and my little niece Andrea.

I am grateful to Ali Ġarousi, Valentí Amador, and Iván Vázquez for their professionalism, and in particular to Florenci Salesas, my studio colleague and great friend.

To all the professionals who have passed through Studio Càmara over fifteen years, for their great contribution to this profession and from whom I have learned so much.

To Mercè Calero for her emotional support.

To Editorial Parramón for teaching me way back the techniques that have helped me grow professionally and for letting me pass on some of what I have learned during this time. And very especially to María Fernanda for putting her trust in me and for supporting this book from the beginning.

My gratitude also to all of you who have purchased this book. I hope that it helps you take the first steps with confidence and that it becomes the foundation for a successful career. Good luck!

Editor in chief: María Fernanda Canal
Coordination: Tomàs Ubach
Text: Sergi Càmara
Drawing and Exercises: Sergi Càmara
Series Graphic Design: Josep Guasch
Layout: Estudi Guasch, S.L.
Photography: Studio Nos & Soto
Illustration Archivist: Mª Carmen Ramos
Production Director: Rafael Marfil
Production: Manel Sánchez

Original title of the book in Spanish:
El dibujo animado

© Copyright Parramón Ediciones, 3.A., World Rights
Published by Parramón Ediciones, S.A.
Grupo Editorial Norma de América Latina
www.parramon.com

© Copyright of English language translation by Barron's
Educational Series, Inc.

All rights reserved.
No part of this book may be reproduced in any form,
by photostat, microfilm, xerography, or any other means, or
incorporated into any information retrieval system, electronic or
mechanical, without the written permission of the copyright
owner.

ISBN: 978-84-342-3268-6

Printed in Spain

ALL ABOUT TECHNIQUES IN

drawing for animation

production

An indispensable manual for artists

250 646 119

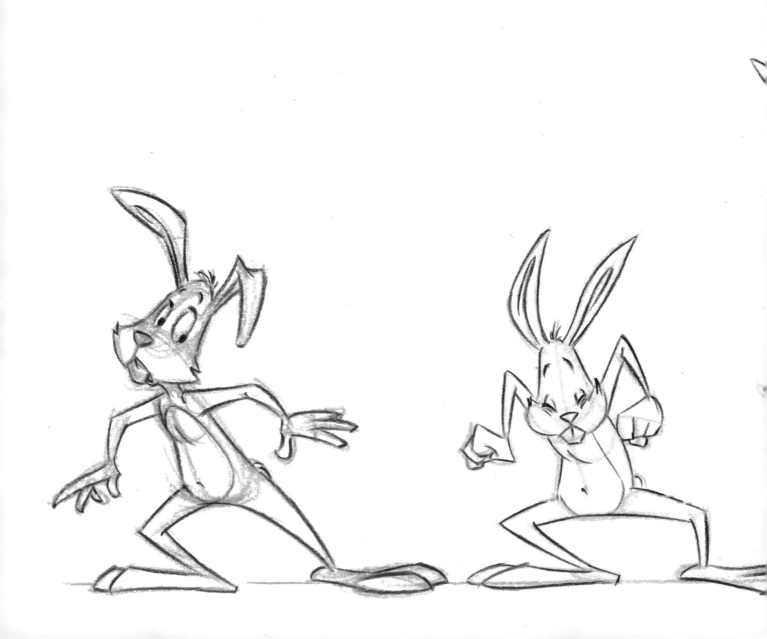

Introduction

The creation of an animated cartoon is perhaps the most multifaceted of any artistic endeavor. In an animated production we find a story that has previously been written or adapted from a literary work; we also note the interpretive value of the actors who lend their voices to the characters, and the music that plays in the background of the film and helps draw us into the plot. The visual art is reflected in the various backgrounds and settings where the action takes place. The quality of the drawing can be appreciated from the beginning to the end of the cartoon in the characters, objects, and so forth. Do not forget the intrinsic art of the scenic composition and script writing that is part of every film, and, of course, the exclusive art of creating the actual animated figures, which brings the actors on paper to life. This art would be difficult to encounter in other artistic endeavors that do not include animation, which has its own rules, formulas, and technical and artistic mechanisms, all of which will be covered in this book. An animated film is therefore the result of an artistic collaboration of a creative group, developed through the talent of a large number of people who contribute their skills in the various disciplines of creation and production.

A few years ago it was impossible for an amateur to get near an animated production unless he or she had great artistic skills and a perfect understanding of the unique formulas of the art of animated cartoons.

The art of the animated cartoon encompasses an entire creative world, ranging from the creation and elaboration of scripts, the knowledge of cinematic language and narrative, on through creating the painted scenery, the background music, and the interpretations of the actors who create the voices for the characters and the animators whose technique and formulas bring the animation to life.

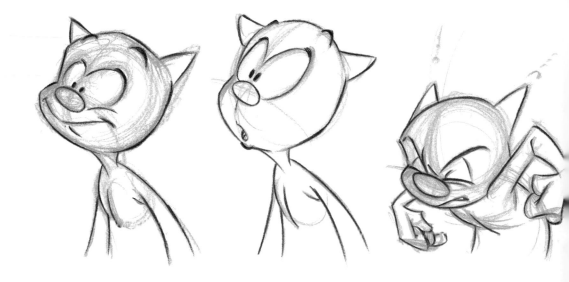

The large budgets of high-quality productions require that the teams in charge of the creation and production very carefully select the artistic personnel who will collaborate on the film. The process of apprenticeship leading to this point is very long and hard.

In its day, television allowed many beginners to participate in productions that were not as critically concerned with quality as were those of the movie industry. Work on television series allowed many artists to learn and assimilate the global language of animated productions and to become professionals capable of applying their talents to any challenge. However, thanks to the creation of new technology, beginners can develop their talent on their own, either to become part of a team in commercial productions or to create their own project from beginning to end and distribute them through one of the many forms offered by multimedia systems. The Internet and various interactive supports allow access to a great number of artists who consider animation an excellent medium for communicating their ideas. The main formulas for beginning to work in this exciting process can be found in this book, but the work and the particular level of development needed to achieve quality are a lifelong endeavor.

Sergi Càmara

Sergi Càmara, born in Barcelona in 1964, has been involved in the world of animated cartoons since 1981 when, at the age of seventeen, he began working as an assistant in an advertising agency in Barcelona. After working in various studios as an animator and storyboard artist, in 1989 he started his own production company, Studio Camara, where he has since worked as a producer, writer, director, project creator, and animator.

He has collaborated on numerous Spanish and foreign productions. In New York in 1997 he found co-producers for his projects, among them "Slurps," a series of short films that he created and directed. This commercially successful series has been shown in more than 130 countries on some of the most well-known television channels in the world: Fox Family Channel (USA), TV Azteca (Mexico), Disney Channel (Italy), Time Warner (Latin America), Taurus Film GMBH & Co (Germany), and Teletoon (France and Canada), among others.

For several years he combined his professional work with teaching, giving classes on animation and script writing at various private centers for professionals in Barcelona and Seoul.

Today he continues to develop new projects for television series while writing and illustrating children's stories for publishers in Spain, England, and the United States.

A Brief History and Chronology

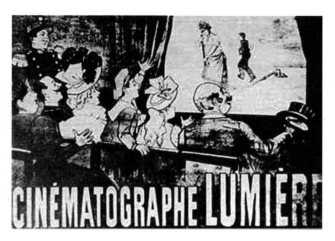

Cinematography was invented by the Lumière brothers, after the birth of animation, but it was the beginning of the movies.

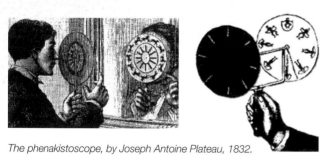

The phenakistoscope, by Joseph Antoine Plateau, 1832.

The most popular of the "optical toys" was perhaps William Lincoln's zoetrope, 1867.

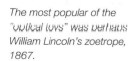

From the first prehistoric drawings, human beings have attempted to capture movement using a series of drawings, attempts that started to become more realistic in the mid-1600s thanks to the magic lantern, considered by many to be the first machine that projected moving images on a screen.

THE FIRST OPTICAL TOYS

The invention of the magic lantern dates to 1640; it was the work of the German inventor Anthonasius Kirchner. The system was very rudimentary but effective; it consisted of drawings on glass plates that were mechanically rotated, giving movement to the characters.

In 1824 the Englishman Mark Roget, who arrived at the conclusion that "all movement could be broken down into a series of fixed images," discovered the principle of "the persistence of vision." Thanks to his discovery, researchers in the second half of the nineteenth century dedicated themselves to creating artifacts that have been improved upon over the years.

One of these machines was the phenakistoscope (1832) by Joseph Antoine Plateau. It consisted of a series of drawings in continuous steps of motion on a disk that turned independently of another disk that had slots cut in it; looking through them caused the figures painted on the disk behind it to seem to move.

Later the zoetrope appeared, invented by William Lincoln (1867), and the praxinoscope, by Émile Reynaud (1878), but it was Thomas Alva Edison who, in 1891, created the kinetoscope, based on all the previous inventions. This machine consisted of a box, inside of which a roll of photographs illuminated by an incandescent lamp rotated at 46 images per second. The spectator could watch the show through a viewer by inserting a coin.

Later came cinematography (1895), invented by the brothers Louis and Auguste Lumière. A few years later some animation pioneers had the idea of capturing images shot by shot with a camera.

Engraving of Émile Reynaud's praxinoscope, 1878.

Thomas Alva Edison's kinetoscope, 1891.

Segundo de Chomón with some images from the movie El hotel eléctrico (The Electric Hotel), *from 1895.*

1905–

Segundo de Chómon, in his studios in Barcelona (Spain), filmed the experimental film titled *El hotel eléctrico (The Electric Hotel)*. This was the first picture filmed using the technique of pixilation, which consists of manipulating elements and characters in the set between each filmed frame. The viewer has the sensation that the objects and characters are moving by themselves. *El hotel eléctrico (The Electric Hotel)* was not the first animated cartoon, but it was the first animated film and the first to use the *one turn, one picture* system, which is still being used by animators today.

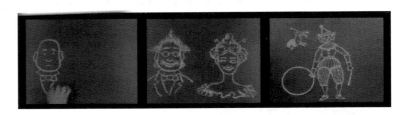

1906–

Humorous Phases of Funny Faces, by the film producer James Stuart Blackton, was a production of Vitagraph Company of America. In it we see the artist drawing characters on a blackboard; the characters come to life through the frame-by-frame technique. Before this, Blackton filmed the movie *The Enchanted Drawing* in 1900, mistakenly considered the first animated film. Actually, it was filmed continuously, with only a few cuts in it to change the expression of the character.

Frames from Humorous Phases of Funny Faces, *by James Stuart Blackton, 1906.*

1908–

The Frenchman Émile Cohl is considered by many historians to be the true father of animated cartoons. His movie *Fantasmagoria*, 117 feet (36 m) long and 1 minute 57 seconds in duration, is completely interpreted by simple line characters animated frame by frame. Émile Cohl made about 300 films, but barely 65 have been preserved. He worked in France, England, and the United States.

Photograph of Émile Cohl and of a frame from the film Fantasmagoria, *1908.*

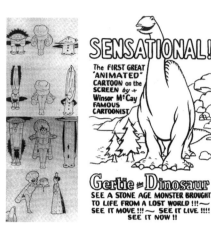

Left: frames from Little Nemo (1911). This film is known for having some frames partially painted by hand. Right: Gertie the Dinosaur (1914).

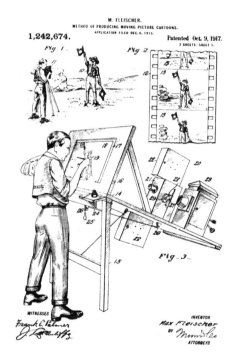

Diagram of the rotoscope patented by Max Fleischer.

The director Quirino Cristiani along with a frame from his film El apóstol (The Apostle), *1917.*

1911–

The American Winsor McCay made his first animated film with his character *Little Nemo.* This is considered to be the first cinematic adaptation of a character from the comics. The film consisted of some four thousand drawings.

Later, in 1914, he created *Gertie the Dinosaur.* It was about an animated character that obeyed the orders of its creator, who was located in front and who interacted with it.

1912–

The Russian cinematographer Ladislaw Starewicz made a movie titled *The Cameraman's Revenge.* Lasting nearly thirteen minutes, this was the first animated film using dolls.

1915–

Another American, Earl Hurd, was the inventor of acetate for animation. This consisted of a transparent sheet on which the animated objects and characters were painted, which was then laid over a fixed background. It revolutionized the incipient industry of this era; because of the transparent acetate it was no longer necessary to draw the background in each frame, which saved a great deal of work.

Also in this year Max Fleischer invented the rotoscope, which he did not patent until two years later. This machine was used for capturing live action images that were used as a reference for traditional animation. Max Fleischer and his studio later became famous for such series as "Betty Boop," "Popeye," and "Out of the Inkwell." This last series combined the animated character Koko with real images in an elementary way.

1917–

Quirino Cristiani, an Italian immigrant in Argentina, created and directed *El apóstol (The Apostle),* the first documented full-length film in the history of animation. Its duration was 70 minutes and it was filmed in 35 mm using drawing and cutout techniques. It was a political satire about the government of the president Hipólito Irigoyen. Unfortunately, the film was lost in a fire.

1919–
Pat Sullivan and Otto Mesmer made the first *Felix the Cat* movie. The adventures of the charming character created by Otto Mesmer and produced by Pat Sullivan were recounted in approximately 175 films made between 1919 and 1930. *Felix the Cat* could be considered the first series of the animated cartoon industry.

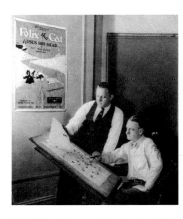

Left: Otto Mesmer (standing) and Pat Sullivan, the creators of Felix the Cat, *1919. Right: A frame of the charming cat Felix.*

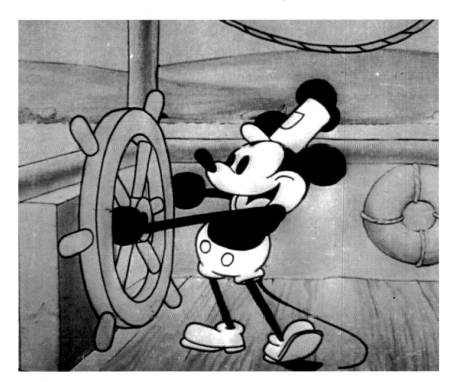

In 1927 Warner Brothers introduced the first movie with sound in the history of the cinema, The Jazz Singer. *Just one year later, Disney introduced* Steamboat Willie, *the first animated short with sound.*

1928–
Walt Disney made the first animated film with sound, with Mickey Mouse as the star, titled *Steamboat Willie*. It lasted 7 minutes and 45 seconds. Ub Iwerks was the principal animator, and the sound was done using the Cinephone monaural system, which synchronized the sound effects with the music, performed by Carl Stalling.

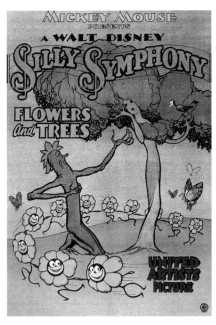

1932–
The first animated film in color was also produced by Disney. *Flowers and Trees* was the first to use the Technicolor system.

Flowers and Trees, 1932, was the first animated film in color.

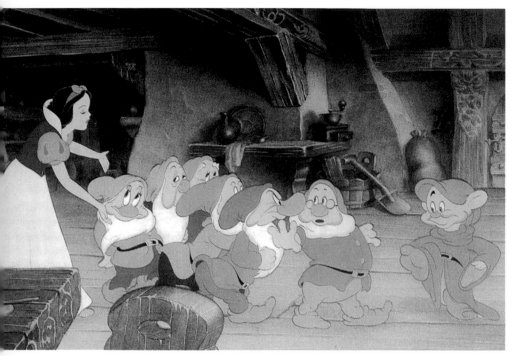

Snow White and the Seven Dwarfs, 1937.

Toy Story, 1995.

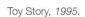

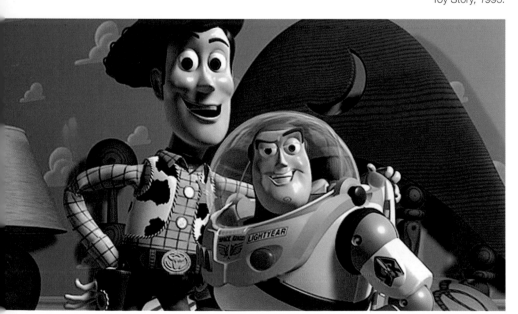

1937–
Walt Disney produced the film *The Old Mill* in his studio, the first short film to use the multiplane camera animation stand, which consisted of a system for filming different levels, adding depth of field to the two dimensionality of animation.

This system was used for another Disney film, *Snow White and the Seven Dwarfs*, which was released the same year. Despite the fact that it was not the first full-length animated film in history, it was the first to achieve international acclaim from both critics and the public.

1964–
Ken Knowlton, from New York, made the first attempts at computer animation at Bell Laboratories.

1995–
Pixar and Disney released the film *Toy Story*, the first full-length film made completely with computers using 3D techniques. These techniques had been investigated previously with very interesting results. In 1982 Disney created the movie *Tron*, which has some scenes created by computer. Later, in 1986, the film *The Great Mouse Detective* contained a sequence inside Big Ben in which 3D animation was used to create the machinery of the clock, which was used as a reference for the traditional system resulting in an impressive integration of the images.

Production chart for an animated cartoon film.

NARRATIVE SCRIPT

DIRECTOR'S WORKBOOK

CREATION OF THE CHARACTERS

CREATION OF THE MAIN BACKGROUNDS

STORYBOARD

CREATION OF MAIN MUSIC

SPOKEN DIALOGUE

CREATION OF INCIDENTAL BACKGROUNDS

CREATION OF COLOR

LIP SYNCHRONIZATION

CREATING LAYOUTS

ANIMATION

BACKGROUND COLORS

LINE PROOFS

CAPTURING, USING CAMERA OR SCANNER

COLORING THE ANIMATION

SCENE COMPOSITION

MIXING/SPECIAL EFFECTS OF IMAGE AND SOUND/CREATION OF INCIDENTAL MUSIC

FINISHED FILM

The Studio and the Mate- rials

"ALL YOU NEED TO DO TO DIRECT A FILM IS FOR SOMEONE TO GIVE YOU THE JOB. SO I TOLD MYSELF, "GUY, THE JOB IS YOURS."

Clint Eastwood

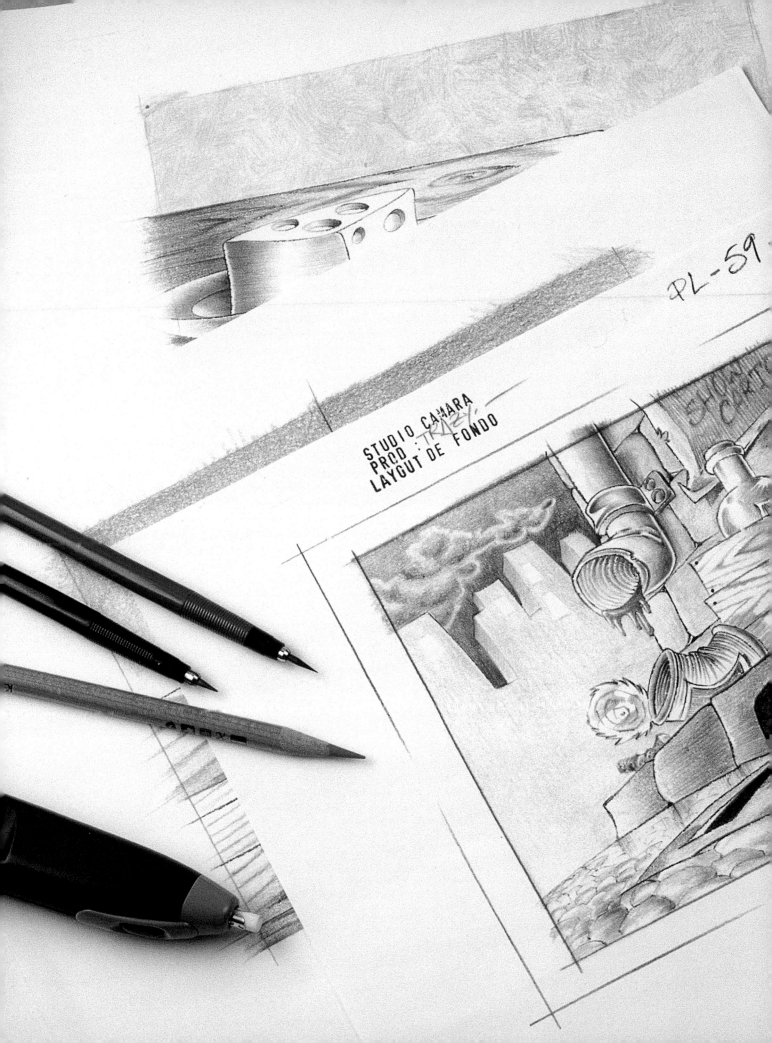

Τhe animator of a television series or a full-length film almost always works on a team and usually has a table in the professional studio where the production is created.

However, technology has put a series of advances within reach of everyone, which allows a great deal of self-sufficiency in creating animated films, and it is more and more common to find animators who work alone or with a small number of assistants. In this case, a studio does not require a large space filled with large and expensive equipment. Only a few square feet are needed to carry out their work in comfort.

In this section, we will see how to organize a studio that is small, but large enough to carry out a wide scope of animated work.

Organizing the Studio

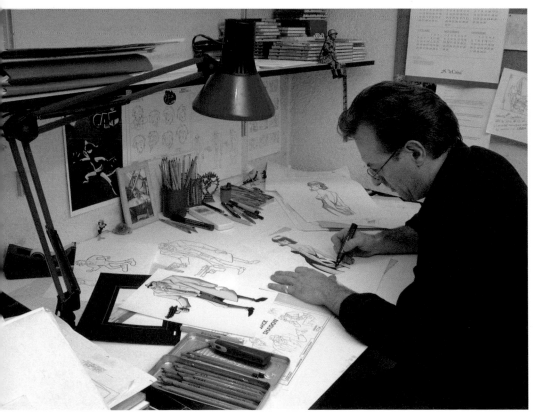

The drawing board for creating characters and backgrounds, and for the development of the storyboard and layout.

THE SELF-SUFFICIENT STUDIO

It is important to have a space with a standard drawing table on which to do all of the creative work and project development: designing the characters and settings, making storyboards, layouts, and creating color for the characters, objects, and so on.

To complement this basic work-space we would add a comfortable chair, a few shelves for storing sketches and records, and an additional table with drawers for keeping paper, materials, and such things.

It is a good idea to have a light box with a translucent plastic surface to help mark references from one drawing to another. Another indispensable light source is a drawing lamp that shines directly on the work surface.

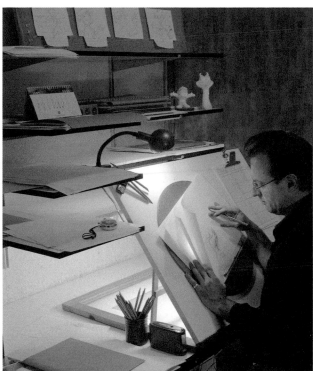

An animation table with the shelves needed to organize the work of the different planes of a sequence. It is important to have a light source coming from below for comparing drawings with each other.

(Below) A room with computers for the processes of capturing, coloring, and composing the final image. (Bottom) The office has cork panels on the wall for detailed study of the different sequences of the film.

This is a professional animation board. The animator, the assistant, and the "inbetweener" do their work on it. The board usually rests on a table that has several shelves for organizing material related to the sequence that is being worked on.

We also need a table for the computer, the scanner, and the material that we use to capture our drawings and digitally process them. It is also convenient to have several shelves to organize and archive the layers of the film. The computer programs will depend on the style of the productions being created. A photographic retouching program, one for generating graphics for finishing backgrounds, and, obviously, one of the programs that are on the market for the capture, processing, composing, and the postproduction of the animated work should probably be sufficient.

Finally, it will be helpful to have a quiet, comfortable room for revising scripts, evaluating projects, receiving visits, and discussing the evolution of the work with collaborators, etc. We can put some shelves in it for books and films that we use for reference and documentation.

The Necessary Materials

Some of these are exclusive and are used only for working with animated cartoons; others are common to any expressive artistic medium.

THE ANIMATION BOARD

This is a special tool for making animated cartoons. It consists of a flat surface that sits at a 45 degree angle (it is adjustable) and holds a rotating aluminum disk with peg bars. The surface of the board requires space on one side to fix the exposure sheets. The disk has a light behind it for keeping an eye on the drawings as the work progresses. It is also important to have a source of light, like a conventional drafting lamp, to counteract the light from the disk in some phases of the animation process.

Animation work implies making innumerable sketches, practice runs, animations requiring later checking, and so on. All this requires a great amount of paper, in addition to the layout drawings, the exposure charts, and the folders that come with each shot that must be animated. This makes it essential to be able to set the animation board on a table that has additional space for organizing the work and shelves within reach for arranging the sketches of the shots that are being worked on, those still pending, and finished ones. Sometimes it is difficult to keep the table in order, but it is important. Generally, the animator's working environment is particularly chaotic.

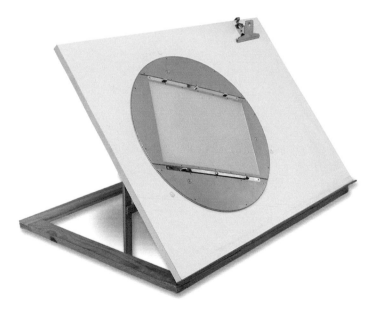

The animation board.

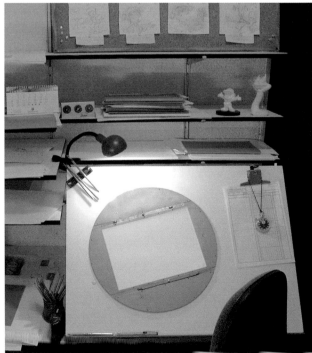

The animator's table with a board on it.

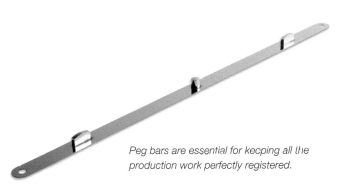

ANIMATION PEG BARS

These consist of a metal bar with three pegs for holding the animation papers to keep them perfectly registered with each other and with the rest of the production materials. The bar is inserted in a slot in the rotating disk on the animation board. It allows horizontal movement to animate the scenes where the camera moves. The peg bars are universal, and the same format is used in all studios.

Peg bars are essential for keeping all the production work perfectly registered.

STORYBOARD PANELS

These are corkboards framed with wood to make them rigid for handling and transporting without danger or for hanging them on the wall. The walls of animation studios are usually covered with them, since they are very useful for placing the storyboard vignettes broken into sequences. The animators also usually have a portable panel on their table as a constant visual reference of the sequence they are working on or for hanging the character model sheets.

Storyboard panels.

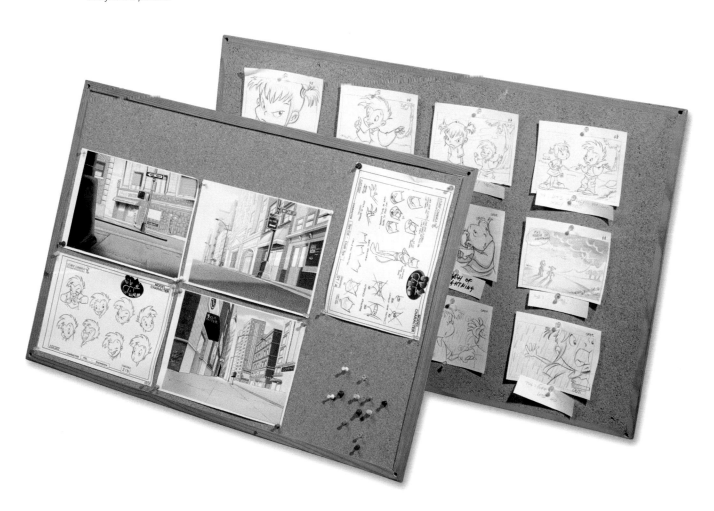

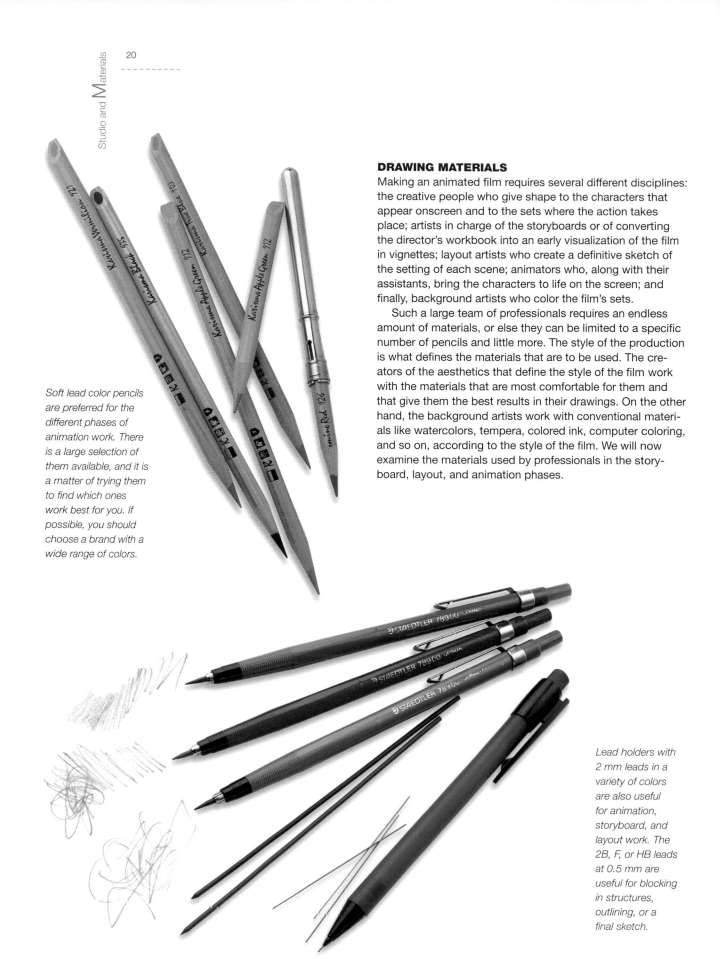

Soft lead color pencils are preferred for the different phases of animation work. There is a large selection of them available, and it is a matter of trying them to find which ones work best for you. If possible, you should choose a brand with a wide range of colors.

DRAWING MATERIALS

Making an animated film requires several different disciplines: the creative people who give shape to the characters that appear onscreen and to the sets where the action takes place; artists in charge of the storyboards or of converting the director's workbook into an early visualization of the film in vignettes; layout artists who create a definitive sketch of the setting of each scene; animators who, along with their assistants, bring the characters to life on the screen; and finally, background artists who color the film's sets.

Such a large team of professionals requires an endless amount of materials, or else they can be limited to a specific number of pencils and little more. The style of the production is what defines the materials that are to be used. The creators of the aesthetics that define the style of the film work with the materials that are most comfortable for them and that give them the best results in their drawings. On the other hand, the background artists work with conventional materials like watercolors, tempera, colored ink, computer coloring, and so on, according to the style of the film. We will now examine the materials used by professionals in the storyboard, layout, and animation phases.

Lead holders with 2 mm leads in a variety of colors are also useful for animation, storyboard, and layout work. The 2B, F, or HB leads at 0.5 mm are useful for blocking in structures, outlining, or a final sketch.

DRAWING MATERIALS FOR THE STORYBOARD

The storyboard is usually made with conventional pencils, preferably with 2B so the line will be expressive. Generally, a previous sketch is made in blue and then it is outlined in black. Occasionally, values can be added to reinforce the dramatic character of some sequences. This process is done using Pantone-type markers or with ink.

Each storyboard artist uses the pencils that feel most comfortable or that can be used to add color to a specific scene.

DRAWING MATERIALS FOR THE LAYOUT

We will focus on the background layout because it requires a more artistic approach than that required for the camera or animation layouts. They are usually monochromatic to indicate the intensity of the shadows and the angle of the light to the background colorists. The most common material used for this is the conventional colored pencil, but some artists prefer to use pastels or materials that are easier to blend. The highlights are added later with an eraser or white tempera.

The layout is monochromatic, paying special attention to lights and shadows.

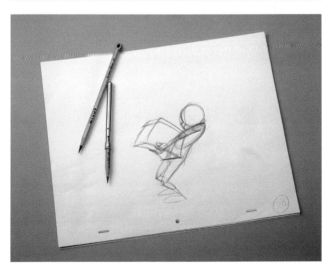

MATERIALS FOR ANIMATION WORK

Each animator prefers a specific type of pencil, but all usually agree that a soft lead pencil or even a grease pencil makes a more expressive and fresher line. The important part of animation is capturing movement, and for this a pencil that "slides" quickly over the paper is necessary.

Animation work consists of different phases, and the animator has the option of using a different color for each of them.
- Red pencil for creating movement with rhythmic and energetic lines.
- Blue pencil for drawing the character and blocking in its structure and volume.
- Black pencil for outlining and adding details.

PAPERS

The backgrounds of an animated film, if painted by hand, are generally done on artist-quality paper using traditional media or on all-purpose paper for the pencil drawing that is later digitized and colored using computer techniques.

In this chapter we will focus mainly on the paper used to do layouts and animation, since it is the most important of the materials that are used, keeping in mind that it is not the defining medium for the final work. The paper is used for creating the artistic part of the production work. After it has been digitized, all the material will be copied to the final medium which, depending on the case, could be 35 mm film, professional format video tape, or a CD, or could be put directly on the Internet from the computer's hard disk.

The paper used for animation work is usually a thin sheet of no more than 24 lb. (36 g), so it will be transparent enough for seeing through several layers while animating. The size varies according to the production, but ranges from 10¼ × 12 inches (12 field paper) to 14 × 17 inches (16 field paper). For full-length films, generally larger sizes and customized sizes (such as for wide-screen productions) are used.

You can work with different formats in a single production to adapt to the different needs of each framing size. For animation and layouts that require that the camera move, a roll of paper can be used, or several sheets can be attached together to make the necessary length.

For the animation and layouts, we use all-purpose paper of the size required for the different frames.

All the materials that are used for an animated production that later must be filmed with a camera or scanned should have registration holes to avoid shaking or unsteady images on screen.

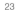

A hole punch is used to make the registration holes required for the animation materials. It is adjustable for the different paper formats and is indispensable for all animation studios.

DOMESTIC ALTERNATIVES

Part of the material necessary for familiarizing yourself with animated drawing techniques can be difficult to find or a bit expensive. You should consider more economical alternatives that will allow you to begin practicing with little risk.

For beginners there are drawing boards with lights inside them, or light boxes, that are quite inexpensive. Another option would be to make one, since it is not very complicated.

There is also an alternative for the hole punch and the peg bars. Any standard office hole punch will work for making registration holes in the paper. They are not standard, but they work well. As for the pegs, with a little skill it is not difficult to make some like those used in photography.

The Story-board

"I HAVE TEN COMMANDMENTS. THE FIRST NINE SAY: THOU SHALT NOT BE BORING!"
Howard Hawks

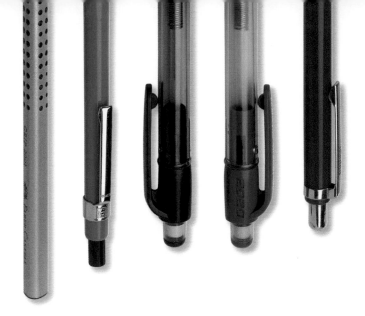

Scenic

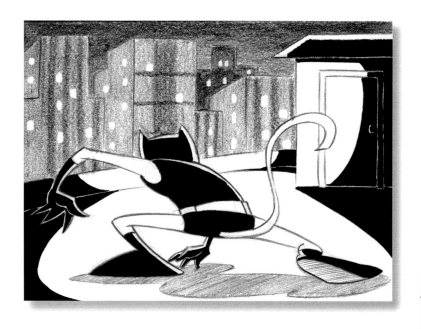

SERGI CÀMARA.
VIGNETTE FROM A STORYBOARD FOR THE TELEVISION SERIES "SPY CAT"

Composition

Making films, whether they are animative movies

or real images, requires careful organization of all the elements that make up the scene. A good composition helps us follow the plot and clearly understand what is happening on the screen, since it directs our eyes toward the unmistakable "center of interest," no matter how many elements are in the scene.

We could say that composition consists of establishing the order and the spatial distribution of the elements that appear on the screen, keeping in mind such factors as the dramatic and aesthetic character. The important thing is that through the composition of the frame we can maximize the narrative potential.

Formats for Film and Television

In the first place, we are going to clear up the difference between "field" and "frame," two concepts that we will be working with a lot from here on in.

The **field** is the space that is defined by the angle of view of the camera lens, and therefore it will contain all the elements that make up the scene.

The **scene** contains all the elements captured in the angle of view of the camera, and consequently they make up the contents of the field.

Both concepts are related to the space in which the content of the film takes place. This space varies according to the format that we choose for our production. Basically, there are two standard formats for making films: the 4:3 and the 16:9 formats. Originally, these formats corresponded to the television and movie screens, respectively; however, today the use of one format or another is mainly based on the aesthetic criteria of the filmmaker.

One of the first steps in making an animated cartoon consists of planning the script scene by scene and creating a storyboard that includes all the information about the film. In each storyboard panel we will usually find the following information: production title, episode and sequence numbers, shot number, duration of each shot in seconds, size of the field that will be filmed, the number of the corresponding background, and also whether the shot maintains a continuity with some previous or later action (hook-up). We also will find a brief description of each scene and the dialogue of the characters. This way we can indicate the camera movements and the special effects, both visual and sound.

On the following page are models of pages for making storyboards in the previously mentioned formats.

These are the shapes of each of the formats.

The 4:3 format may permit a more dynamic production, since describing a large landscape forces us to plan and carry out camera movements. The 16:9 format is appropriate for a more descriptive production. Simply put, it is a matter of deciding which format is easier to work with or which would work better for telling the story the way the filmmaker wishes.

The storyboard sheets are usually 11 × 17 inch (DIN A3 format); this is an ideal size for working on a story.

Here is a 16:9 format panel. This type of storyboard panel is used to make the director's workbook. Later, the vignettes are photocopied, and revisions can be made on the copies.

Some Ways of Composing a Scene

The fundamental job of every filmmaker is to concentrate the audience's attention on what is happening on the screen. We can neither bore the viewer with monotonous and uninteresting scenes, nor cause visual fatigue by forcing him or her to watch scenes full of elements with visual contrasts and constant and excessive changes in angles. The secret is to find a balance for each shot.

The director's job is to guide, to direct the viewer toward the scene's focal point, and the elements found there should be placed so that they emphasize what is important for the image, and for the whole scene as well.

We must remember that the viewer has a limited amount of time to understand the whole scene and the meaning of the shot, barely a few seconds. If some essential element is not quickly visible, its meaning will be lost.

There are some guidelines that will help us compose our shots correctly and that will make our story perfectly understandable.

COMPOSING WITH MOVEMENT
In the dynamic composition typical of the cinema, movement captures the viewer's attention. Despite the fact that the eye is held by a specific focal point, the movement of some element will catch the viewer's attention, even if it is located in a secondary zone of the shot.

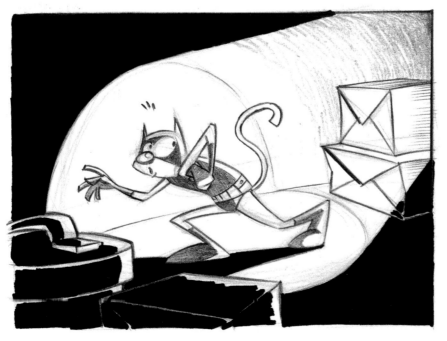

COMPOSING WITH LIGHT
Drawing the viewer's eye toward an illuminated object can be a compositional strategy for emphasizing specific elements of the shot, or for making them less important by making them darker. Another approach is to create strongly contrasting light and shadows to add an especially dramatic note to the shot.

Light is an important element in scenic composition, since it creates the image on the screen.

COMPOSING WITH SELECTIVE FOCUS

The focus of the camera can help us compose a scene. For example, we can focus on an area of the shot to make it visible and blur all those that may distract the viewer's attention.

Using selective focus we can emphasize a particular detail in a scene without cutting to a new shot.

COMPOSING ON A SURFACE

This is the typical scenic composition in which the elements move from right to left or from above to below, creating a two-dimensional effect of the action. The result is very theatrical, and the objects and characters enter and exit laterally from the point of view of both the audience and the scenery.

This composition is used in television series with very low budgets and in programs for preschool audiences.

COMPOSING WITH DEPTH

In this composition the elements move toward and away from the screen, creating a sense of three-dimensionality. To emphasize the depth, it is good to group and superimpose the objects in the scene while making sure that they are not isolated from one another and that all help create volume in the shot. The results can be very cinematic.

The drama of this composition required careful planning so it would not cause visual fatigue in the viewer.

COMPOSING IN ASYMMETRICAL FORM

Symmetrical composition is adequate for emphasizing an important moment associated with certain scenes depicting royalty or majesty, or in other words, solemn pictures. An asymmetrical composition, on the other hand, will be more effective for the rest of the scenes.

Breaking the symmetry of a scene helps create a more dynamic shot.

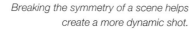

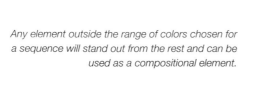

COMPOSING IN LINE

The direction taken by the lines in the scene help us direct the viewer to the center of interest, but they also add a psychological aspect to the scene and the meaning of the narration. For example, vertical lines give a sense of rectitude, stability, order, and control of the situation. Diagonal lines can indicate lack of balance, or also movement in dynamic actions. Horizontal lines show repose or exhaustion, and curves communicate sensuality. It all depends on the content of the scene and the composition of the shot, while making use of lines for transmitting the desired idea.

Using lines, we can direct the eyes of the viewer while also adding a psychological factor to the scene.

COMPOSING IN COLOR

We can use complementary colors and contrasting colors in this composition. Objects of the same size can seem larger or smaller according to the color, or seem less noticeable in the background among the rest of the surrounding elements.

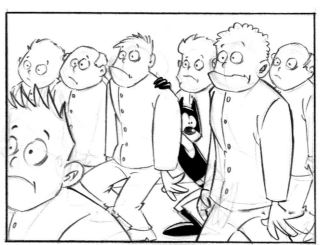

Any element outside the range of colors chosen for a sequence will stand out from the rest and can be used as a compositional element.

THE RULE OF THIRDS

This is a classical rule that recommends dividing the scene into three equal parts in the horizontal direction and three equal parts in the vertical. These divisions are then used to frame the scenic elements in perfect balance within the divided space.

According to the rule of thirds, it is not recommended to locate an element in the center of the scene, since any point of interest placed on the horizontal or vertical lines will make the scene more interesting. But it will be even more solid if we locate elements on any of the intersecting points.

The rule of thirds is recommended for 4:3 and 16:9 formats. The forms in the compositions can be the same for both cases, but in each of them, because of their particular characteristics, the optimization of the format will be different.

This is a scene divided into vertical and horizontal thirds. Using this formula correctly will have very positive results if we know how to combine the different resulting parts to frame our main subject and direct the viewer's eye to it.

From a dramatic point of view, this type of composition is strongly recommended, since it can be readily used to achieve psychological effects.

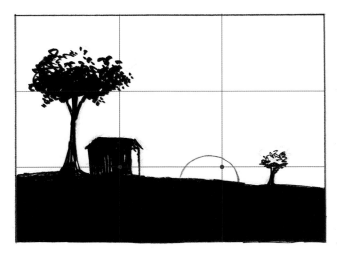

A landscape framed in the lower third creates a feeling of space; it is an ideal composition for depicting bucolic scenes.

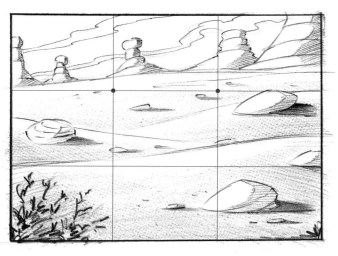

If we frame the landscape in the top third, we take space away from the sky and create a feeling of lack of oxygen.

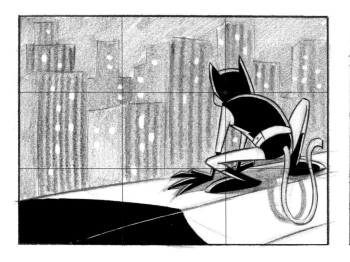

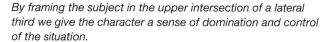

By framing the subject in the upper intersection of a lateral third we give the character a sense of domination and control of the situation.

By placing the subject in a lower side intersection, we give the viewer a sense that the character is oppressed or dominated.

USING GEOMETRIC FORMS

One way of checking whether our scenic compositions work well is by trying to fit them into a simple geometric structure, or perhaps into letter shapes like C, D, S, Z, and so on, which are easily assimilated.

It is important to find the visual synthesis independent of the scenic complexity that each shot might contain.

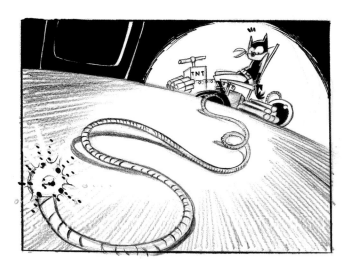

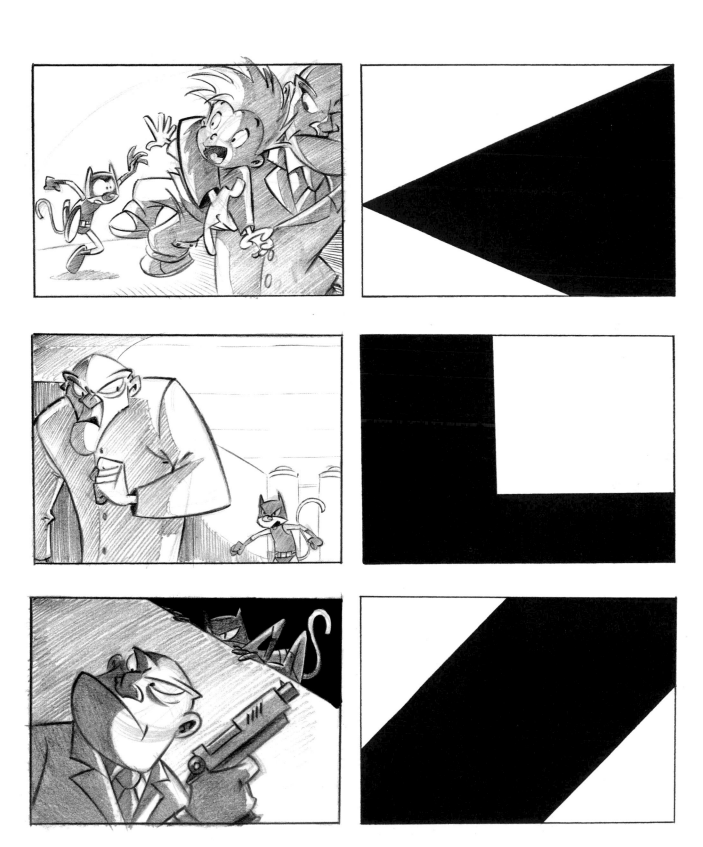

Planning
Scene by

STUDIO CAMARA.
THIS IS A STORYBOARD OF SEPARATE SHOTS THAT CAN BE CHANGED
IN ORDER TO STUDY THE ENTIRE FILM SEQUENCE BY SEQUENCE.

Scene
The work of making a film
once we have a narrative script

in our hands. From this moment on, our mission is to convert all that the scriptwriters have created in descriptive texts and dialogue into images.

Generally, we will work sequence by sequence, grouping a number of shots that can be used for telling one part of the entire script. The most important part of this task is to understand the narrative so we can choose those shots that best tell the story, and to use our knowledge of composition to express the content of each shot in the plot in the best possible way to focus the viewer's attention on the essentials. It is in this phase that we could say, "Let the show begin!"

There are different ways of presenting a written script, almost as many as there are scriptwriters. Each writer lays out the contents of the story in the way that is most comfortable for him or her, despite the fact that there are standardized systems for submitting scripts to producers for their approval.

Some scriptwriters create their narrative and descriptive texts by indicating the lines of dialogue and little else. Others divide the plot into sequences, and divide sequence into different shots. Some even plan the shooting scene by scene, indicating shots and all sorts of details.

Types of Shots
According to Focal Length

THE SEQUENCE AND THE SHOT
It is important to be clear about the differences between the terms "sequence" and "shot," since most scripts are based on this structure.

The sequence contains a group of related shots that have in common the continued duration of an action, from the moment that it begins until it is finalized, which will then create a jump in time or in space and in so doing start a new sequence.

The shot is the basic unit of cinematography. It contains no cuts in the physical sense. The consecutive order of different but related shots, one after another, and the nature of each one of them are fundamental to the visual aspect, the narrative style, and even to the concept of the film.

The following covers some of the different shots according to the camera angle. While considering the shots, keep in mind where the shots cut, or crop, the human figure and the role of this cropping in the composition of a setting.

ELS/EXTREME LONG SHOT OR WIDE SHOT
This is the shot that has the widest possible camera angle. Its field of vision is a landscape or any large space.

It gives us the most visual information possible about the overall surroundings of the characters. Many animators use it at the beginning of the sequence as an opening shot, in the classic style. Others prefer to reserve it as a dramatic resource for climactic moments in the action, or for emphasizing the drama of something that is being explained.

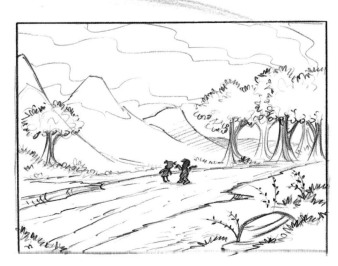

ELS/Extreme long shot or wide shot.

LS/LONG SHOT OR FULL SHOT

This shooting angle is closer, but it is still wide and shows the characters in their entirety, allowing us to observe details in their dress, features, and expression.

The tension of the action and dialogue produced in closer shots is relaxed in this angle, since we are able to perceive more information in the setting, and the viewer automatically situates him or herself in it.

It is usually interesting to include wide shots with different points of view in the middle of a sequence since they add new information to the narrative.

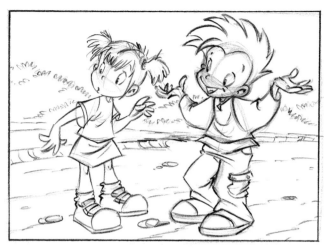

LS/Long shot or full shot.

MLS/MEDIUM LONG SHOT OR KNEE SHOT

This shot is cut slightly above or below the knees of a human figure. In principle, either of these two options is correct. This shot is very useful for emphasizing the physical expression of the characters because it removes the feet and half the legs from the scene—the least expressive parts of the body.

MLS/Medium long shot or knee shot.

MS/MEDIUM SHOT OR WAIST SHOT

This angle cuts the figure at waist level; therefore, the information communicated by the background is still important, but it is less significant than in the previously explained shots. At the same time, the importance of the character's face and expression is increased.

Generally, the closer we are, the more information we get from the character, from the face and its expression, while we receive less superficial information from the setting.

This is a very comfortable shot for narrative, which allows us to cut to a wide shot or a close-up without abruptness. At the same time, it combines the virtues of both and can last longer on the screen than other shots. Despite this, there are no rules regarding the duration of a shot; it all depends on the style or genre.

MS/Medium shot or waist shot.
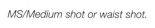

A medium shot can also be cut across the chest; in this case it is called a medium close-up (MCU) or bust or portrait shot. It is ideal for emphasizing expression, while creating the same psychological impact as a close-up.

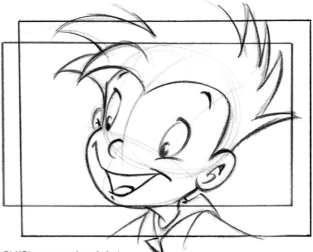

CU/Close-up or head shot.

CU/CLOSE-UP OR HEAD SHOT

This shooting angle is at neck height, and the character's face nearly fills the entire field of vision in the 4:3 format. In the 16:9 panoramic format, this shot still allows some background details to be seen, unless we use an even closer shot, cutting off part of the character's chin and head; in this way we can achieve the same effect in both formats.

In this shot the person's face is the only dramatic resource appearing in the screen; it can also be used as a climactic element and for maximum dramatic tension, much like the long shot. The difference is that in a long shot the drama comes from the immensity, the design, and the composition of the scene, while in the close-up we communicate the drama through the expression of the character.

XCU/EXTREME CLOSE-UP OR DETAIL SHOT

This shot selects a detail or fragment of an object or a person. It is useful for emphasizing details or showing a brief action of a character; for example, someone who is hiding something in his pocket or looking at a note on a tiny piece of paper. Or it may be used for dramatizing an action, adding a detail shot of the smoking barrel of a pistol, a hand attempting to grab on to a ledge, and so on.

XCU/Extreme close-up or detail shot.

HOW TO PLAN A SEQUENCE

There is a way of moving from one shot to another smoothly and without the viewer missing the plot that he or she is watching on the screen. It is not logical, for example, to go from an extremely wide angle to a close up or a detail shot. However, we should not limit ourselves to fixed rules, since experimentation can result in pleasing surprises. In the following example of a fragment of a sequence, we will see how to use different shots to narrate a typical dialogue scene between two characters.

1. Close-up of Lucy listening to her brother Pol speaking off camera.
2. Medium shot of Pol trying to convince his sister to carry out a plan.
3. Medium long shot of both of them. Here we see the setting and the placement of the characters.
4. Long shot that maintains the sense of the dialogue while giving us more details about the setting.

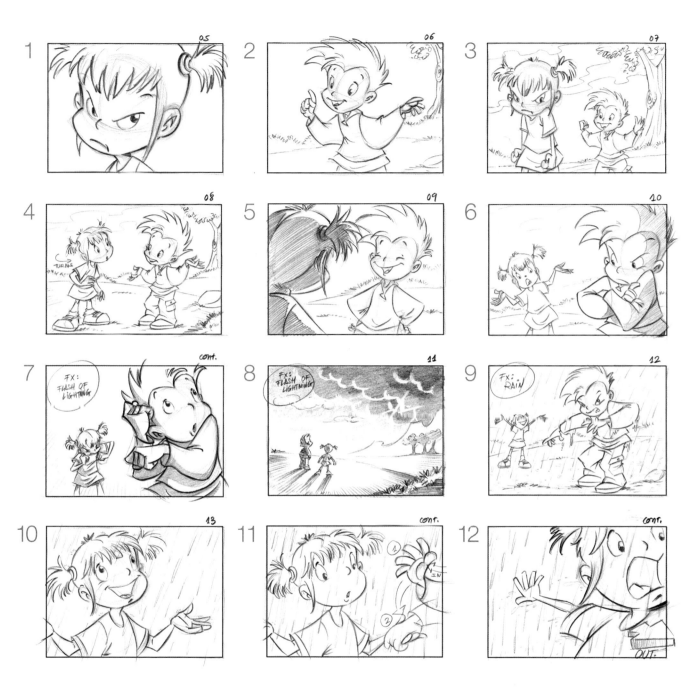

5. Medium shot (or over-the-shoulder/OTS) in which Pol finishes his dialogue and waits for a favorable response from Lucy.

6. Medium shot. Opposing shot of the previous one where Lucy shows an adverse reaction and Pol an annoyed attitude.

7. Continuation of the previous shot. Lightning interrupts the characters' dialogue, and this causes a change in the action.

8. Extreme long shot, or wide shot, where the setting changes as the storm clouds approach.

9. Long shot, or full shot. It begins to rain and both characters react differently to what is happening.

10. Medium close-up. We center our attention on Lucy, who is happy to see that the rain has frustrated Pol's plans.

11. Continuation of the previous shot. We notice Pol's waving and signaling motions, as he grabs his sister by the hands.

12. Continuation of the same shot (point-of-view/POV). Pol pulls Lucy and makes her leave the scene.

In this group we organize the shots according to the camera's point of view; we do not specify the camera shots, but we do consider its height and horizontal and vertical angles with respect to the subject we wish to film.

Types of Shots
According to the Camera Angle

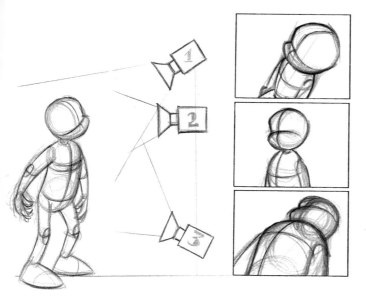

In the diagram we see how the character is framed from the same distance (a medium shot); however, the way it looks on the screen is very different because of the camera angle used for filming. This approach emphasizes the psychological aspect of our scenes.

HORIZON LEVEL
The camera is positioned at the level of the horizon line of the land-scape or of the eyes of the subject. Using this shot we achieve great objectivity in the narrative, since we see the same thing on the screen that we would see in a natural situation with the element being filmed. It constitutes a point of view that is closer to what the eye sees, and this communicates tranquillity and naturalness to the viewer.

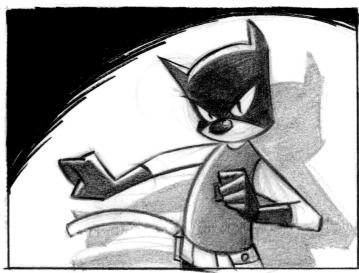

A camera angle at the horizon line has a natural feeling.

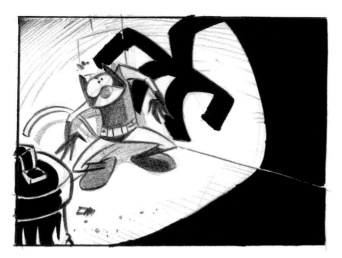

DOWN SHOT

In this situation the camera is placed above the horizon line of the landscape or the eyes of the character, with the lens pointing toward the subject.

If we work with long shots, this camera angle will be very useful for landscape description and for contemplating some element seen from the top of a building, and so forth.

In closer shots, and especially when dealing with characters, this angle creates a sense of inferiority in the character being filmed.

The down shot depicts characters as defenseless in dangerous situations.

UP SHOT

This time the camera angle is below the horizon line or eye level. This point of view gives a sense of importance and superiority to the element being filmed. Steep angles and up shots accentuate the perspective by flattening characters or making them look larger.

An up shot shows the superiority of some characters.

TILT

For this type of scene the camera must be diagonally tilted to the left or right so that the image on the screen seems twisted. This camera angle gives the viewer a sense of being off balance or of falling. It is a very effective approach for depicting an emotionally unbalanced character or accentuating a sense of chaos in a situation.

The tilt depicts a sense of insecurity in a character.

Camera Movements

With a movement of the camera we can describe a scene by moving along it in any direction. We can follow a character in its action, create the illusion of movement in static objects, and so on.

After the introduction of 3D in traditional animated cartoons, camera movements stopped being a challenge for the animated filmmaker, except that the movement of the camera must support, reinforce, and contribute to accurately telling the story. Using 3D makes any possible challenge seem natural without having to resort to "effects" that recreate the feeling of complex camera movements.

The movements that we will discuss here are the most usual and traditional of any animated films.

TRACKING IN / TRACKING OUT

This is where the camera moves into or away from the setting. In the old days, this camera movement created the effect of zooming in, since the camera moved vertically on the tower of the automation stand and the filmed image was absolutely two-dimensional. In 1937, with the introduction of the multiplane camera, the effect was improved, since the camera crossed several levels in its travel, creating an effect of depth. Finally, with the combination of 3D with traditional animation, tracking was able to create an authentic effect of moving through the setting, since despite being virtual movement, it actually existed.

Tracking movements, in any direction, add great spatial depth to the action and increase the perspective.

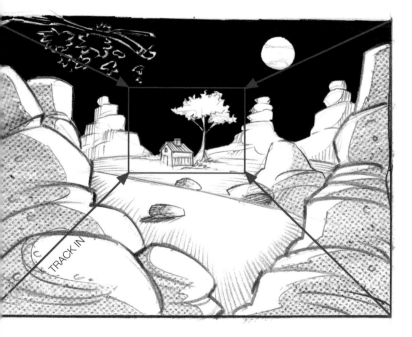

As the tracking advances toward the house in this setting, we observe the following: the rocks that are in the foreground get closer to the camera, growing in size and then disappearing on both sides of the frame, or view.

At a slightly slower speed, the same thing happens to the branch with leaves in the upper area, which then also disappears from the frame, or view.

The rocks on the next plane, like the previous ones, disappear at the sides after growing larger as the camera approaches them. Finally, we are in the second and final framing of the scene in the setting with the house in the foreground.

With tracking we observe that elements come closer and disappear at different speeds, but as we get closer to the house in the second framing, the moon, for example, does not increase in size because of its great distance. Therefore, tracking maintains the depth of field and reinforces the perspective of the elements that are found in the frame, or view.

PAN

Traditionally, in animated cartoons "panorama" referred to the movement of the background across the camera, or else capturing the width of the landscape in following the movement of a character. In live filmmaking this movement would be called "traveling" because the camera moves parallel to the character being filmed. In live action cinema, the pan would be a following movement or a scenic element where the camera would rotate on its own axis. Nowadays, and despite the fact that both effects can be done easily, most filmmakers continue to use the term pan for horizontal, vertical, or angled traveling. However, either of the two concepts can be correct as long as the terminology has been clearly established among the film crew.

Here is an example of a vertical pan. We can make it move upward or downward. The camera movements are usually filmed from a single piece of artwork to avoid jumps in the image.

START
PAN

STOP
PAN

A horizontal pan can move toward the right or toward the left. It is a good idea to begin the camera movements slowly and finish with gradual stopping to maintain a smooth motion.

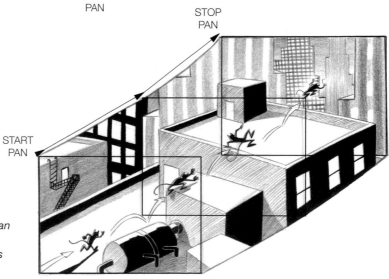

An angled pan can be completely straight or can describe an elliptical motion. We can combine any pan with tracking in and tracking out movements; it is simply changing the sizes of the fields.

ZOOM

What really moves in a zoom is the internal mechanism of the camera, specifically its lens.

Manipulating the lens of the camera and changing its focal length is how we move the image that we are focused on either forward or back. The effect is similar to tracking, but the fundamental difference is that tracking penetrates the space and the viewer subjectively accompanies the camera in its movement. In zooming, we bring the scene closer with the optical movement, but unlike tracking, the perspective flattens and depth of field is lost.

ZIP PAN

This is a short panorama in any direction made at great speed, so that during its movement it creates a blurred effect. It is used to make an abrupt change in point of view. On occasion, it is used as a transition between sequences.

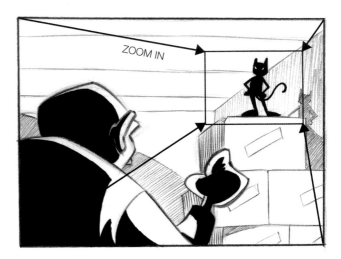

Zoom.

Zip pan.

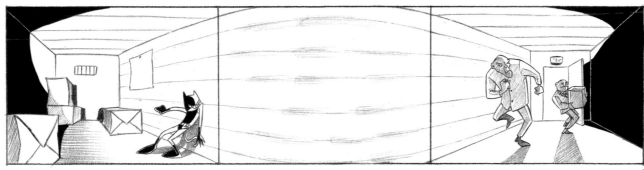

STOP ZIP PAN

START ZIP PAN

CAMERA SHAKE

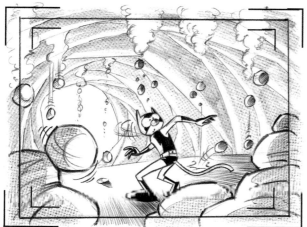

SHAKE

This trembling of the camera is used when there is a violent impact on a character or the set. It is usually a brief move-ment, but harsh. In animation the shake should create a random sensation, even though the movements of the camera are absolutely controlled. This is done to suggest an earthquake, the solid step of some heavy character advancing, or it can also be used for a falling action, a punch, or an explosion off camera.

Shake.

FROM THE ANIMATION STAND TO THE COMPUTER

In the beginning, animated cartoons were made using completely handcrafted methods. The finished animations were drawn in ink or photocopied on acetate cells. Then, on the reverse side of the drawings, color was added to the animations using acrylic paint. After this process was finished, the colored "cels" were taken to the animation stand to be filmed. The film camera was suspended from the stand's tower and was used to capture the images frame by frame. It had a table that could be moved in any direction. The panoramas, rotations, and so on, were filmed on this table, while the in and out tracking was filmed from the tower.

Nowadays, software applications have completely taken the place of the animation stand, since they can be used to do the same tasks in a much more effective manner and in less time. There are computer programs that base their functions on the old stands, are very intuitive, and very easily recreate the same effects in 2D that were made on a conventional animation stand, while also allowing multiplane photography effects to be created very simply. In addition, the integration of 3D with traditional animated films opened up the same possibilities for them that can be achieved in any live action film.

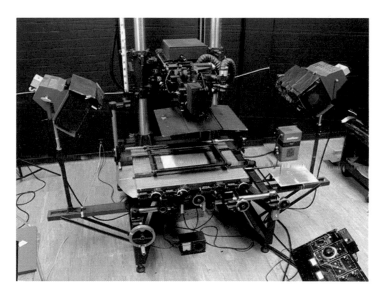

Photograph of an Oxberry animation stand in which we can see the table with the levers used to control all of its movements, and the columns for raising and lowering the camera. Generally, the stand had an automatic focusing system that would keep the subject in focus during its trajectory. It had powerful lights with polarized filters to illuminate the scenes without creating reflections on the acetates.

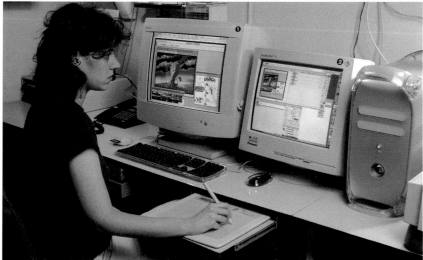

A conventional computer is used for the entire process of producing the color in the animations and the composition of the scene, along with the backgrounds and the work of the final generation of the scene. If the work is a combination of traditional animation with a 3D setting, other computers with different programs are used to create the backgrounds and camera movements.

Creating the

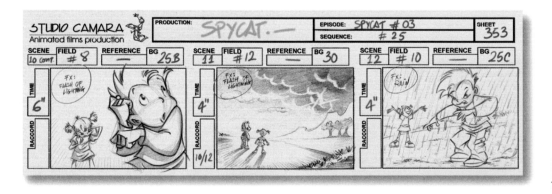

SERGI CÀMARA
SPY CAT, 2004. STORYBOARD FRAGMENT.

Storyboard

The director of
the film should be an expert

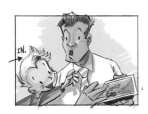

storyboard artist, or at least a perfect communicator of ideas to the person or persons who are working on the storyboard. In essence, the storyboard is the pre-production of the film, a succession of drawn shots, based on the narrative script, where all aspects of the film can be seen: the number, the size, and the duration of each shot, the relationship between the shots in the same sequence and between the different sequences themselves. The notations on the different scenes indicate composition, illumination, transitions, camera movements, dialogue, and a description of the action. In the storyboard we can even see aspects related to the rhythm of the film. Since it is a succession of drawn shots, it offers the possibility of a detailed study of the visual approach to the narration.

Finding the Right Shot

When beginning to work on the storyboard, we must think in strictly filmmaking terms. We are not making a short story, but working on the embryonic stage of a movie, and we must include all the aspects that will later allow us to make a good film from the finished plan. The ideal is to reinforce and enrich the history with aspects that even the scriptwriter had not considered.

We have to work from general to specific. We should approach the global aspects of the film in such a way that we understand the meaning of each sequence, and we should be able to express the essentials in each shot.

We will probably have to repeat the same exercise in reverse, studying the rhythm of each sequence based on the structure and approximate duration of the shots that were made, then comparing the results of one sequence with the others, and visualizing the meaning and overall rhythm of the film.

There are no guarantees, but it is possible that by using this procedure we will be able to see on the screen the same thing that we had originally visualized.

But …how should we approach reading the narrative script to convert it into shots in a movie? Let's imagine a brief description that a scriptwriter is giving us of a scene:

- Spy Cat reacts with fear and powerlessness before an unknown enemy that has him trapped and in imminent danger.

We see the powerless expression of the hero and we can guess the presence of danger judging by the direction he is looking, but we do not know the reason for his reaction or the setting where the scene is taking place.

Here we see a detail of the enemy and the frightened character. This scene could suggest the possibility of a confrontation between the two, or the possibility that Spy Cat might run away.

Perhaps this would be the best point of view. The steep angle emphasizes the inferiority of the hero to his rival, of whom we do not see a single detail, though his shadow is projecting menacingly. The wide shot shows details of the surroundings and communicates a feeling of being trapped.

We can also choose to not limit ourselves to a single shot and instead use a series of them, which could combine to communicate the idea more effectively.

In this example we have a rear shot of Spy Cat, who turns when he notices something behind him and is frightened at what he sees. The next shot shows an aspect of the "unknown enemy" in a steep angle shot that shows his superiority. We finish with the previously selected shot and the shadow of the enemy, who is moving closer to Spy Cat, until the screen fades to black.

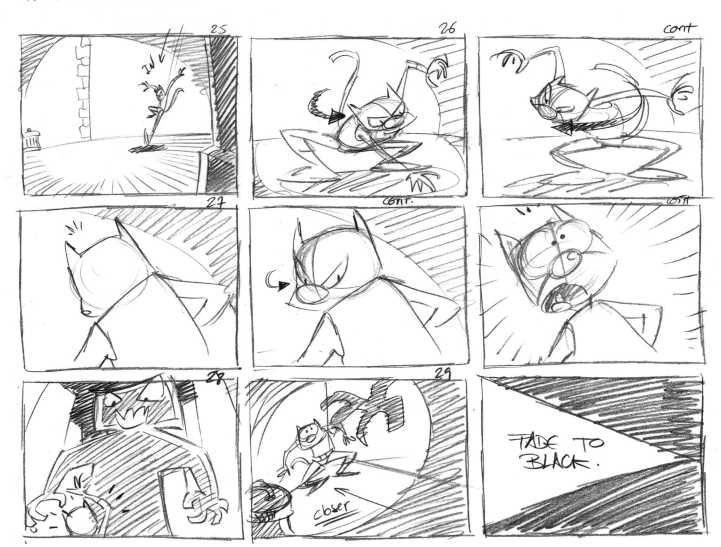

Since the storyboard should serve as a guide for the director and the rest of the crew, the directions specified on it must allow us to easily identify each sequence and scene. All this information should be on the card that we use.

Basic Directions

Each story panel contains information referencing the shot to which it belongs. On the heading of each page of the story is information related to the title of the episode and sequence number.

We can adapt the board to our needs, marking camera movements and special effects. The important thing is to give the required information in a clear and efficient form.

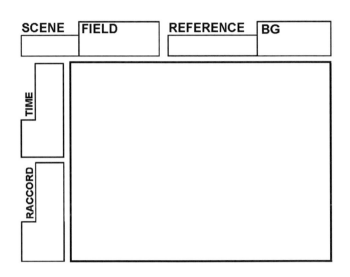

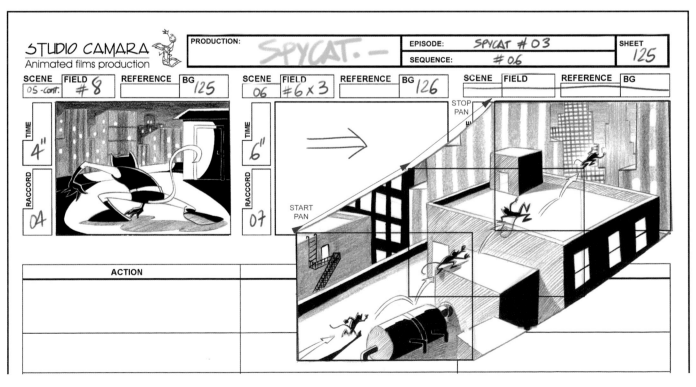

TRANSITIONS

There are many ways of passing from one sequence to the next in a film. We have already commented that a change in sequence is the same as a change in the action, which helps us move the story forward in time and space.

Within a sequence we usually move from one shot to the next with cuts. It is a natural transition, dynamic and very evident, although we are barely aware of it, since we continue in the same space and time situation. Cutting can also be used for changing sequences; however, to show changes in the setting, the passage of time, or narrative jumps, we can use narrative techniques called transitions.

Despite the fact that the transitions can be many and varied, we will focus our attention on the three most important ones: the cut, the fade out / fade in, and the fade to black. The rest are different interpretations of these three.

THE CUT

This is a clean and direct jump from one scene to another. It suggests a narrative continuity, so special care must be taken with the visual hookup, or continuity. Cutting makes the narration fluid and does not necessarily imply a drastic change in the action.

FADE OUT / FADE IN OR CROSS DISSOLVE

This refers to a gradual passage to the next scene. The duration of this transition indicates the intensity of the change of theme, place, rhythm, or time. The fadeout / fade in can be used to narrate past events (flashback) or future events (flash-forward). It can also be used to show the passage of a long time (for example, the construction of a building).

We use a panel on the storyboard to indicate the transition of a fade out / fade in.

FADE TO OR FROM BLACK

The image of the shot darkens until the screen is filled with black, or the reverse, beginning with black and slowly lightening until we can see an image. These are used for the end and beginning of a sequence. It assumes a true change in the narrative. It could also be used to mark the changes between acts, since it implies the passage of a long period of time.

We indicate a fade to black and a fade from black with these symbols.

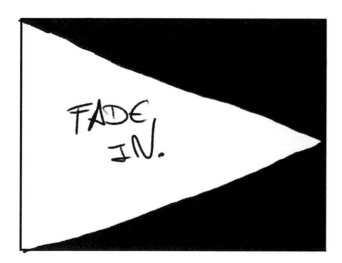

Finishing Styles

We have mentioned before that the storyboard is not the final art, but a medium that helps us achieve an end; therefore, it should be clear, concise, and concrete.

The final art on the storyboard depends to a great extent on the format of the film and the understanding and the cohesion of the crew. The storyboard for a short film made by a small number of people in a single studio is not the same as one for a television series with many working professionals and where the episodes may be divided among studios in several locations.

Next, we will see some styles of final storyboard artwork. All of them are valid and abide by the premises of cohesion and understanding.

A storyboard made with very simple and dynamic sketches can be enough for a short animated film where the director is in constant contact with the production team.

An elaborate storyboard is good for making an animated film in which several teams are isolated in very specialized departments and in which the director does not have direct access to the members of each specialty.

This storyboard fragment will work perfectly to show a small group of professionals the director's intention. Some later explanation to the leaders of the different departments will be enough for working on and giving a coherent form to the initial idea. Another example is the one on page 51. In both, despite their simplicity, we recognize the characters, identify the shots, and in those shots where it is necessary, we see lighting directions.

An idea for shooting a sequence can come from the most unexpected place. The director works on his initial ideas on any kind of paper, which he later passes to those responsible for making the definitive storyboard, along with all the pertinent verbal instructions.

Without worrying about the finish, the important part of each story is to recount the plot, basing it on the shot angle, the camera angle, the composition of the scene, and the lighting factors.

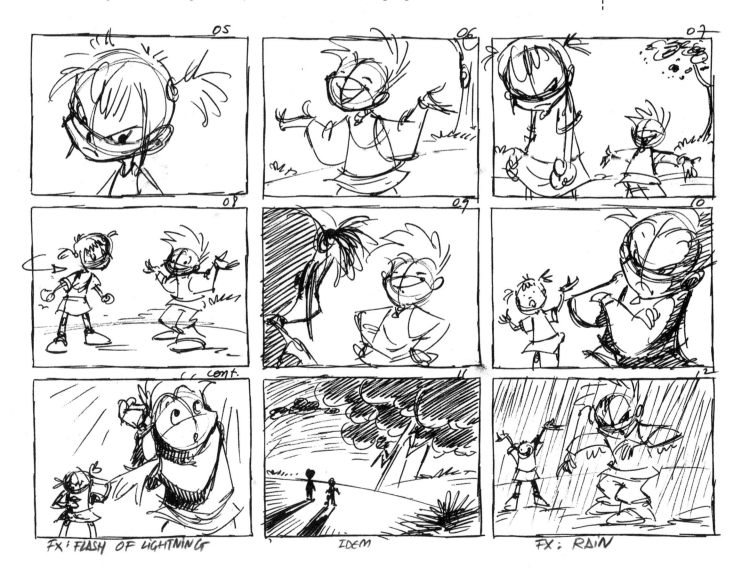

FX: FLASH OF LIGHTNING IDEM FX: RAIN

This model of final art is perhaps the most conventional. We see the shots clearly, we easily identify the characters, the lighting directions are exact… In reality, whatever the style of the finished artwork, the basic directions are the same, and what varies is the greater or lesser amount of detail.

This style of storyboard is the one that is most commonly used for television series. The fragment on page 41 would also work as an example.

Conventional storyboards for television series are usually done with normal pencils, and ink is used only when the light and shadows have an important relevance to the scene.

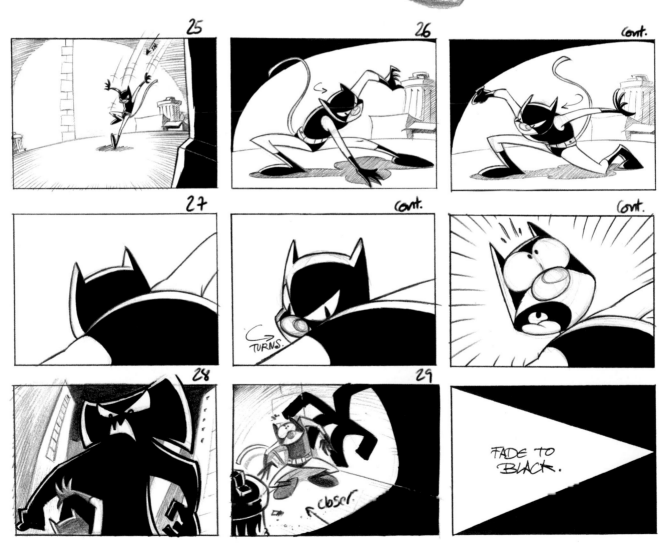

This elaborate style is mainly used for storyboards created for advertising. Paradoxically, it is work that is done by a few professionals, whose director is in close contact with them; even then, it is helpful for the storyboard to be detailed. This contradiction exists because the client who will give the approval to make the film is usually from the company that makes one product being advertised and is not necessarily familiar with the internal language of an animation studio. In some way, this finished artwork is meant for the client to "see," as much as possible, the finished film.

In animation work for full-length films, it is common to work with a mixture of three styles. A first stage sketch is used so the director can indicate basic ideas regarding the narrative style. A more elaborate second stage is used to aid in the layout work, and a third stage in color is used for some of the sequences in which the chromatic ranges are fundamental in relating the story or communicating a state of mind.

In animated cartoons for advertising, the color storyboard is used so the client has all the information about the various details that will appear in the film. In full-length films the use of color in the storyboard is reserved for sequences in which the color is part of the plot or has the function of communicating feelings to the viewer.

Creating
and Constructing
Char-
acters

"IT IS EASIER TO TURN AN ACTOR INTO A COWBOY THAN TO TURN A COWBOY INTO AN ACTOR." *John Ford*

Creating the Actors
Based on a Written Script

The real actor in an animated film is the animator himself, although he or she works through a character that is brought to life with a pencil. The character will lead the audience through the story. Therefore, our "actors," besides wearing the clothing and accessories needed to take the viewer to the era and place where the story takes place, must also have the psychological profile, physical structure, and integrity required by the story. To do this, the production team must do some heavy research and a detailed study of all the possibilities to find the most appropriate "actor" to communicate and breathe life into the character that plays the role.

The script is the basis for this work of creating characters and sets. The creative team presents their sketches to the director and together they begin to define those characters that have the perfect structure and profile.

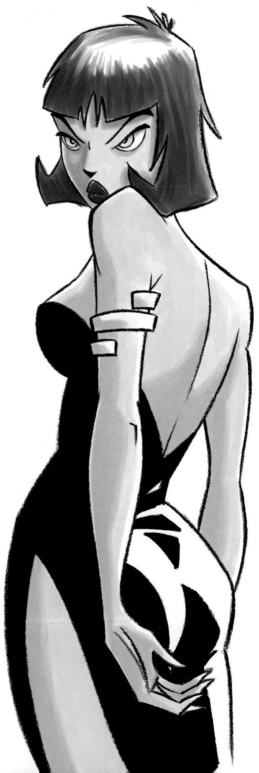

An individual detailed study of each character will help us find the typology and personality that the script requires in order for the story to work well.

Unless you purposefully mean to do otherwise, the characters that exist in the same story should share the same graphic style. Any style that is coherent and unified will make a good script believable.

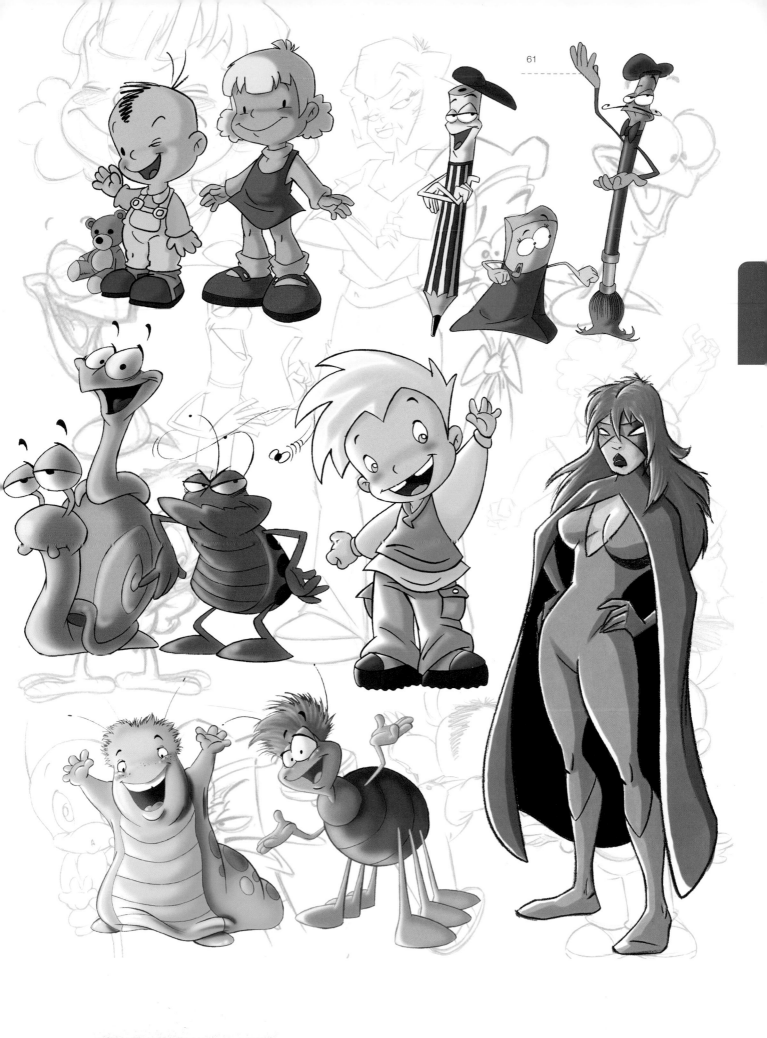

Constructing Characters
with Simple Geometric Forms

The work done by the creative people in this stage of the production will be interpreted later by the rest of the team of artists in the studio. Therefore, it is important for the creative people to base their work on graphic solutions that are easy to assimilate and repeat, so that all the artists will be able to easily draw the characters.

Creative work that is not well defined and is poorly structured will result in different interpretations of a single character that will create inconsistencies in the style and form. As a consequence, this will produce an incorrect and unpleasant sensation on screen that in no way will help achieve our final objective, which is to tell the story.

CONSTRUCTING THE HEAD

We will begin by approaching the cranial structure of the head as if it were a round mass, whether it is oval or completely spherical.

For the creation of our characters we must keep in mind that the cranial structures with the greatest volume belong to the characters with the greatest intellectual capacity, the smallest to the simpler ones, and the oval, angular, and pointed shapes to scheming and sinister characters. On these bases we can begin to draw some axes that will give us the approximate positions of the eyes and some of the more important features of the face.

The simplest and most usual way of creating a repeatable character is to base it on simple geometric structures. For example, juxtaposed circles of the correct sizes and proportions will allow us to give form to an infinite number of different alternatives.

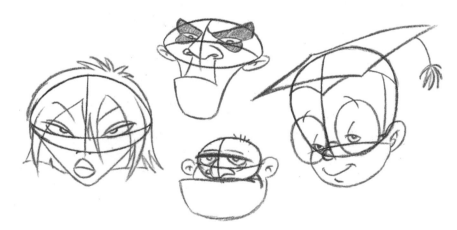

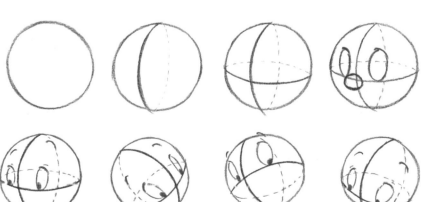

The axes will indicate the placement of each person's characteristics and the perspective of his or her face. The vertical axis divides the face and gives a sense of the inclination of the head, while the horizontal axis that we draw to place the eyes will show whether the face is looking up or down.

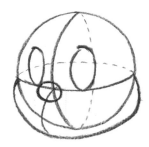
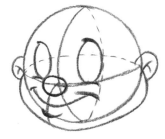

The jaw structure is the second circular shape used to construct the head. In it we will also draw the axes that will allow us to center the mouth and determine the correct position of the nose. This structure will give us much more information about the person and show something more of its character.

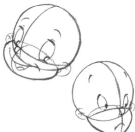
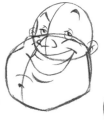
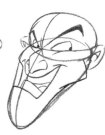

A small jaw structure with delicate forms indicates a fragile person; a large and rounded jaw suggests a large and heavy person, while a square or angular jaw indicates a strong character with the ability to make decisions.

We must clearly understand the difference between the cranial structure and the jaw structure as this will help us when it is time to do the animating. While the cranial structure is hard and rigid, the jaw is softer and more moldable. This fact will be important when we have to animate the dialogue and expressions of the character, since the strength of our animation will depend on this area of the face.

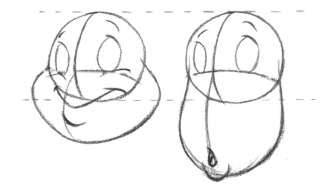

The majority of characters in movies and on television series are based on this formula. This apparent simplicity makes them assimilate well and ensures a uniformity of style even though several different artists may work on the same character.

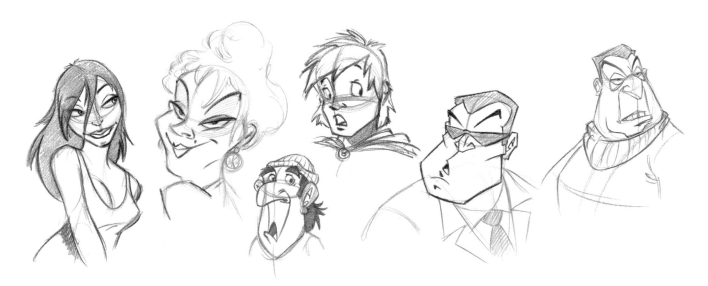

CONSTRUCTING THE BODY

For the general construction of a character we start with the classic academic formula that divides the human figure into a total height of eight heads. This formula represents the ideal proportions of a person. Obviously, we will adapt the formula to our creative needs in form as well as in style, since sometimes a studied deformation will create interesting artistic solutions.

Nevertheless, a good base in realistic drawing from the model, and a clear and detailed study of proportion and the workings of the joints, muscles, and bones will help us confront our creative moment with greater confidence.

Using the script as a guideline, we will figure out the different typologies of our characters using the formula of spherical and oval masses. We will accentuate the typical characteristics of each of the types that will be represented, according to their role in the film and according to their physical and psychological characteristics.

Sometimes the scriptwriter barely gives us any details about the typology of the character, and the entire creative process will be our responsibility and depend on our intuition. Other times we will have a detailed description. Therefore, it is a good idea to approach this creative process as a team, together with the artistic director, the scriptwriter, and the artists charged with the creation of the characters.

This is the classic formula of proportion based on eight heads in the ideal human figure for men and women; for children and young adolescents the formula specifies four and six heads, respectively, and a heroic figure is nine heads high.

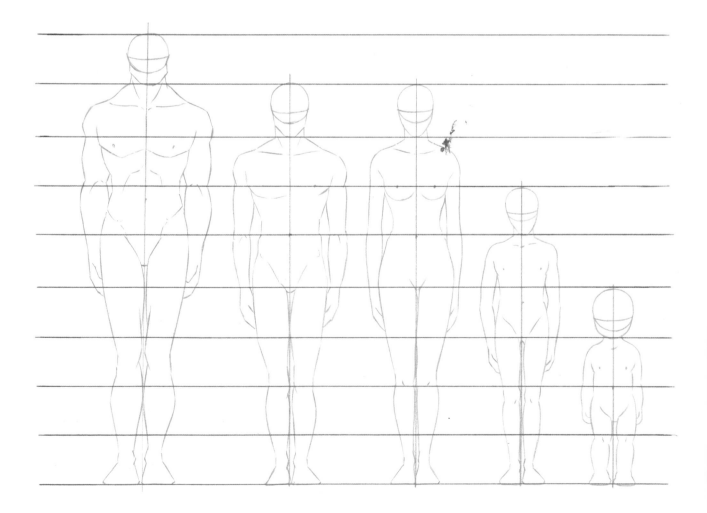

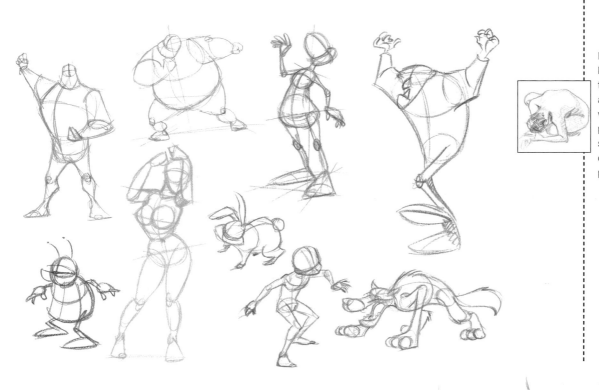

It is important to know that part of the portfolio of an animator who wishes to work in a professional studio should be based on life drawings of people and animals.

We draw ovals to represent the chest and abdomen, and also for the legs and arms. Each form, each structure will have different characteristics. We must be clear that the basic idea is to begin with general structures that can be easily assimilated and repeated. We will create the individual characteristics for each person with the details.

We can also represent the hands and the feet with ovals. Later we will study the expressive value of the hands, but now we will try to get a grasp of the general structure to get a start on our first creative attempt.

To join our oval structures we will use a basic sketch of the skeleton and a series of lines and axes. In general, the first sketch of the figure is made using the axes and the skeleton. On this underlying structure we can place the general volumes using spherical and oval masses.

Posing the Character: Defining Its Form

A crucial characteristic that we must strive for in any character that we are going to create is the pose. From a distance we are able to recognize people by the way they walk, the way they move, and by their gestures. So, when we refer to the pose, what we really mean to say is that the viewer, with a simple glance at the person, can see all that he or she has to see. Therefore, our line must show charm, communication, magnetism, and simplicity.

The characters, whether heroic, sweet, or evil, are not only recognized by their body types and their details but also by their poses. Through their poses we should be able to transmit their moods, their attitudes, their intentions, and all that the scene requires. In the few seconds that the scene lasts, the audience must capture its entire dramatic content. This is essential, since the plot will be under-stood through the visual continuity of one scene after another.

Here we show a series of graphic approaches that will allow us to give our characters the appropriate pose that will be right for the scene.

Through the pose we are able to bring any character or even any object sufficiently to "life" to communicate feelings to the viewer. The pile of papers that we are using for these sketches can become an ideal person at any moment, capable of being the protagonist and telling any story.

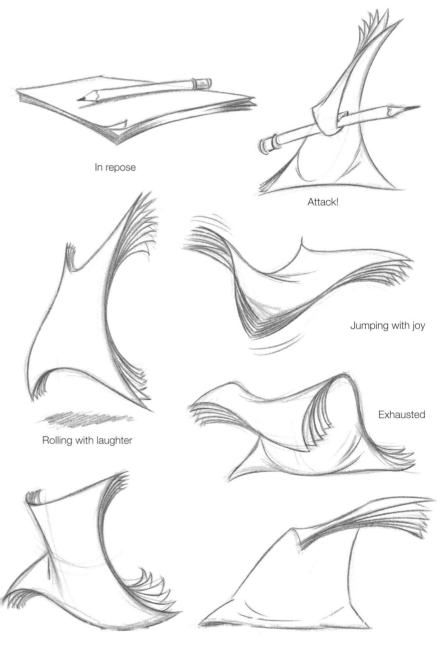

In repose

Attack!

Jumping with joy

Rolling with laughter

Exhausted

Running

Looking around

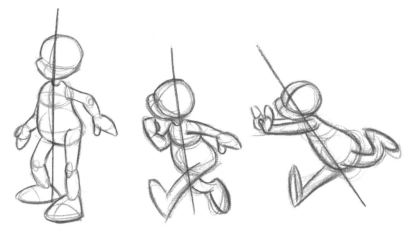

The center of gravity keeps the person balanced, not only when standing but also in dynamic balance when moving. We will see that by using the appropriate center of gravity, we can work with a character in any pose or angle and always maintain a feeling of stability.

THE AXES

We should learn to work with a group of imaginary lines that will give our characters balance and stability, independent of the actions they carry out, and that will help us construct them in correct perspective.

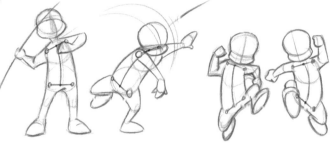

The axes of the shoulders and of the hips show us the perspective of the character in the shot. Both axes in their actions can move in opposite directions to maintain the balance that the figure needs when making specific movements. The twisting or leaning of one of these axes in any direction will always cause an opposing movement in the other at the same speed. The two axes always move in relation to the center of gravity.

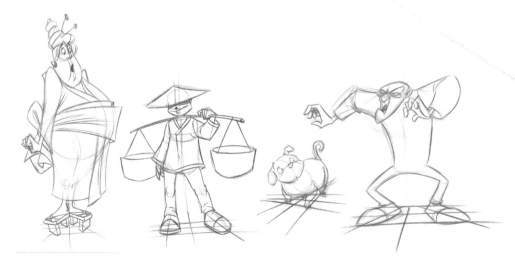

The perspective lines of the feet on the floor set the pose, independent of the center of gravity and the two axes of the shoulders and hips. These new axes confirm the balance and the perspective of the figure in general, and depict a character that is solid, stable, and "real."

FLOATING LINES

These are imaginary lines that reside in the mood, the personality, and the force of the character.

They help us make clear psychological differences between the characters and their different physical structures. Just like real people, animated characters can have a specific physical makeup that in itself gives them the ability to do certain tasks, but they will always confront these different situations in one way or another as a function of their character's personality.

Therefore, the floating lines indicate their temperament—whether the characters will be more or less brave or determined or vulnerable, or able to make their own decisions.

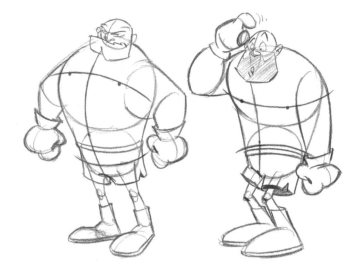

The floating lines are a combination of the thoracic axis and the axis of the hips. Therefore, despite sharing a very similar physique, a convex combination indicates a temperamental and brave person able to stand up for himself. A concave combination, on the other hand, indicates a timid, indecisive, and sometimes even cowardly person.

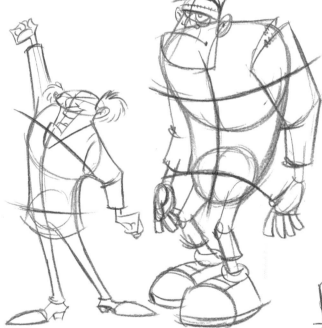

We can also create a strong contrast between two people with different physical structures, as in this example, where the smaller person makes the decisions and gives the orders, while the big and strong character obeys.

It is possible for the same person to show different moods. He can be energetic and lively at the beginning of his adventures and tired and beaten at the end of the struggle.

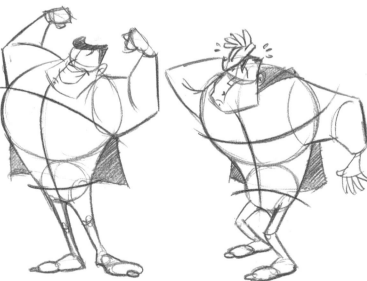

CONSTRUCTING SOLID AND THREE-DIMENSIONAL DRAWINGS

If we are focusing only on what will be a traditional animated film, we should not forget that our characters are simple lines drawn on paper, and therefore true three-dimensionality is impossible. However, throughout the movie we should communicate a sense of volume and depth, both in the setting where the action takes place as well as in the characters doing the acting. Only with talent and professionalism will we be able to transport our audience to any place or setting, no matter how sophisticated, without giving the viewers the feeling of seeing flat, two-dimensional drawings.

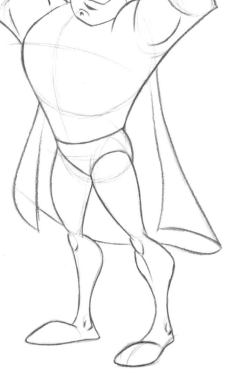

Three-quarter views will help us achieve three-dimensionality. It is good to avoid poses where the character is seen completely from the front or the side. This does not mean that those poses cannot be used, because sometimes they will reinforce the dramatic action.

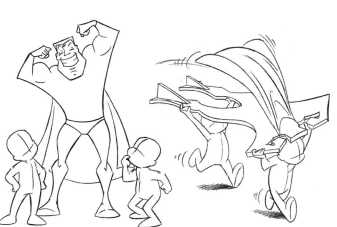

CONSTRUCTING ASYMMETRICAL STRUCTURES

Using this type of construction will help us give the characters dimension and volume, and it will also break the monotony of the pose and of the action in general.

An asymmetrical construction will greatly reinforce the believability of our characters. On the other hand, we can make use of symmetry for more grotesque characters that we are using for their comic effect.

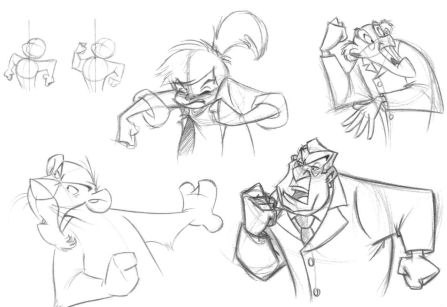

Asymmetrical construction will give the characters a naturalness and realism.

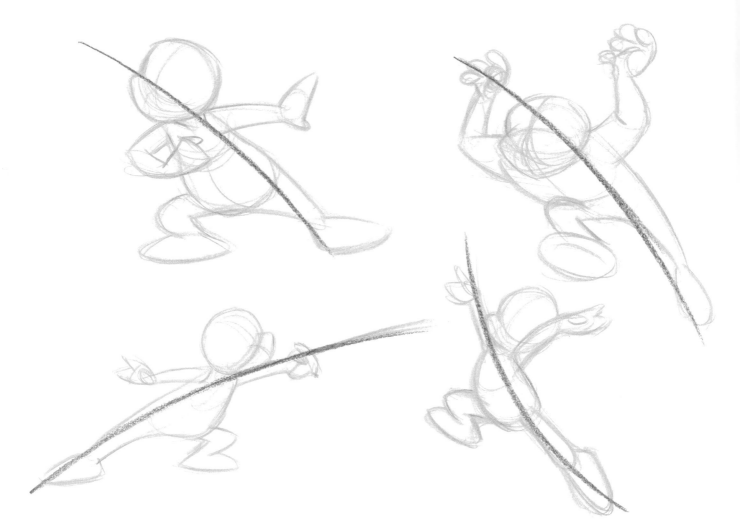

THE ACTION LINE

This is perhaps the most important imaginary line and one that we must keep in mind when creating the animation. The line extends through the character in its main action. It reinforces the dramatic effect, the intention of the movement in its expression, the dynamism, and the direction of the energy.

It is usual practice to draw the poses of our characters based on the line of action and to organize the different solid structures on it, composing the typology little by little.

All the structure and energy of the character is organized based on its line of action. We achieve two important effects with it: on one hand, it accompanies the main action and gives it intention and dynamism; on the other, it creates a simple and clear structure for a character that we can easily understand.

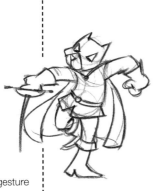

An incorrect gesture line can ruin a pose and the viewer's understanding of the action.

Throughout the animation, the line of action evolves with the character in a waving motion that gives the action cadence and smoothness.

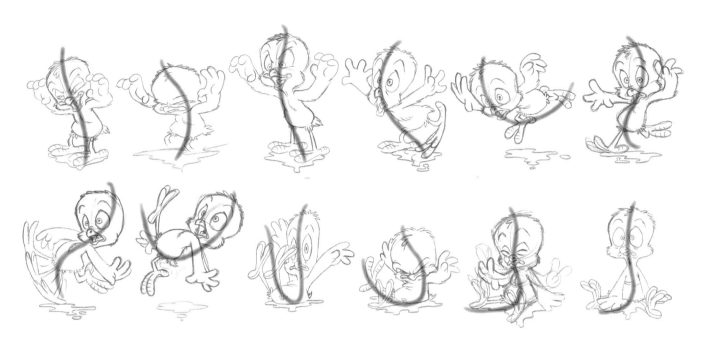

THE SILHOUETTE

Our main objective should be that of creating poses that effectively communicate the essence of the action. It is a matter of finding an ideal and well-structured drawing that centers the viewer's attention on the main action. When we present our sketches to a creative team, or when, in animation, we determine what the main poses for a specific action will be, we should make sure that the silhouette of our work clearly describes the intention of each of our drawings.

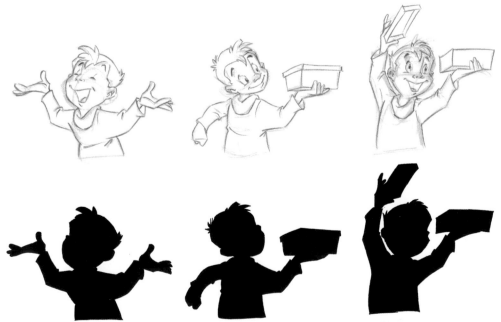

The clarity of our poses is essential for making the action understood.

Animated characters are fictional beings representing humans who are purely imaginary or based on reality, and they will be the basic pieces that move the story forward or are affected by it. The incredible flexibility of animation allows the characters to also be animals and objects.

The Basic Typologies of the Actors

A character in a movie is motivated mainly by his or her thoughts or actions, or by his or her reaction to the thoughts or actions of others. The psychology can be as deep and ambiguous as we want it to be, or it can border on a basic simplicity that can be easily understood at first sight.

Depending on the story, the characters and their psychology can be more important and interesting than the action itself, or the situation can be completely the opposite. Either approach, or a balance of both, can provide very good results.

A character has to be able to transmit its mood, attitude, and something about the personality in a simple and effective way.

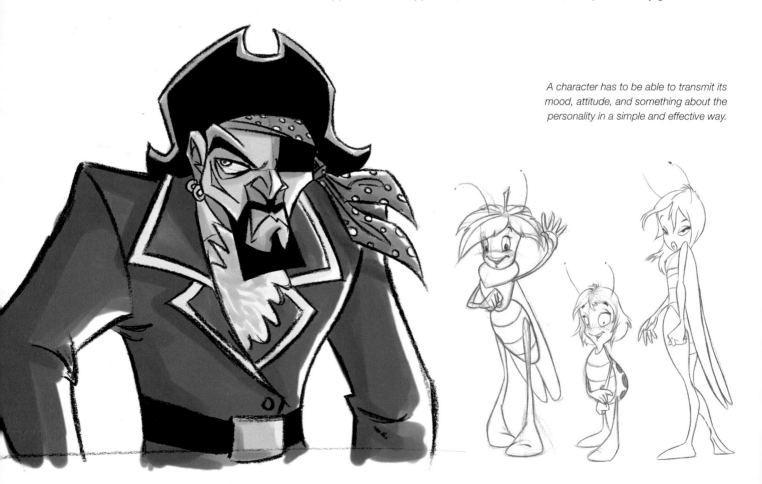

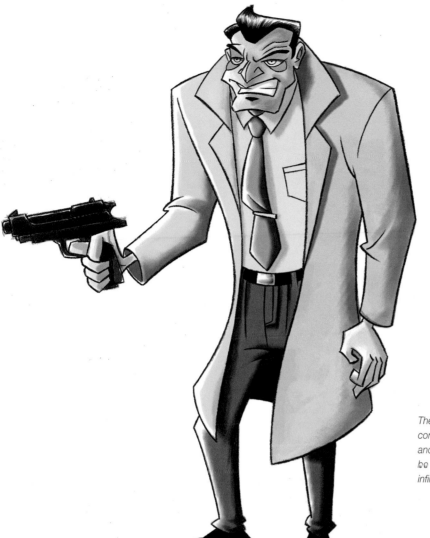

A good way to give personality to a drawing is to take inspiration from a real person and to try to "capture" his or her essence in the drawing.

The volumetric construction, the pose, and the expression will be helpful for creating infinite variations.

GENERAL CHARACTERISTICS OF STEREOTYPES

It is important to give each character its appropriate personality, character, and temperament. To do this, we will create a stereotype of its physical appearance so that at first look the character will bring us closer to its personality.

It is logical to think that the physical appearance will condition in part the way a person is; it will also condition him or her when executing specific physical activities.

We use the formula of the oval structures to construct the volumes of the head, chest, and hips. The different types will be determined in great part by the dimensions, changes of form, and variations that will be applied to them.

The examples that we are going to see next will demonstrate the most stereotypical features that make the characters stand out according to their different types, but, obviously, the creative artist must experiment with his or her own formulas when creating the characters.

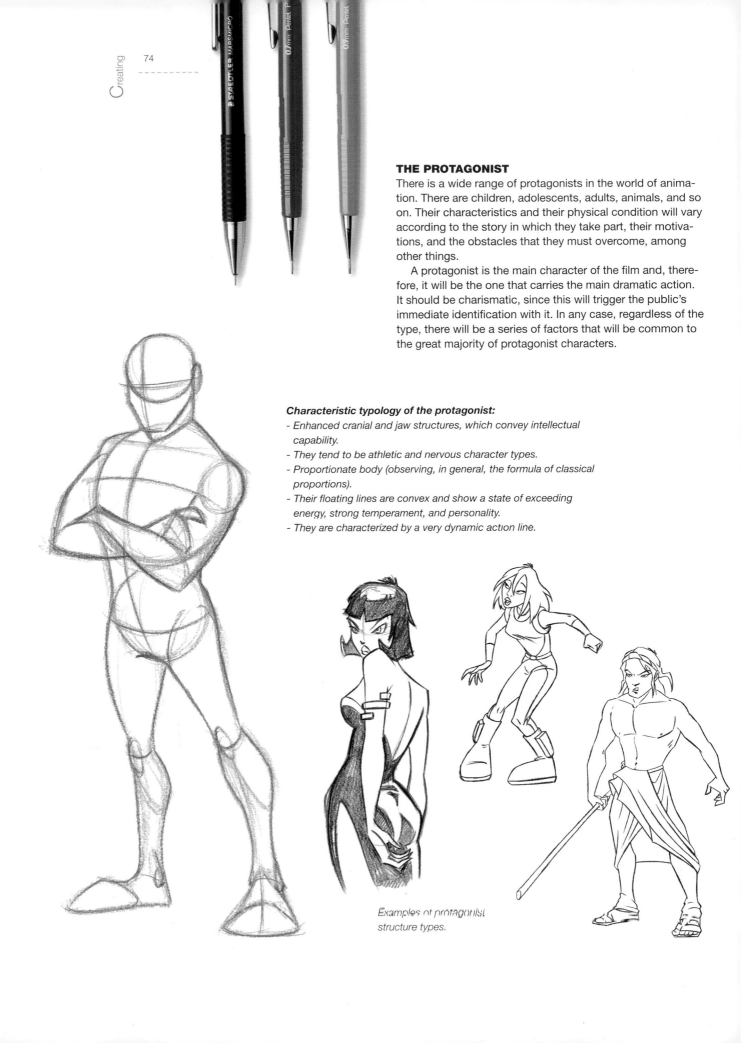

THE PROTAGONIST

There is a wide range of protagonists in the world of animation. There are children, adolescents, adults, animals, and so on. Their characteristics and their physical condition will vary according to the story in which they take part, their motivations, and the obstacles that they must overcome, among other things.

A protagonist is the main character of the film and, therefore, it will be the one that carries the main dramatic action. It should be charismatic, since this will trigger the public's immediate identification with it. In any case, regardless of the type, there will be a series of factors that will be common to the great majority of protagonist characters.

Characteristic typology of the protagonist:
- *Enhanced cranial and jaw structures, which convey intellectual capability.*
- *They tend to be athletic and nervous character types.*
- *Proportionate body (observing, in general, the formula of classical proportions).*
- *Their floating lines are convex and show a state of exceeding energy, strong temperament, and personality.*
- *They are characterized by a very dynamic action line.*

Examples of protagonist structure types.

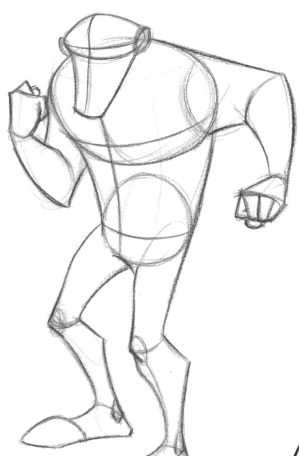

THE VILLAIN

Villains tend to be the most important characters in animated films, often even more so than the protagonists. First, in cases where the goals of both characters oppose each other, villains are the ones who break up the plot. Second, villains tend to be more charismatic than the protagonists since they have an essential motivation that makes them act and put their ingenuity to the test, while the protagonists often act as a consequence of the actions created by the villains.

It is also possible that the protagonists and the villains pursue the same dramatic goal and therefore fight each other to attain it.

The interest of our story will be determined by how bad, how strong or powerful, and complete the character of the villain is. The villain will be in charge of presenting the challenges to the hero; therefore, the stronger the villain is and the harder the protagonist has to fight, the more interesting the movie will be.

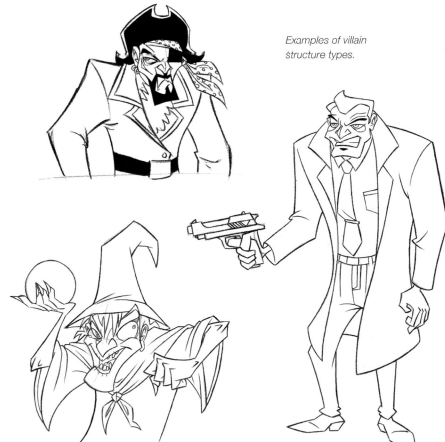

Examples of villain structure types.

Characteristic typology of the villain:
- *Oval cranial structure and angular jaw.*
- *Unequivocal malicious grin and somewhat enigmatic.*
- *Head proportionally equal or superior to that of the hero or protagonist.*
- *Concave or convex floating lines. In this case, the rest of the pose will define its body structure.*
- *Dynamic line of action despite its slumped appearance. It will generally show a defiant tone.*

THE HEROIC CHARACTER

This is the positive protagonist who must impress the audience with force, powers, intelligence, or extreme bravery. The heroic protagonist is usually in constant struggle with dramatic barriers that will present themselves during the movie, and will generally overcome them, always setting a good example with his or her actions and decisions.

The hero will always fight against anything that is negative, normally portrayed by an antagonist who pursues the hero's demise and will always have equal and even superior strength, power, and ingenuity. Only good deeds and a show of cleverness in the final climax will place the hero above his or her rival.

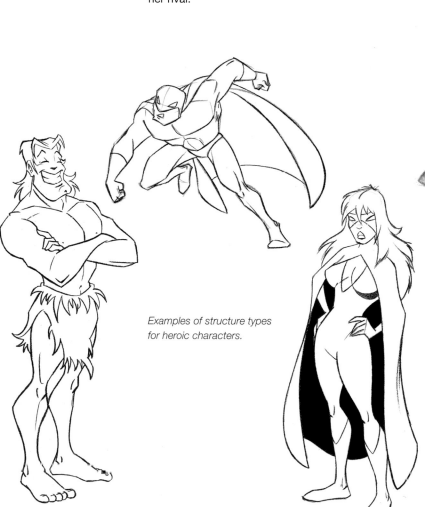

Examples of structure types for heroic characters.

Characteristic typology of the heroic character:
- *Normal cranial structure and voluminous, square, angular jaw.*
- *Characters that proportionally combine the athletic and heavy types.*
- *Body beyond the eight heads of the classical formula, in general, about nine heads.*
- *Convex floating lines in a constant state of maximum alertness and of quick recovery capability.*
- *Dynamic and vigorous line of action that predisposes them to immediate action.*

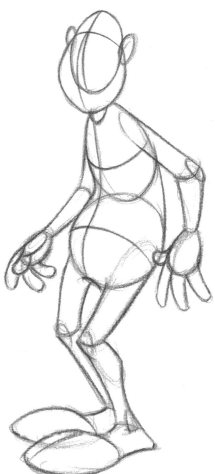

THE ANTIHERO

This character does not stand out for intelligence, beauty, strength, bravery, or any other special virtues. Its mediocrity is its most characteristic feature; therefore, its attractiveness comes only from its simplicity and the "close" reality with the spectator, because unless it is exaggeratedly clumsy and stereotypical, the identification with the adult spectator is automatic.

It tends to be the secondary character that accompanies the hero or its antagonist. In these cases, the antihero will provide the affection and warmth to the story that is sometimes lacking in the other characters.

We must remember that we are dealing with basic stereotypes. The ideal approach is to create our own structures, to experiment, and to try to convey the basic message in function of the character's initial construction.

Characteristic typology of the antihero:
- *Its cranial structure tends to be small and oval, while its jaw can vary according to each case; or it can be small and sunken inward or large and hanging.*
- *Very narrow forehead; eyes semi-closed and languid; large nose and a mouth with protruding teeth.*
- *Its proportion in heads can vary according to the case, but it is important not to make them look like gracefully proportioned characters.*
- *The floating lines are concave and show a chest that is somewhat sunken with a bulgy stomach. Its pathetic aspect is highlighted by long extremities that end in hands and feet that are large and awkward.*
- *The line of action is absolutely slumped, as if carrying a weight on the shoulders.*

Examples of structure types for antiheroes.

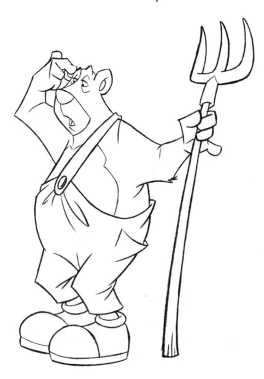

CHILDREN'S CHARACTERS

As a general rule, children are protagonistic characters; they stand out for their friendliness, intellectual brilliance, and their ingenuity rather than for their strength and power. Their extroverted personality will make it easier for them to find the necessary allies, who will make up for their physical shortcomings and who will help them win over their antagonists (who generally are superior in strength and size because they are usually adults). Their gentle character makes them charismatic to the audience, in particular to child audiences, who identify with them immediately.

Characteristic typology of children's characters:
- *The cranial structure tends to be quite a bit larger than the jaw. In general, the entire head will be large in relation to the body.*
- *The forehead is usually high and clear. The eyes are large and separated, and the nose and the mouth somewhat small.*
- *The bodies of the smaller children usually have a four-head proportion. Those of adolescent children are approximately seven heads tall. In any case, in animation this can be freely modified, and we can create two-and-a-half head structures like the one in the example.*
- *The floating lines are convex and they indicate a good disposition. Along with a combination of short and robust extremities, they will provide some detail about the character's fragility.*
- *The line of action is also dynamic.*

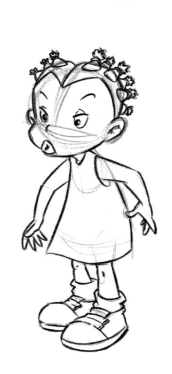

Examples of structure types for children's characters.

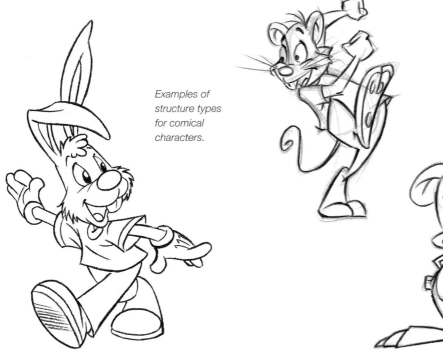

Examples of structure types for comical characters.

THE COMICAL CHARACTER

This is usually the typical character that appears in the most cartoonlike animated films. The comical character transmits the most charming comical moments in film or television. Remember, for instance, the number of strong boxes and other heavy objects that have fallen on their heads, and the many accidents from which they always come out unharmed and victorious. Their psychology can be that of a rambunctious character or a charming one, a companion to protagonists or villains. In the latter case, it is usually the character destined to receive the consequences of all the comic gags that occur along the action.

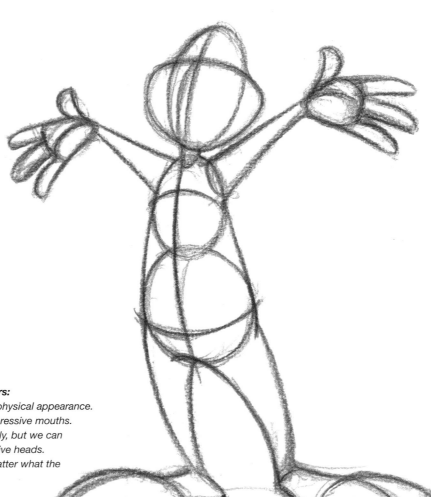

Characteristic typology of comical characters:
- *Elongated cranial structure and exaggerated physical appearance.*
- *Shrewd eyes and large, exaggerated, and expressive mouths.*
- *The proportion in heads can vary tremendously, but we can generally use an average between three and five heads.*
- *Floating lines are almost always convex no matter what the character's typology is.*
- *Extremely dynamic line of action.*

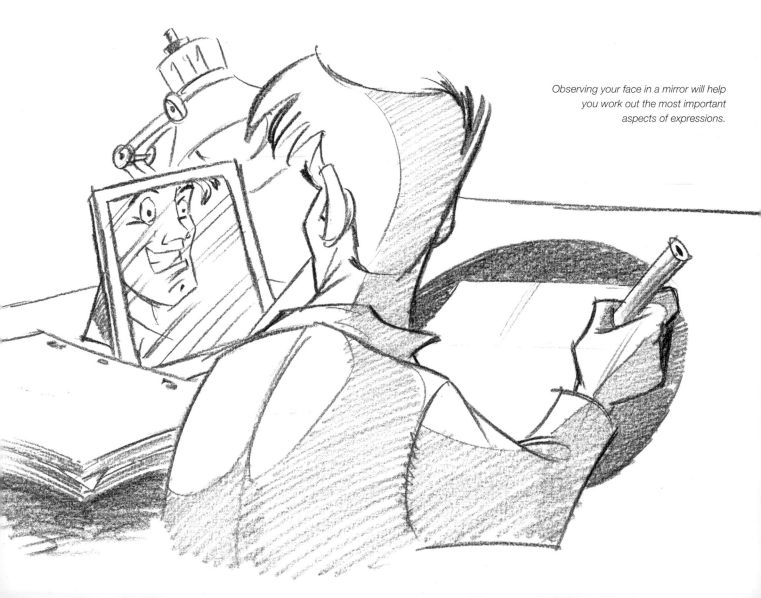

Body Language, Nonverbal Expression

An animated character must be an excellent actor and a master at conveying emotions. The animator should be able to translate various moods onto paper, not only by paying attention to the character's movement but also by reflecting, as we have already seen, the personality, the mood, and the identity. The dialogue of the film is not the only element that has to tell us something about the story. The character must convey to the spectator the feelings expressed, anticipate the dialogue itself, and even be talented enough to transmit

that without using words. Many animators work with a mirror placed at face level on their drawing boards to study their own gestures and to bring realism to the expression of their characters.

We have seen how nonverbal communication works through body language by means of poses. However, the face and the hands are perhaps the most important elements that we have to give expression to any animated character.

Observing your face in a mirror will help you work out the most important aspects of expressions.

THE FACE

It is here that we find the most significant features of human expression. In animation, those features are also transferred to other characters, such as animals and even objects, because anthropomorphism is the best way to turn them into characters. This is a traditional characteristic in the history of animation.

Perhaps the eyes are the features most capable of expressing any attitude or emotion, but they work in combination with other parts of the face, such as the eyebrows, the eyelids, and the cheeks. Notice how all of them maintain a relationship when they convey an expression. A movement of the eyebrows will affect the upper eyelids, producing a smaller or greater opening of the eye, also in its upper area. Any extreme movement of the mouth will affect the cheeks, and as a result, the lower eyelids and the shape of the eyes.

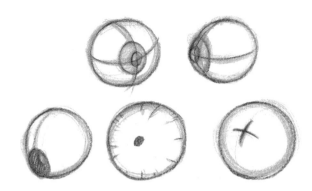

The location of the pupil inside the eye tells us in which direction the eye is looking. The shape of the pupil also tells us something about the attitude, but with these elements alone it is difficult to capture the overall expression.

The combination of the pupil and the eyelids is more interesting because together they provide more information.

It is important to keep in mind that the eyebrows and the cheeks are the features that affect the eyelids and that they radically change the shape of the eye and its expression.

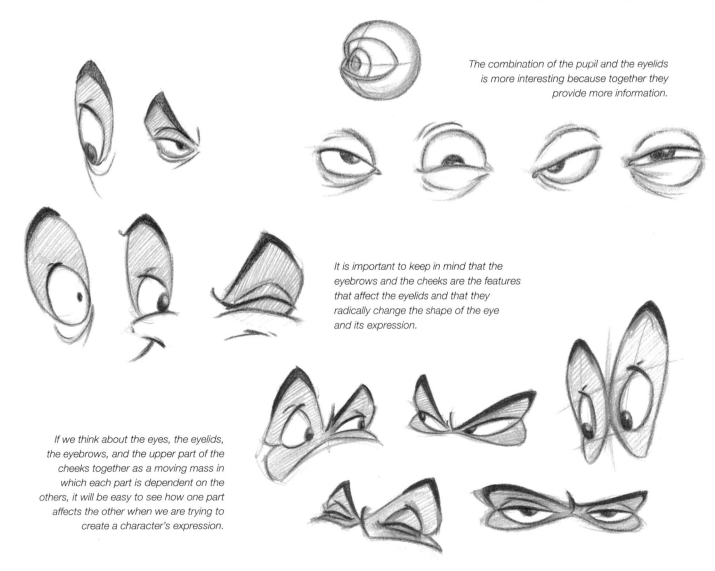

If we think about the eyes, the eyelids, the eyebrows, and the upper part of the cheeks together as a moving mass in which each part is dependent on the others, it will be easy to see how one part affects the other when we are trying to create a character's expression.

THE EXPRESSION

It is important to keep practicing the effect that the features seen thus far have on any given character. Let us take several different characters and observe the overall effect of the eyes with the eyelids, the eyebrows, and even the mouth.

It is important to practice ways in which we can transmit to the audience what we really want to convey. We will find several "acceptable," even correct expressions for certain actions, but only one will be the best.

THE HANDS

The hands have an expressive component that is as important as the character's face itself. The hands are the part of the body that, because of their articulations, can have the greatest number of positions. Moreover, we use them constantly to converse and to convey a number of emotions. We can use them to express ourselves not only through their variety of movements but also because of their position with respect to the rest of the body. We will not communicate the same expression if our hands are at waist level, shoulder level, or above the head.

Obviously, a hand has five fingers, and that is the basis for the most realistic characters; however, there is a perfectly accepted formula of four fingers for the simplest or more caricature-like animated cartoons. The elimination of one of the fingers responds more to an economic criteria rather than an aesthetic one, because the elimination of the finger translates into an important savings for the entire production team.

In any case, we will try to distribute all the fingers in parallel configuration. Their different movement combinations will give us an expressive quality and aesthetic value.

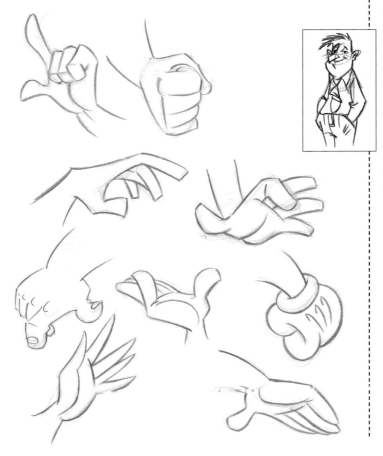

Generally, the hands are difficult elements to draw for the less experienced artist. We should not avoid them by hiding them in pockets or behind the character. In animation, it is important to give them all their expressive importance.

The construction of the hands will vary according to the style and the sophistication of the character. We can begin with an oval to represent the metacarpal area and from there we can project the necessary ovals for the different fingers. Or, we can simplify the entire structure by drawing a mass in the shape of a mitten and then construct the fingers with ovals, which will correspond to the total length.

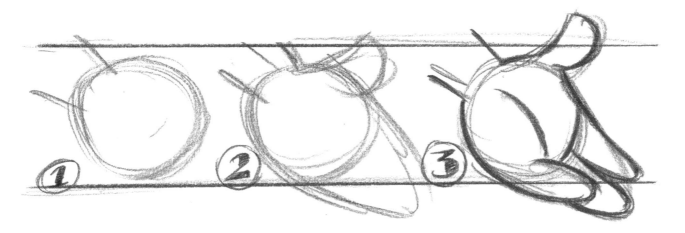

Model *Sheets*

Once the characters have been created and approved, the creative team begins to work with the model sheets. These sheets show the characters with different attitudes and expressions, and reveal the details of their structure, construction, and so on. The purpose of the model sheets is to provide a constant reference for the animator and the layout artists and to demonstrate the graphic style designed by the main creator. A wide range of model sheets are produced for the main characters, which usually include:
– Model of overall characteristics (chalk-talk)
– A 180° turnaround
– Model of expressions and attitudes
– Model of hands (as a fundamental element of expression)
– Model of vocalization (for dialogue scenes).

For incidental or secondary characters, the artistic director will decide which models are needed the most, but as a general rule a 180° turnaround and a model of expression and attitudes are sufficient.

Models are also created to compare the sizes of the characters that appear in the same production so that the artists can use them as a reference when they need to animate scenes in which two or more characters appear together. Each production also has elements for the accessories and for the objects that the characters use in the scene, of which corresponding model props are needed. Finally, colored models are created.

Model of the general characteristics in which specific particularities of each character, style, construction, and finishing details are shown.

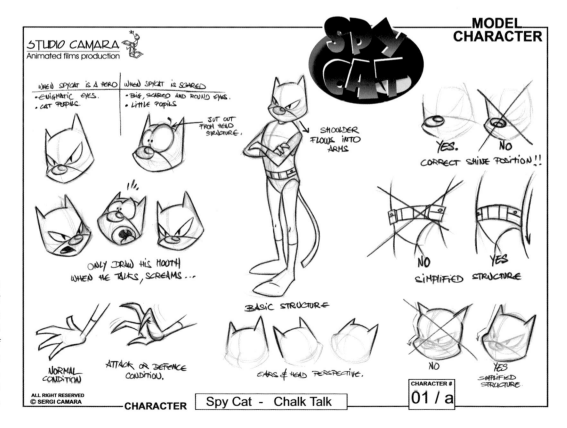

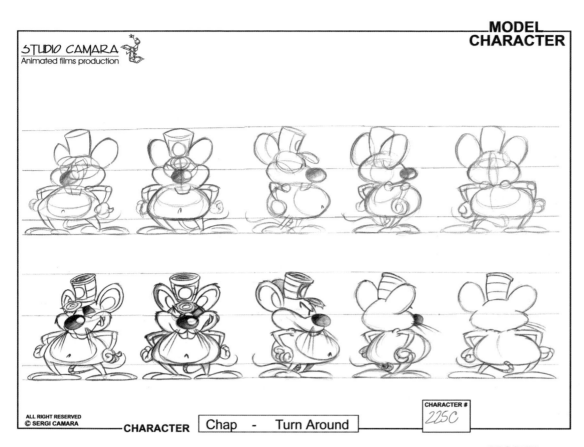

STUDIO CAMARA
Animated films production

MODEL
CHARACTER

ALL RIGHT RESERVED
© SERGI CAMARA

CHARACTER | Chap - Turn Around

CHARACTER #
225C

A 180° turn to give the animator a reference of the character from different points of view. The purpose is to gain a three-dimensional understanding of the character.

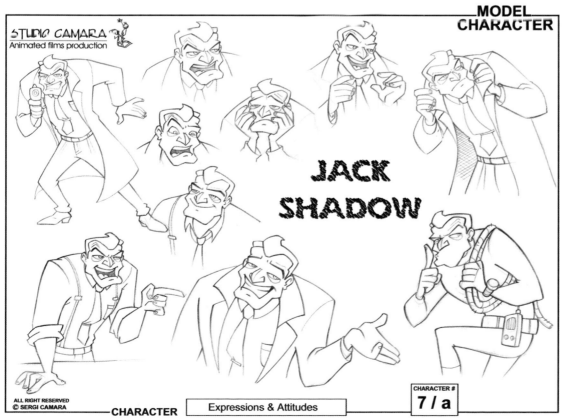

STUDIO CAMARA
Animated films production

MODEL
CHARACTER

JACK
SHADOW

ALL RIGHT RESERVED
© SERGI CAMARA

CHARACTER | Expressions & Attitudes

CHARACTER #
7 / a

Attitudes and expressions that show each character in its most common pose and personality.

Sometimes, the expression and attitude models are done separately to give the animator more concrete information. In practice, there are no specific rules, and each creative team develops the models to fulfill the requirements stipulated by the team that develops the different steps of the production.

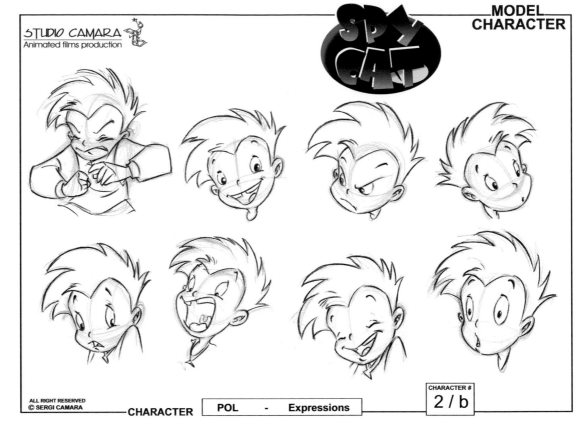

ALL RIGHT RESERVED
© SERGI CAMARA

CHARACTER POL - Expressions

CHARACTER #
2 / b

The hands are, after the face, the most important expressive features. Therefore, it is necessary to have a model that shows concrete information about each character's hands.

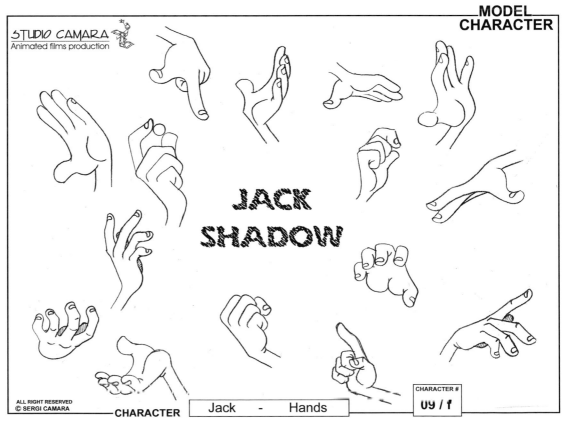

ALL RIGHT RESERVED
© SERGI CAMARA

CHARACTER Jack - Hands

CHARACTER #
09 / f

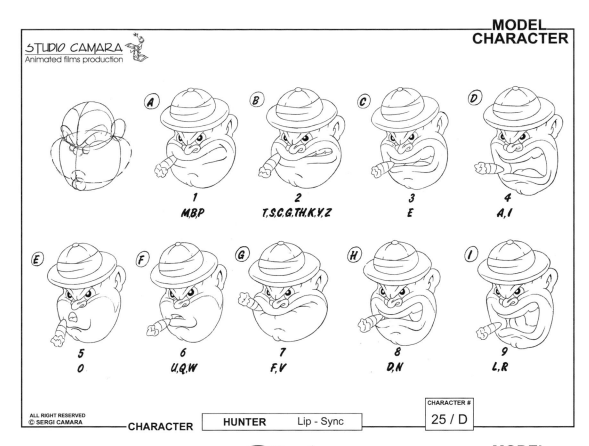

ALL RIGHT RESERVED
© SERGI CAMARA

CHARACTER | HUNTER | Lip - Sync | CHARACTER # 25 / D

With the vocalization model, the animator has a set of mouths for each character, along with the code established in each specific production. These models are usually simple guides, since the animator gives each character the expressive characteristics that he or she deems necessary according to the tone and the intention of the dialogue.

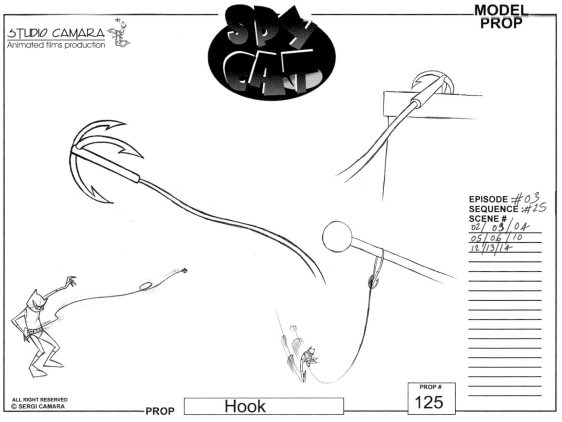

ALL RIGHT RESERVED
© SERGI CAMARA

EPISODE #03
SEQUENCE #25
SCENE #
02/03/04
05/06/10
12/13/14

PROP | Hook | PROP # 125

A separate model will be created of even the most trivial element that appears in the scene and that may require animation at some point. The prop models offer a reference of how the object in question looks from various points of view and a reference to the sequences and the shots in which it appears.

The Layout

"WHOEVER SAYS THAT FILMS ARE NOT THE RESULT OF COLLABORATION IS A FOOL. IT IS JUST
A MATTER OF HOW MUCH AND WITH WHOM YOU COLLABORATE."
Stanley Donen

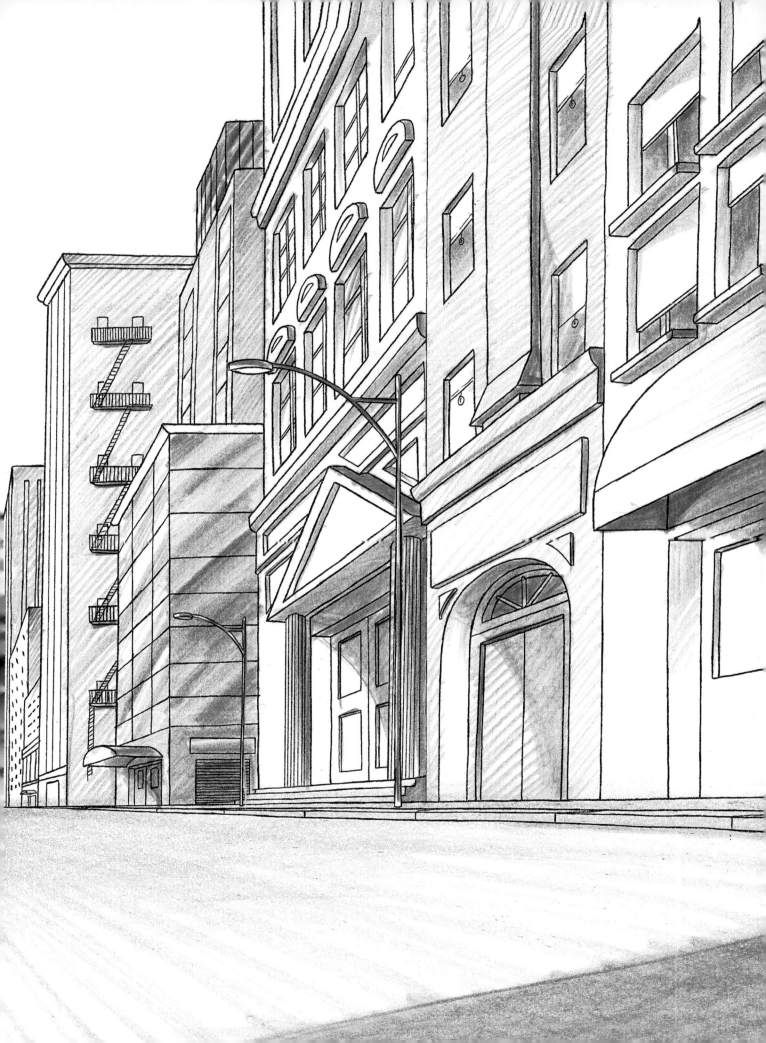

Elements That Make Up the Layout

The layout is part of the intermediate production, between the storyboard and the completion of the scene. It is a link between the script, which has been converted into preliminary images created in the storyboard, and the work of the other creative departments: the animation, the development of sets (backgrounds), the color work, and the work of the camera operator.

The layout artist should be very familiar with the film's aesthetics and must have artistic talent, but he or she must also be capable of providing all the necessary information, technical and artistic, to the rest of the members of the different production departments. A layout of a finished scene will consist of the following elements:

– The camera layout
– The background layout
– The animation layout
– The exposure sheet with all the required indications.

All these materials, once finished, will be placed in a folder, which will later be given to the animator who will do the animation of the scene, and to the background artists so they can color the backgrounds.

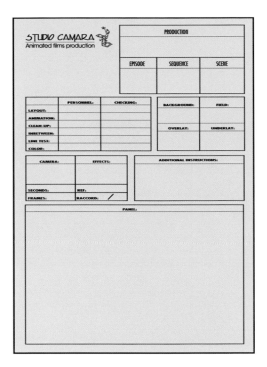

Shot by shot, the artists in charge of the layouts will include their specifications and give them to the person in charge of the animation and the backgrounds in a folder similar to this one. This will ensure complete order and control of the production, as well as an easy method for subsequent reviews of the work and a very efficient filing system for the materials.

THE FIELD GUIDE

The director selects the field sizes that he or she wishes to use in each shot, and the layout artist uses the storyboard as a basis to create each frame.

The field guide determines exactly the zone in which each scene will be photographed, and it is also used to plan the different camera movements.

On the next page we show a few examples of what some field guides would look like for formats 4:3 and 16:9. Both belong to #12 field guides used for television series; there are also #16 field guides used for full length films. The use of one field size or another is determined by the content of the frame. In general, the following criteria are used:
– Field #6/7—For detailed shots or close-up shots
– Field #7/8—For close-up shots, medium shots, and medium long shots
– Field #8/10—For medium long shots, wide shots
– Field #10/12—For wide shots, long shots.

The fields below a 6 field are generally used for tracking in and tracking out.

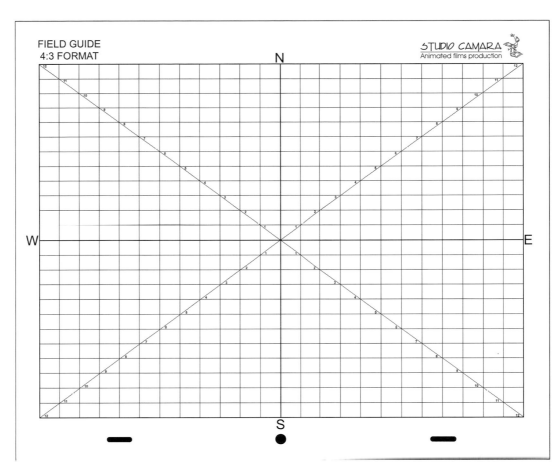

FIELD GUIDE
4:3 FORMAT

STUDIO CAMARA
Animated films production

Field guide for format 4:3 and a 12 field. Its dimensions are 12 × 8¾ inches (30 × 21.80 cm).

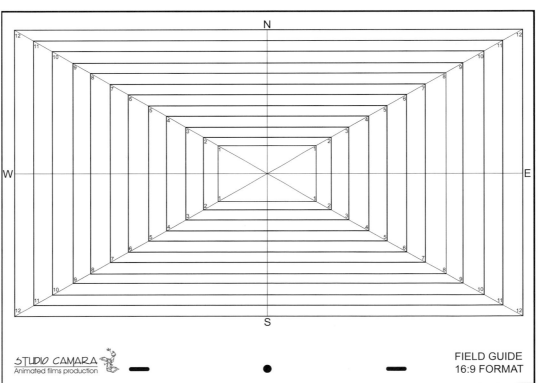

Field guide for format 16:9 and a 12 field. Its dimensions are 16 × 9 inches (40 × 22.5 cm).

STUDIO CAMARA
Animated films production

FIELD GUIDE
16:9 FORMAT

The Camera Layout

This indicates the size of the field in which the action of the scene will take place, or the different sizes in those cases in which there is camera movement. There are different criteria for the labeling of the different fields that are related to a single shot. Some directors prefer that layout artists mark each one of them with a different color so they are easier to identify. Others prefer a single color to indicate all the fields. What is really important to indicate in detail are the field sizes, the direction in which the camera moves, and some additional indication that each layout must include to make them easier to identify. These indications are normally as follows:

– Title of the production and episode number
– Sequence number and shot, or scene, number
– Field size and background number in use.

These indications are placed in a small box in a visible margin of the layout.

Small box with the required information for each shot. This makes each element of the layout easier to identify with its corresponding scene. In animation productions, the volume of material used is overwhelming, and this is the only way to keep every element in every scene under control and identified.

When we work in television productions, we must plan our scene with the recommended safety margin of one-and-a-half fields inside the field selected. This will prevent smaller television screens from leaving some important element of the image out of the scene.

To indicate the movements of the camera we establish an order between the different fields and we mark them with a letter, A, B, C, etc. The movement used will be described with the directional arrows that will carry us from one field to another. To finish, it is very important to indicate in a corner of each framing the size of the field used every time.

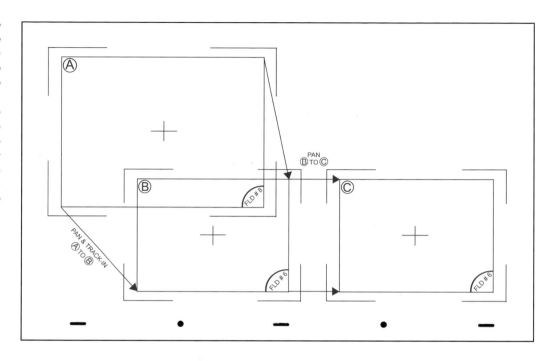

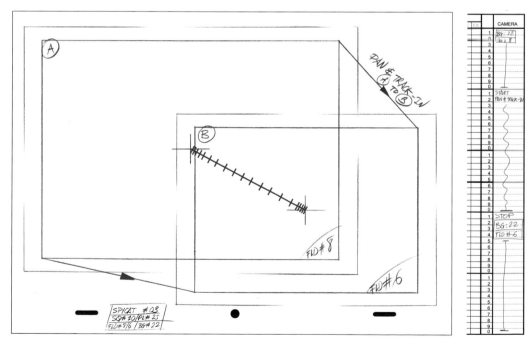

The speed of the camera movements can be indicated by connecting the centers of the various views and marking the distance that the camera will have to travel over the background in each frame. Here, we have worked in a small acceleration and deceleration at the beginning and at the end of the movement so the camera can move smoothly.

Similarly, we have started the scene in view "A" at an 8 field and we pan and track in for 20 frames up to view "B" to a 6 field, where the scene will end. In the exposure sheet we will indicate the frame number where the camera begins to move, its duration, and the frame where it should end.

The Background Layout

The animator will use the background layout as a reference for animating the characters in the background in which the action will take place. This way, he or she will be able to perfectly control the perspective and to reference the animation to the elements of the background. It is also very helpful for the artists in charge of coloring the background because they can have a precise sample of all the details with the necessary notes about light, shadows, and other elements.

It is therefore important for the background layout to be as detailed as possible so that it can provide all the information needed to the respective teams of artists who work with it in various capacities.

The background layout designs are usually monochromatic so they will be able to provide the most important information. Later the background artists, with the director, will select the appropriate color ranges for each scene.

Layout artists use several reinforcement arrows as guides to signal the direction of the main light source to the rest of the team.

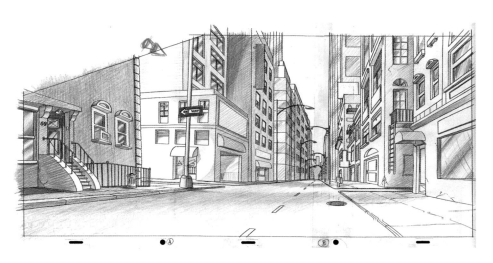

The information on light and shadows is essential. Layout artists must clearly indicate the direction of the light and the intensity of the shadows in each shot. This work is repeated in all the backgrounds that appear in the same sequence to maintain visual continuity from one shot to another, and their proper light and shadow positions each time. These indications are also helpful for the animators, because they will know at all times where the light will fall on the characters that they are animating.

Sometimes the use of the overlay and underlay is emphasized. These are parts of the background that are worked separately from the rest of the background. They are used in different ways:

– In still, or fixed, shots (without moving the camera) they are used for the characters to pass behind, or for creating effects for a selective focus.
– In shots with camera movement, they move together with the background but at a different speed. This way, we convey a sense of depth by moving the elements that are closer to the camera faster and the ones farther away slower.

Let us imagine a landscape in which there is a green meadow with a few trees in the foreground and some clouds in the sky. The sky with the clouds would be the background per se and would be worked on a separate level to be able to move it slowly, simulating the movement of the clouds. The green meadow would be the underlay since the action of the characters in animation would take place in it. Finally, the trees would be the overlay, and we would perhaps blur them a little bit to create depth.

Overlay (OL)

Underlay (UL)

Background (BG)

The overlay and underlay are elements of the background that are created at separate levels to achieve depth or to allow the objects and subjects to interact among the elements of the background.

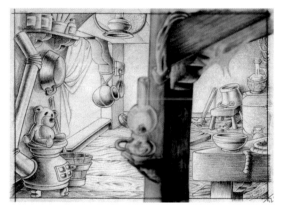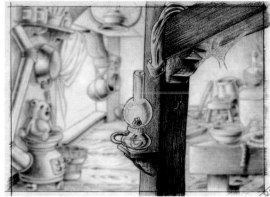

An example of how selective focus is used on a background layout and its corresponding overlay.

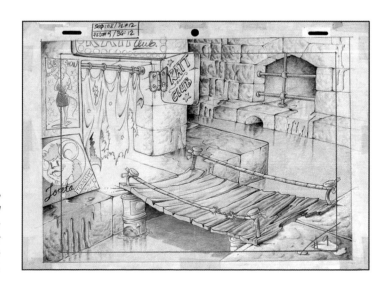

A finished background layout must look something like this one. In it we can observe the incidence of light and shadows on the set, and the size of the field in which the scene and the safety field will be photographed. It also includes a box where the sequence and the shot to which the background number belongs are indicated.

The *A*nimation Layout

The animation layouts are usually drawn in blue to distinguish them from the animation drawings, which are also included in the same folder once the scene has been animated by the animation artists. In any case, as with camera layouts, each production establishes its own guidelines. The final sketch of a series of animation layouts must be very clear and precise, and the artist has to pay special attention to the following aspects:

- Model of the character
- Relative sizes between the various characters that take part in the scene
- Pose
- Expression
- Staging
- Perspective of the characters in relation to the perspective of the background and the rest of the elements of the decor.

The layout artist must create as many poses as he or she thinks are required by the animator to understand all the action that will take place in the shot.

In cases in which some actions do not overlap others, the artist will lay out several poses on a single piece of paper, but different papers will be used if one pose interferes with the proper understanding of the following one. It is very important to number the poses required for each shot in correlation: pose #1, pose #2, pose #3, etc. In addition, we will assign numbers to each animation layout sheet indicating the total included in each shot. For example: 1 of 4, 2 of 4, 3 of 4, and 4 of 4. This way there will be no risk of losing any of them.

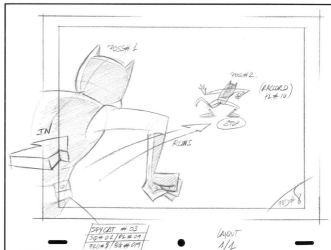

The layout must contain all the necessary indications so the animator can clearly understand the action. The characters that appear in the layouts must be in model form; therefore, the animator will work consulting the model sheets to adhere closely to the production style.

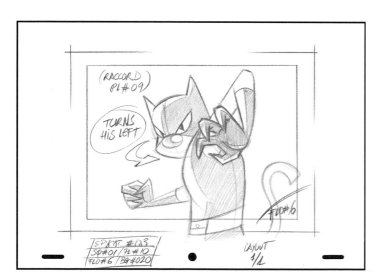

We can accompany all the graphic information with written notes if we think that this will provide essential information to the animator. For example, we may indicate if the action in a shot hooks up with the previous shot or with the next one—in other words, if there is continuity in the action.

All the elements of the layout must be carefully checked and included in their corresponding folders with the exposure sheet that corresponds to the shot. Included in the folder is all the information needed, and each department carries out the required tasks.

The actions are accompanied by arrows, which indicate the direction, the entries and exits from the frame, and so on.

The references for cutting the character to match the elements of the background, as well as the safety zone of a field larger than the size of the field selected are marked. The animator will animate the shot by observing this safety field.

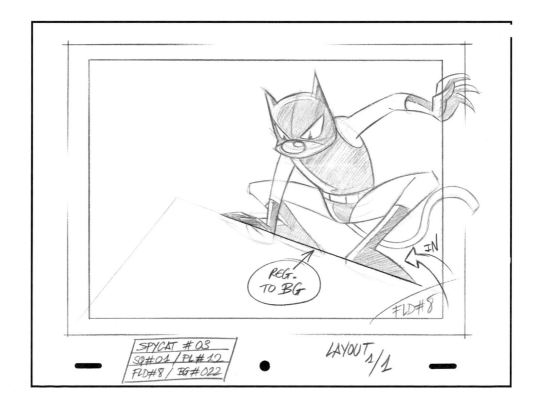

The Anima-tion

"THERE IS NO PARTICULAR MYSTERY IN ANIMATION…IT'S REALLY VERY SIMPLE, AND LIKE ANYTHING THAT IS SIMPLE, IT IS ABOUT THE HARDEST THING IN THE WORLD TO DO."
Bill Tytla, Animator at the Walt Disney Studios, June 28, 1937

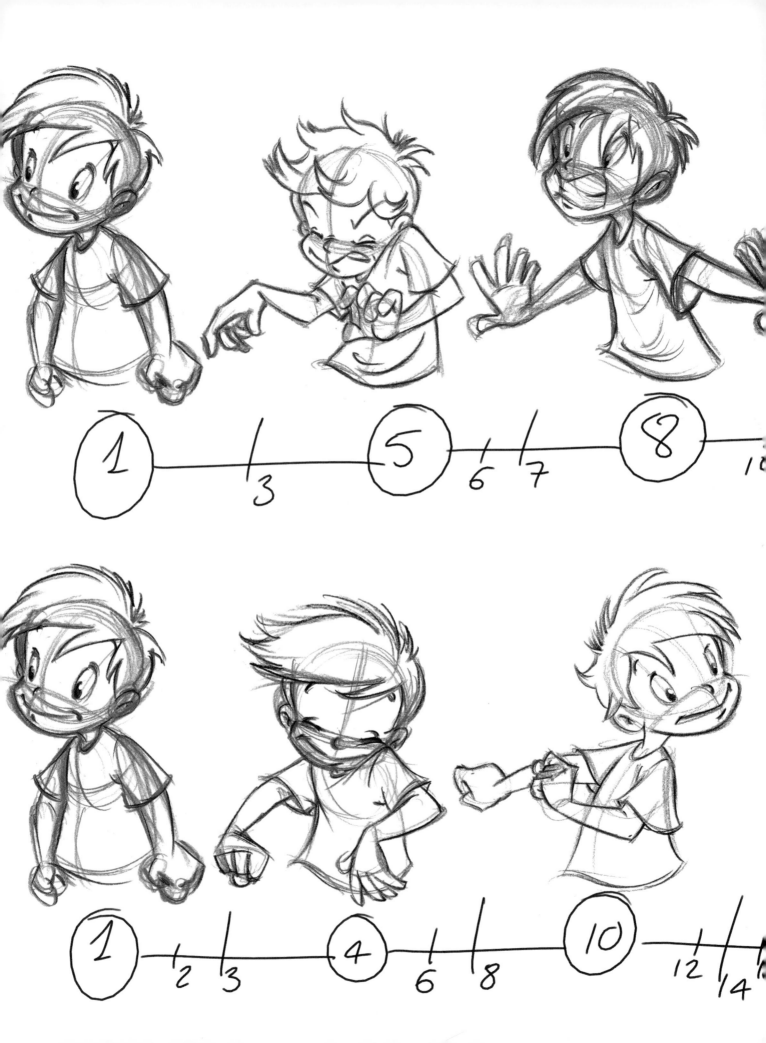

Bringing Inanimate

SERGI CÀMARA.
GERARD MEETS..., 1998. ANIMATION SKETCH

Characters to Life

The cinematography process begins with a principle

called "persistence of vision," which consists of projecting static images of a character executing any action on a screen at a speed of 24 frames per second. The result is a sense of flowing movement, which appears real because the human brain does not perceive the individual images, but sees them as a continuous action in real time. In animation we substitute that series of filmed images with drawings executed with continuity of action and cadence.

Basically, what we see on the screen is the illusion of movement. Movies are possible thanks to a combination of the slow human visual process and the fast movement of some images projected at a specific speed. Each movie that we see is basically an optical illusion, or in other words, a fantastic trick.

Life Drawing and the *Sketch Book*

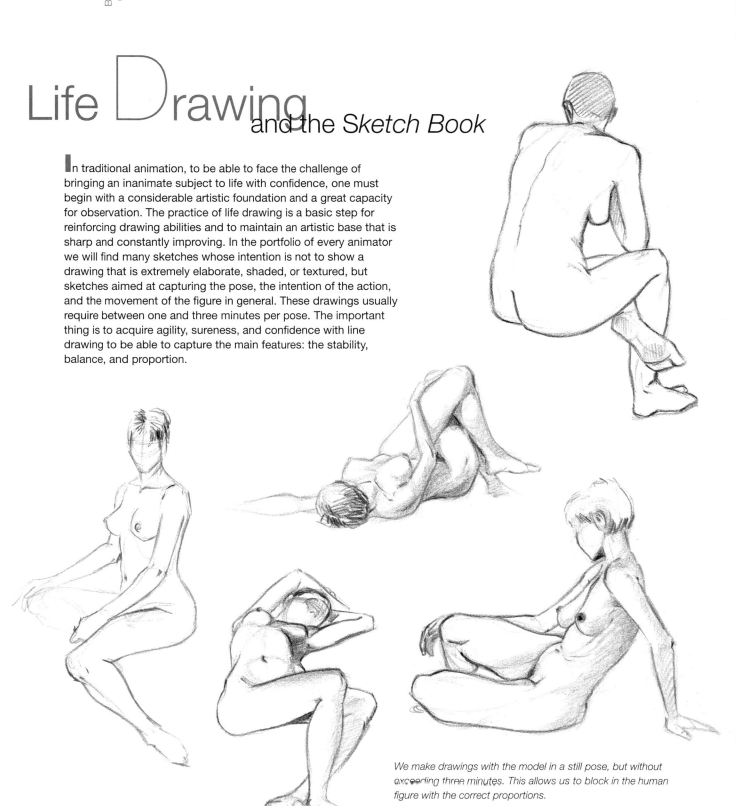

In traditional animation, to be able to face the challenge of bringing an inanimate subject to life with confidence, one must begin with a considerable artistic foundation and a great capacity for observation. The practice of life drawing is a basic step for reinforcing drawing abilities and to maintain an artistic base that is sharp and constantly improving. In the portfolio of every animator we will find many sketches whose intention is not to show a drawing that is extremely elaborate, shaded, or textured, but sketches aimed at capturing the pose, the intention of the action, and the movement of the figure in general. These drawings usually require between one and three minutes per pose. The important thing is to acquire agility, sureness, and confidence with line drawing to be able to capture the main features: the stability, balance, and proportion.

We make drawings with the model in a still pose, but without exceeding three minutes. This allows us to block in the human figure with the correct proportions.

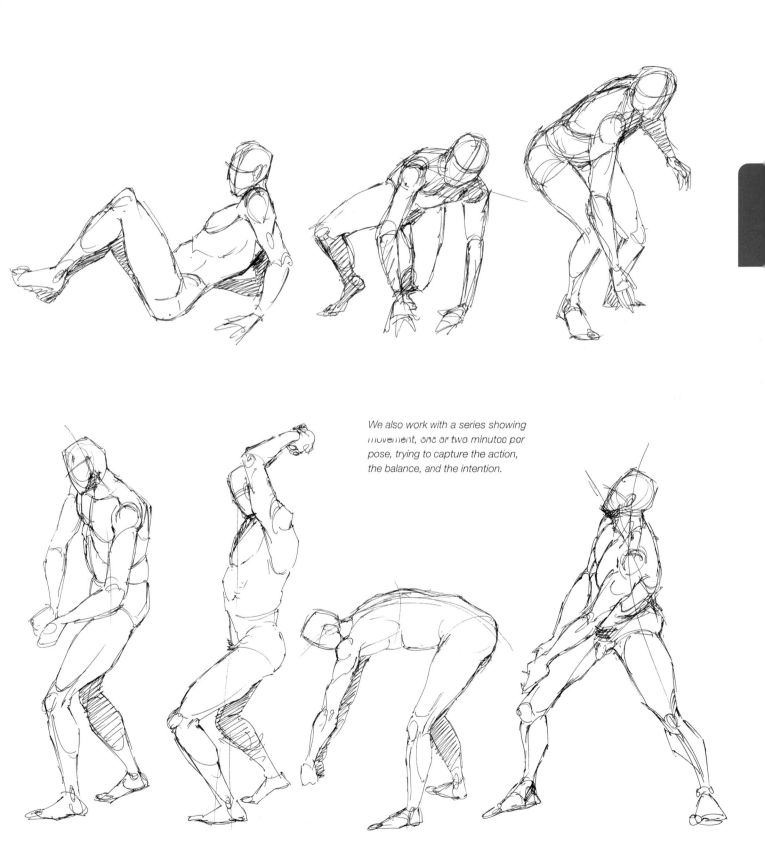

We also work with a series showing movement, one or two minutes per pose, trying to capture the action, the balance, and the intention.

It is important to know animal anatomy. In our careers as animators we will have to animate numerous animals in an endless number of different actions. Furthermore, often the protagonists of the animated series or films will be animals that take on the roles of humans to tell the story. Knowledge of animal anatomy will allow us to create an animate figure that will become a true-to-life character.

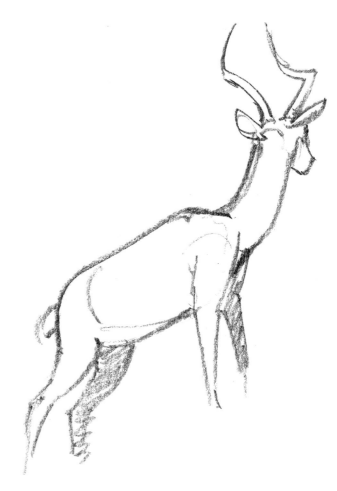

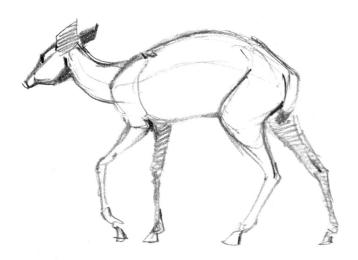

Our own pets or animals found in pet shops and zoos offer us important practice and the possibility of a very pleasant learning exercise.

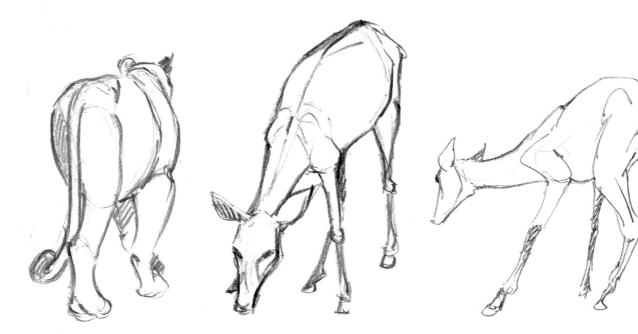

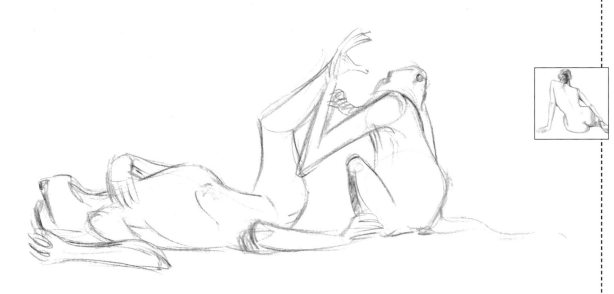

Knowledge of both human and animal anatomy is very important in animation work. It enormously improves the quality of the drawing and helps the artist understand the general dynamics of movement.

The ability to observe is innate in everyone, but it must be reinforced every day. A good exercise is to always carry a small drawing pad in which to make sketches of different day-to-day situations, or to jot down scenes from our imaginations. The point of the sketchbook is to preserve the habit of observation, to search for new graphic solutions, and even to stimulate future creative ideas.

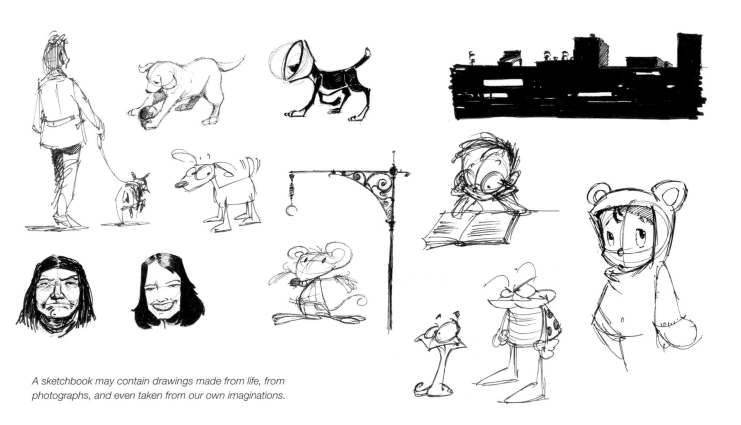

A sketchbook may contain drawings made from life, from photographs, and even taken from our own imaginations.

The Exposure Sheet:
From Paper to Camera

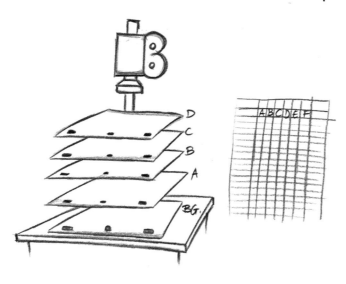

In this diagram we see how the exposure sheet is used. There is an order in which certain elements must be arranged on the animation stand to be captured by the camera. Sometimes, the order of the levels can go from right to left, although level "A" in general will be closer to BG, and the last one will be the closest to the camera.

The drawings that the animator makes to stage an action are not the result of chance. Each one of them depends on the next one to ensure visual continuity and the proper understanding of the scene. In addition, each drawing must last a specific projection time on screen and maintain a specific order with respect to the rest so that the operator can film them and produce the number of frames established by the animator.

In animation it is customary to work in "ones" or "twos," that is, in such way that each drawing maintains one or two frames on-screen, with the exception of pauses, which tend to have a minimum of six frames, or the fixed drawings whose duration on screen will vary with each case.

The cameraman receives all the specific directions to film the scene in the exposure sheet, which has a series of columns that contain various boxes. Each box, arranged vertically, corresponds to a frame in which the animator introduces a code that corresponds to one of the drawings of the scene.

The exposure sheet sample illustrated here shows 50 frames (European; in the U.S., 60 frames are needed), or in other words, two seconds of projection on a television screen.

Let's remember that for the big screen it is 24 frames per second; this means that the number of boxes in the exposure sheet varies according to the medium used.

In some cases, the exposure sheets are divided into sets of 24 or 25 frames, and 16 in others, which is a foot. In any case, the distribution of the columns and their use, independent of the format, is more or less the same.

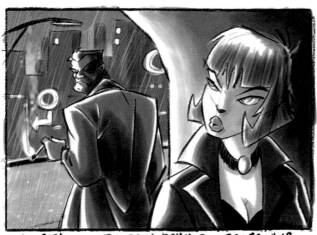

Story panel corresponding to a shot. The following page shows a exposure sheet with the needed instructions for this scene.

Sample of a exposure sheet (on page 107).

STUDIO CAMARA
Animated films production

JACK SHADOW

SHEET: 1

BG: 87	OL: —	UL: —	EPISODE: 03	SCENE: 215A	FRAMES: 50	RACCORD: 195 / —
			SEQUENCE: 12			

LEVELS — SMOKE — RAIN

ACTING (JACK / TESS)	DIAL	LIP	#	A	B	C	D	E	F	G	FX	FX	FX	#	CAMERA
			1	1A	✕	1C					1S	1	3	1	BG: 87
			2											2	# 12
			3								2S	2	4	3	
			4											4	
			5								3S	3	5	5	
			6											6	
			7			2C					4S	4	6	7	
			8											8	
			9			3C					5S	5	1	9	
			0											0	
Antic.			1	2A		4C					6S	6	2	1	
			2											2	
Antic.			3	3A		5C					7S	1	3	3	
			4											4	
			5	4A		6C					8S	2	4	5	
			6											6	
			7	5A		7C					9S	3	5	7	
			8											8	
			9	6A		8C					10S	4	6	9	
HOLD & talks			0											0	
TURNS HIS HEAD TO TESS.			1	7A		9C					11S	5	1	1	
			2											2	
			3	8A		10C					12S	6	2	3	
			4											4	
			5	9A		11C					13S	1	3	5	
			6											6	
			7	10A		12C					14S	2	4	7	
			8											8	
			9	11A		13C					15S	3	5	9	
			0											0	
			1	12A		14C					16S	4	6	1	
			2											2	
HOLD			3	13A		15C					17S	5	1	3	
			4											4	
			5	14A		16C					18S	6	2	5	
			6											6	
			7	15A		17C					19S	1	3	7	
			8											8	
talks			9	16A	1B	18C					20S	2	4	9	
			0											0	
			1			19C					21S	3	5	1	
			2											2	
			3		2B	20C					22S	4	6	3	
			4											4	
x Blink.			5		3B	21C					23S	5	1	5	
			6											6	
			7		2B	22C					24S	6	2	7	
			8											8	
			9		1B	23C					25S	1	3	9	
			0											0	

The first column, labeled "Acting," is where the director, or even the animator, plans the action of the scene, determines the time needed for each action, and the appropriate interaction between the different characters and the rest of the elements that take part in the shot.

JACK	ACTING	TESS

Antic.

Antic.

Antic.

TURNS HIS
HEAD TO
TESS.

HOLD.
&
TALKS

DIAL	LIP

The "Dial" and "Lip" columns are reserved for the dialogue. The "Dial" column shows the dialogue of the characters on the screen. The "Lip" column establishes the lip sync, measuring the dialogue frame by frame. The sound technician enters the dialogue on the chart, giving the animator an accurate reference for synchronizing the dialogue with the characters. The transcription in the "Lip" column is written in the original language of the production; therefore, it will not be useful in countries where the film has to be dubbed into another language. Perhaps that is why it is only filled out for full-length films, some television series, and advertising spots.

The "Levels" columns are used by the animator with his or her drawings. He or she will be able to distribute the characters appearing in the scene among the levels available. Columns "FX" are for special effects.

LEVELS							SMOKE	RAIN	
A	B	C	D	E	F	G	FX	FX	FX
1A	1C						1S	1	3
							2S	2	4
							3S	3	5
	2C						4S	4	6
	3C						5S	5	1

CAMERA

BG · 87
12

The column labeled "Camera" is where the technician indicates the different camera movements that will occur in the shot's action. This way, the animator will be able to plan the action according to whether or not there are framing variations.

The remaining boxes are used to organize and classify the shot according to the sequence number, shot number, and so on. There is also a space available for the number of the background (BG) used for that scene and other technical aspects, which are very useful for the operator and for the rest of the team.

| BG: 87 | OL: — | UL: — | EPISODE: 03 | SCENE: 215A | FRAMES: 50 | RACCORD: 195 / — |
| | | | SEQUENCE: 12 | | | |

Clarity is essential for the technician to be able to understand the exposure sheet. The numbers must be clear. For faster identification, if needed, they can be accompanied by the letter of the corresponding level.

1	12A		14C
2			
3	13A		15C
4			
5	14A		16C
6			
7	15A		17C
8			
9	16A	1B	18C
0			
1			19C
2			
3		2B	20C
4			
5		3B	21C
6			
7		2B	22C

The Work of the Animator:
Animation

The animator works on a complete sequence or on part of it. At the same time, he or she plans a series of correlated shots with the idea of providing visual fluidity and rhythm to the action to hold the interest of the audience.

The sequence is the dramatic unit in which the content of what we must convey to the spectator is found. The shot, on the other hand, is part of this content and at the same time the basic unit of the animator's work.

Not all the drawings that are needed to transmit the content in a shot are done by the animator. The focus of the animator is the perfect planning of the overall picture, the creation of the key drawings that will provide complete sense to the action, and the planning of the in-between drawings that will be produced by his or her team of assistants.

We have the story of the sequence that we are going to animate, the corresponding layouts for each shot, and the exposure sheet with the information that we need frame by frame. How do we begin?

THE THUMBNAILS

Good animation begins with proper planning, and the best way to do this preliminary work is to start with the thumbnails, or "roughs," which are small and quick drawings that capture the essential part of the shot's action. Thanks to them we can study the staging of the characters, the pose, and so on. We carry out as many tests as needed until we finally obtain those that best suit the shot that we want to animate. Once the decision has been made, we transfer them to the final animation paper, where they will serve as the basis for the key drawings.

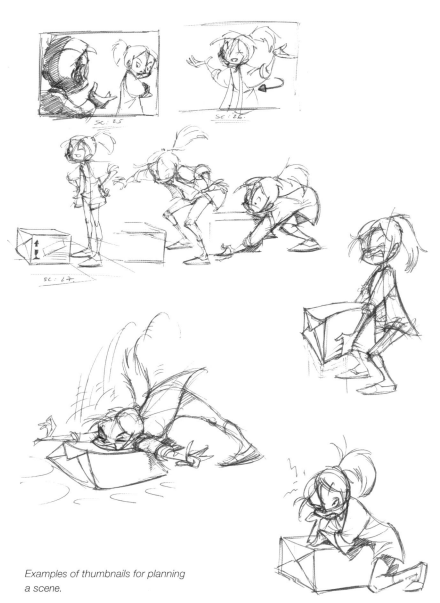

Examples of thumbnails for planning a scene.

HOW THE ANIMATION IS CONSTRUCTED

The entire animation job is done on an animation disk lighted from below. We create the first drawing of the action, followed by the second one, which is done by placing a new piece of paper over it, perfectly centered with respect to the previous one thanks to the pegs on the disk. The light below maintains a visual reference of the drawing underneath and makes it possible to proceed with the next one correctly. It is a task that requires absolute concentration and attention. We use the thumbnails as a basis and we adapt them to the original size assigned to each scene.

In the first phase, the entire action that is contained in one shot is worked with very loose sketches. We focus on capturing the essence and the sense of the action through movement. The sketch is done loosely and spontaneously, drawing the lines of the action and rhythm, looking for the correct flow and cadence of one drawing in relation to another. With each sketch we study all of the expressive possibilities, we test all the options, and we retain the most effective one.

Some animators photocopy the thumbnails to the required size for the animation of their scene, and from that they develop the beginning of their animation. Others use them as a reference and draw them again on the final paper to the required size. Both options are effective.

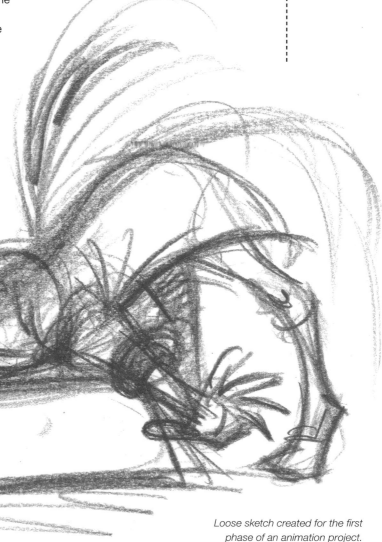

Loose sketch created for the first phase of an animation project.

In the second phase, we look for the skeleton of the charac-
ters, their structure and their volume. At this point the action
has been animated. We have started with the thumbnails to
create the key poses and we have worked them only in terms
of their movement, but now we must turn those sketches into
the character that carries out the action.

A good skeleton for an animation pose is the result of
many sketches; that is why it is important to create the first
basic drawing with simple doodles that do not require a sub-
stantial investment of time. Many will be discarded because
they will not be suitable for the action that needs to be ani-
mated, and a drawing that has been constructed and worked
on in detail will make us hesitate about whether it should be
eliminated. It is possible that the animator will not want to
discard it, to not waste the time spent drawing it, and this
will no doubt compromise our work. I insist…let's work with
doodles!

When we work with loose lines and quick sketches, it is
very probable that we will lose control of the volume and the
structure of our characters. Now we must try to recover
them, omitting, for the time being, superfluous details. We
will focus on recovering their structure, on fitting them inside
their skeletons, and in reviewing once again the key poses.
It is an ideal time for defining the intention in some of them
even further, and to improve the meaning of the action,
although the most important thing is to recover the overall
structure of the character.

*Key drawing in which the structure
of the character is recovered.*

In the third phase, the details of the character are included.
This is almost the first time in the entire process that we
begin to draw. Not only do we get into the details, such
as buttons, pockets, and adornments, but we also
focus on the expression. We try to give the character
its maximum expression.

*Key drawing in which the details of
the character have been added
and the expression has been worked on.*

The animator will be concerned mainly with the rhythm, the structure, and the animation of the character. It would also be ideal to take care of the minimal details, but the work of the assistant will also be to check the entire scene, drawing by drawing.

The fourth and final phase consists of polishing and profiling. The "cleanup" process of our animation can be left in the hands of other members of the team; in any case, it is the time to make sure that all the poses of our animation are final.

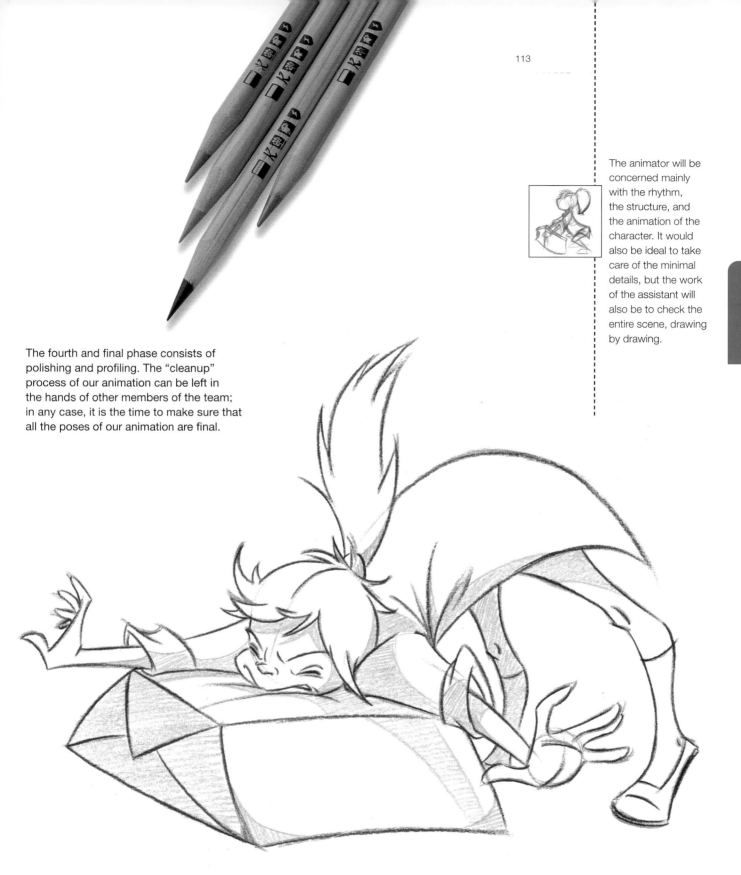

Key drawing finished and ready for the final cleanup.

Checking the Animation
by a Preliminary Viewing of the Drawings

Some animators preview the work every three to five drawings. The main difference resides in the fact that three drawings correspond to six frames and five to ten, in those instances in which we film our drawings at two frames each. The idea is to "flip" the group of drawings we wish to check.

With a proper grasp of the fingers and movement of the hands, we can recreate the speed of the 24 frames per second to get an idea of how our animation works. A little practice and experience in this method will produce absolutely satisfactory results.

There is also a method for checking the animation of the complete take once it is finished. It consists of passing the drawings in front of our eyes at a rate of speed similar to the projection speed. Once the animation has been previewed with this system and revised, a preliminary filming is done, called the "line test," to determine if further revisions need to be made.

Notice the placement of the fingers to view a group of five drawings and to recreate the speed of projection of 24 frames per second.

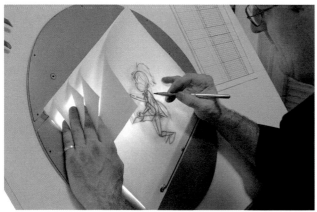

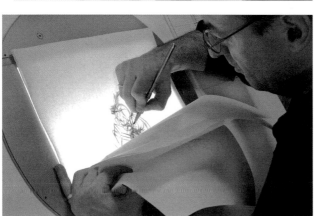

By staggering the drawings and letting them fall in front of our eyes, we can recreate a feeling of movement of the complete shot.

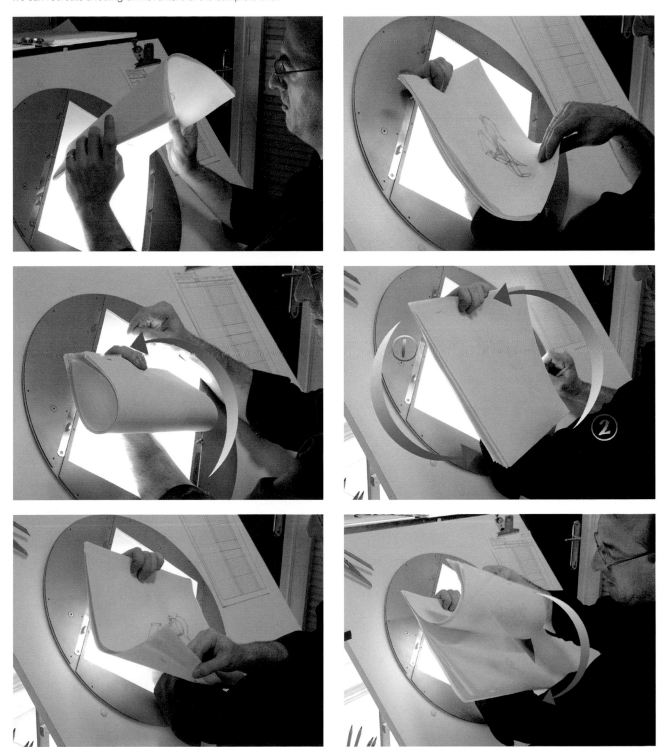

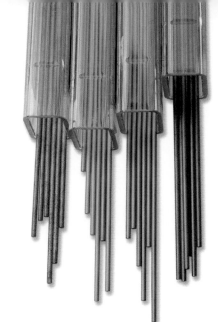

We have seen how an animator works, what the main stages of producing an animation are, and the importance of key drawings, but… what exactly are key drawings? They are the drawings that tell the story and that define the main moments of the movement. The animator must foresee a key drawing each time that the following occur along the action: the beginning or the end of movement, a change in direction, or a variation in rhythm.

Key Drawings: The Essence of the Action

In the illustration of the pendulum, drawings 1 and 5 are the ones that determine the change in the direction of the movement. They are the end drawings that tell us what is happening in the story.

Between these two ends, the animator plans the necessary drawings to create fluidity. Let's imagine that a total of 5 drawings are sufficient to create the illusion of the pendulum's movement from one end to the other.

Let's observe drawing 3 carefully:
In example A, drawing 3 does not convey the desired pendulum effect. It goes from one end to the other, but it lacks any type of intention.

In example B, the necessary "arc" has been kept in mind to maintain the length of the cord that holds the pendulum, thus producing the necessary cadence. Drawing 3 is the one that we call the "breakdown drawing," the one that determines the change of rhythm in the movement.

Given the importance that drawing 3 has in providing the desired movement, rhythm, and cadence of the animation, we conclude that drawings 1 and 5 (ends) and drawing 3 (breakdown) will be the key drawings of this animation. In turn, the animator must plan with a graphic the position of drawings 2 and 4, which will later be produced by one of the members of his or her team.

Remember that not all of the drawings of the shot are done by the animator; some of them are done by a team made up of an assistant and an inbetweener.

The assistant is the artist in charge of the final cleanup of the drawings, that is, of creating the drawing that the viewer will see in the movie.

The inbetweener is the artist who completes the movement by producing the inbetween drawings that go between the animator's key drawings.

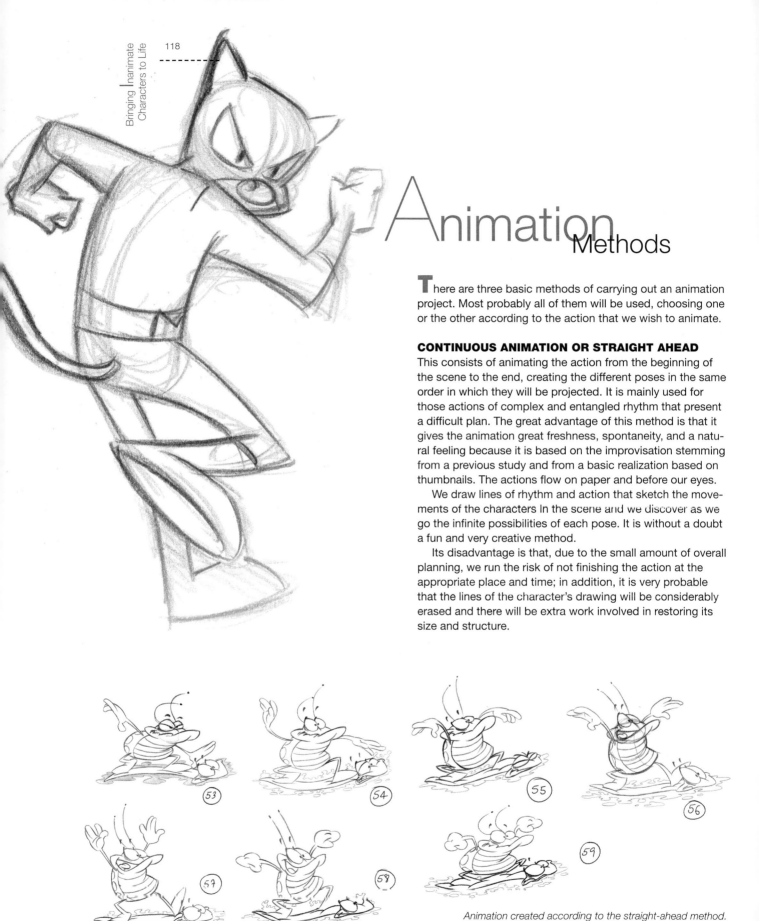

Animation Methods

There are three basic methods of carrying out an animation project. Most probably all of them will be used, choosing one or the other according to the action that we wish to animate.

CONTINUOUS ANIMATION OR STRAIGHT AHEAD

This consists of animating the action from the beginning of the scene to the end, creating the different poses in the same order in which they will be projected. It is mainly used for those actions of complex and entangled rhythm that present a difficult plan. The great advantage of this method is that it gives the animation great freshness, spontaneity, and a natural feeling because it is based on the improvisation stemming from a previous study and from a basic realization based on thumbnails. The actions flow on paper and before our eyes.

We draw lines of rhythm and action that sketch the movements of the characters in the scene and we discover as we go the infinite possibilities of each pose. It is without a doubt a fun and very creative method.

Its disadvantage is that, due to the small amount of overall planning, we run the risk of not finishing the action at the appropriate place and time; in addition, it is very probable that the lines of the character's drawing will be considerably erased and there will be extra work involved in restoring its size and structure.

Animation created according to the straight-ahead method.

ANIMATION POSE BY POSE

This consists of studying the action, producing the thumbnails, and transferring them to the animation paper, methodically working through the main poses of the action in the scene. The important thing is to take care of the details of the key drawings and to plan the rest, calculating the inbetweens according to the needed rhythm.

We will animate pose by pose in those shots that require great control of the staging, the dialogues, or the interpretation scenes of the character. The advantage of this method is that we have total control of the staging since each moment of the action is calculated and we fit our plan perfectly in time and space. Aesthetically, we can construct the character perfectly by paying great attention to the pose.

The disadvantage is that, as a result of such lengthy planning, we may perhaps lose some freshness and naturalness.

Pose-by-pose animation is more measured and controlled than continuous animation; however, it is important to evaluate which animation is more appropriate for each action.

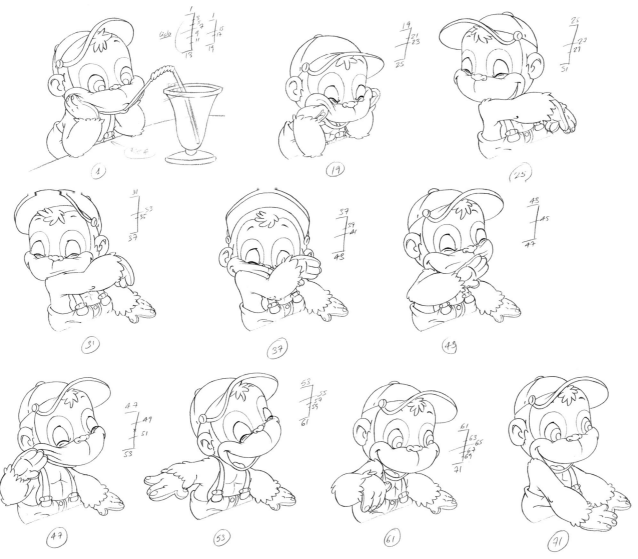

Animation created with the pose-by-pose method.

COMBINED ANIMATION

This consists of working a single action with both methods, extracting the advantages of each one of them.

We plan the animation beginning with the thumbnails; we create the necessary poses one by one and with rough edges, which results in well-studied poses that are, however, very sketchy. This way we begin with correct and controlled volumes and proportions of the character.

Then, we work from one pose to the next in continuous animation to create an action that is spontaneous and natural. When we arrive at the poses, we use them whenever they fulfill the need to define the action; otherwise, we redraw them and adapt them until the desired effect is achieved.

To finish, we adjust and define all the resulting key poses by adjusting the volumes and proportions and adding the pertinent details.

Animation created according to the combined animation method.

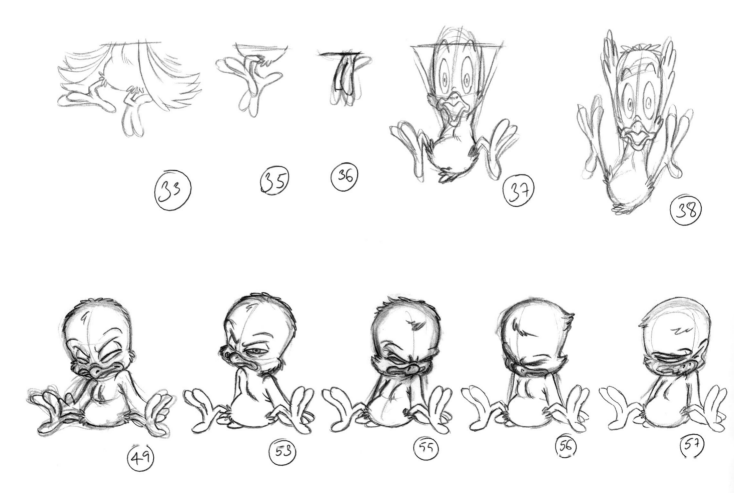

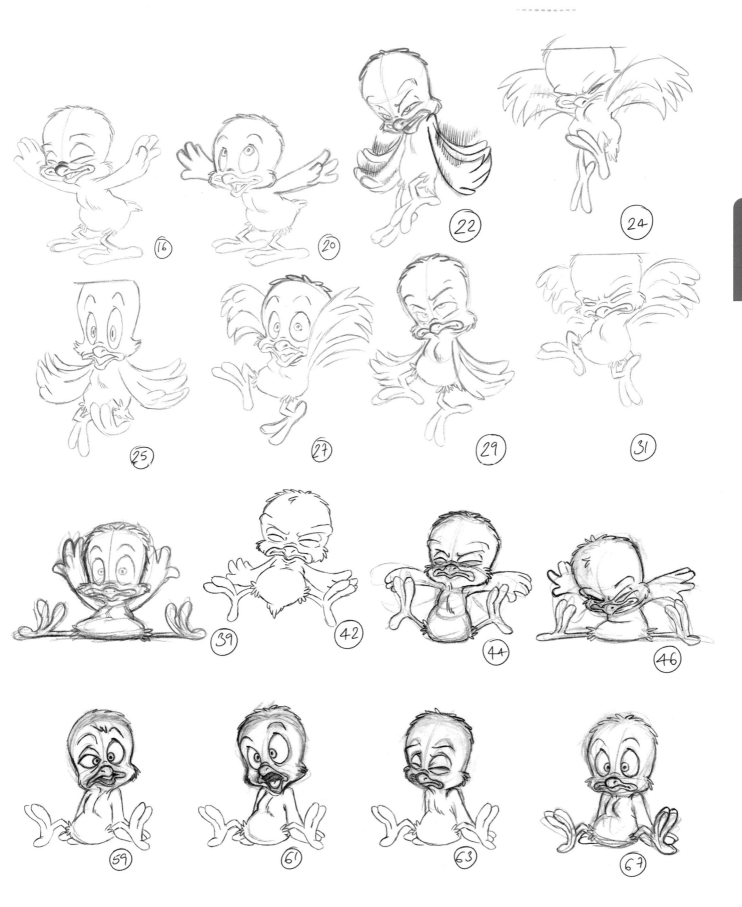

The Laws of Animation

The material that a body is made of will affect its animation.

One must start with the basic idea that the entire body is subject to a series of laws that act upon it in a decisive way and that therefore alter its way of carrying out a specific action.

The animator has to keep in mind these laws at the time of creating the animation:
a) Physical laws: gravity, friction, inertia, and so on.
b) Laws according to the body's nature: material that it is composed of, external phenomena that could act upon it, and so on.

To proceed properly in the animation of the scene, it will be important to perform a simple preliminary "scientific analysis" that will clarify the following aspects:

1- The material that the object or the subject that is to be animated is made of and how it may react when moved in a specific manner. In cartoon animation, it is common to resort to subjects that are not necessarily human to tell a story, and they can be affected in various ways by the laws of physics.

2- The weight of the subject and how it will be affected by gravity, friction, and so forth.

Due to their weight and material, the reaction of the objects is different when they come in contact with the ground.

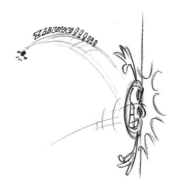

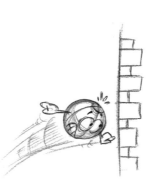

3- Whether the movement that must be executed is voluntary or a consequence of a force or phenomenon that acts from the outside.

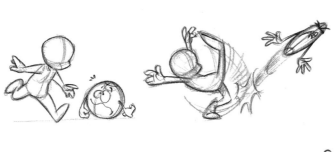

The forces that act from outside also affect different objects in very different ways.

NEWTON'S LAWS OF MOTION
What has been said before can be summarized in Newton's laws of motion.

1- A body at rest has a tendency to remain at rest, while a body in motion tends to remain in that same motion.

2- A body's rest or movement is only altered by the action of an outside force or by other forces that make it move in different directions.

3- For every action there is an equal and opposite reaction.

Animation is a creative art and as such the possibility of breaking and violating these laws can constitute a style in itself and can give rise to countless humorous results.

The recurring image of an individual suspended in the air when the bridge has been destroyed shows us how to break a fundamental law and turn it into a gag.

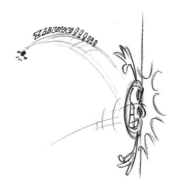

Effects in Animation

To animate the characters we use a set of principles that give us a soft and fluid visual effect. These effects create distortions, sometimes important, in the structure of our characters, but the changes happen so quickly that they are unnoticeable to the human eye.

In animation, the correct application of the effects give us the same sense of reality as a living image.

THE SQUASH AND STRETCH EFFECT

This is the most typical characteristic of all animation. Regardless of the action that needs to be animated, the squash and stretch effect provides visual fluidity and helps us create animation that is dynamic and perfectly comprehensible to the viewer.

We always make use of this effect, in subtle as well as in exaggerated animation. We must use our imaginations and common sense while not losing sight of the character's mass. It is a matter of creating distortion, but maintaining the mass.

In animation, we divide the effect into:
- Squash
- Stretch
There is a direct relationship between these two concepts and Newton's laws.

A balloon full of water in our hands stretches, contracts, changes its shape, but its mass remains the same.

An external force that acts on a body tends to deform it (squashing). Once it is freed from that force, the body reacts with an equal force but in the opposite direction (stretching) until it returns to its normal shape.

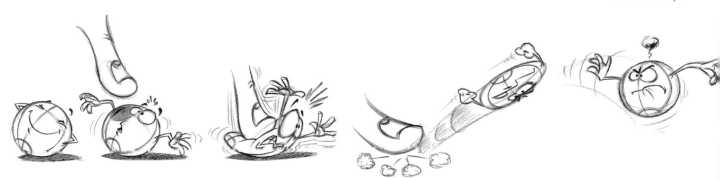

The following diagram clarifies the conditions in which we can apply the squash and stretch effect in animation.

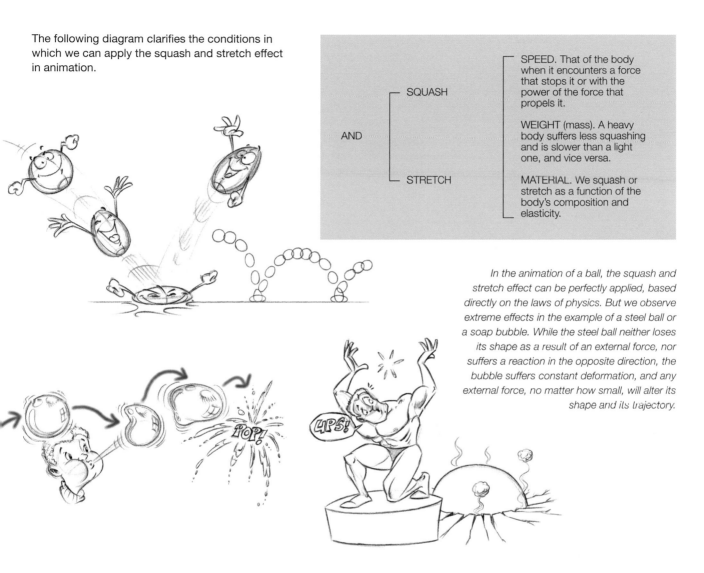

AND
— SQUASH
— STRETCH

SPEED. That of the body when it encounters a force that stops it or with the power of the force that propels it.

WEIGHT (mass). A heavy body suffers less squashing and is slower than a light one, and vice versa.

MATERIAL. We squash or stretch as a function of the body's composition and elasticity.

In the animation of a ball, the squash and stretch effect can be perfectly applied, based directly on the laws of physics. But we observe extreme effects in the example of a steel ball or a soap bubble. While the steel ball neither loses its shape as a result of an external force, nor suffers a reaction in the opposite direction, the bubble suffers constant deformation, and any external force, no matter how small, will alter its shape and its trajectory.

The different intensities of an action force us to use either more or less squash and stretch effect. Likewise, the characteristics of the character tell us to what degree we should extend its use. The more realistic characters must have a subtle effect, enough for the *movement to be simply fluid. The more comical or cartoonlike ones have no limitation. We can apply the squash and stretch effect until it creates a gag in itself.*

SPEED LINES

These are lines of movement that accompany the action
when it is fast and dynamic. Its use is optional, and the
viewer does not notice them, but they can enrich an
action and make it more fluid.

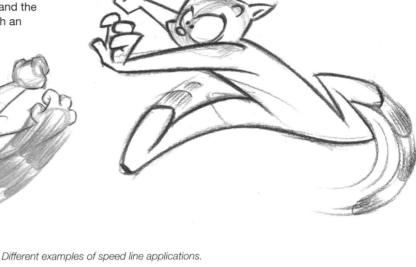

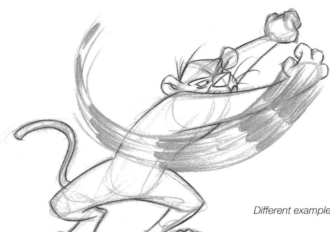

Different examples of speed line applications.

MULTIPLE IMAGES

These are used in those actions in which the arms, legs, or any other
part of the body move at high speed. The proper use of this effect
produces a surprising and effective illusion of movement. Due to the
speed required by an action in which multiple images are used, caution
must be exercised so it is executed in a way that is not evident to the
human eye; otherwise, instead of achieving the necessary fluidity, it can
obstruct the action.

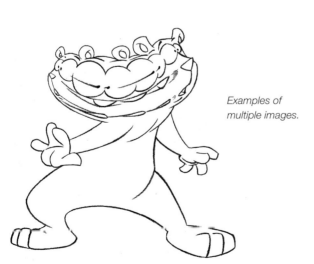

*Examples of
multiple images.*

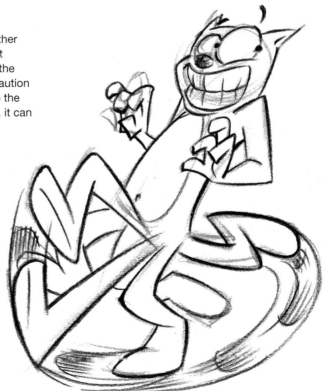

THE BLUR

This effect consists of diffusing the character's drawing partially or completely to substitute it with a smudge. This effect makes it possible to create extreme speed in the movement. The ideal approach is to blur the character with its own colors to achieve a visually attractive effect.

It is also used to recreate a "record" of a very quick action, for example, when a character leaves the frame at high speed.

Examples of blur applications.

Experimentation with animation effects has given rise to some of the most charming finds in classic animation. Some of them, due to their effectiveness, are used constantly.

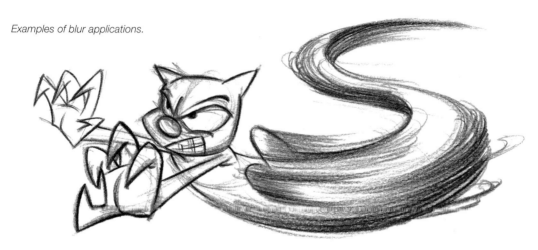

IMPACT

This effect is used when a character or an object punches another, for example in falls, crashes, and so on.

The effect produced is a sort of "explosion" that, when accompanying the action at the opportune moment, highlights the impact perfectly, giving it greater emphasis. Only three drawings are needed to achieve good results.

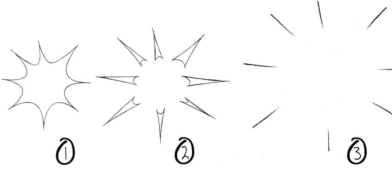

Impact effect.

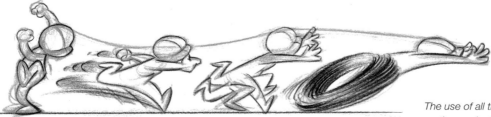

Speed Lines Multiple Image Blur

The use of all these effects is optional; it depends on the production that is being done and the guidelines given by the creative team.

Action:
Anticipation, Action, Reaction, and Recovery

To speak of action in an animated cartoon is to speak of everything that happens in a shot. As with real image movies, when the director says "Action" the movie camera begins to roll and starts capturing images of the scene, until "Cut" is announced and the camera stops. If the take is valid, it will result in a finished shot.

The same thing happens with animated cartoons; regardless of the time a shot lasts, everything that happens in it is the action.

Keeping in mind what the overall dramatic action of the shot means, the character will possibly have to execute various movements that will interpret different actions. For example: it begins with a resting pose, the dialogue begins, the character turns to see what is happening behind him and goes to see what is happening by leaving the frame.

We see that it is a normal take in which three different actions take place. To properly plan each one of them, we must observe these basic concepts:
- Anticipation
- Action
- Reaction
- Recovery.

Three different actions in a single take: beginning of the dialogue, turning the head, and leaving the frame.

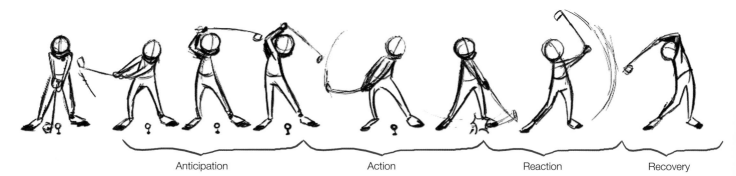

Anticipation Action Reaction Recovery

In this sequence we can see the entire process clearly. When hitting the ball with a golf club, the objective is the ball and we begin to anticipate striking the ball and calculating the swing with an accurate aim. Then, we strike, and the action takes *place. Observe how the club does not stop at its objective; the inertia created by the momentum carries it beyond the ball. The golf club "surpasses" the objective until the force of the inertia dies down. After that, it enters the recovery phase.*

ANTICIPATION

This is the preparation that takes place before an action begins. It is usually a previous movement to the action and in the opposite direction from it. It is used not only for executing the action but also to prepare the viewer for what the character is going to do.

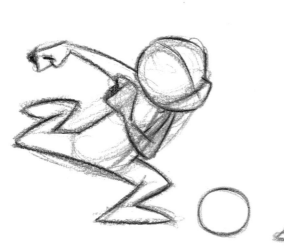

We may be able to imagine the "action" process as that of an arrow being shot by a bow: we anticipate by tensing the cord of the bow to give the arrow momentum, then we let the bowstring go, which reacts by sending the arrow toward the target, and finally the bow returns to its natural state.

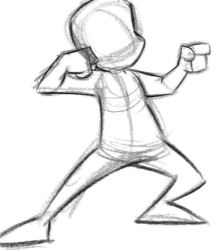

We anticipate the character before kicking or punching and for the strike to have an important effect. We give it a backward impulse in anticipation, and finally we kick.

ACTION

This consists of the action itself. Anything that a character is going to execute will be an action, preceded by anticipation and followed by a reaction. In a shot in which various actions will be constantly taking place, we will be connecting them together and planning anticipations for each of them. Those that require more momentum or force on the part of the character will have greater anticipation and will be more evident. The more subtle ones will practically be unnoticeable to the viewer.

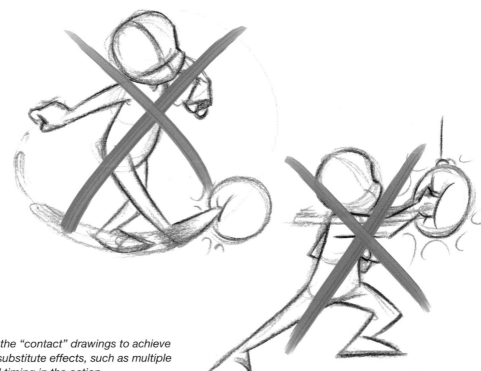

Generally, in quick actions we eliminate the "contact" drawings to achieve flow in the action. In their absence, we substitute effects, such as multiple images or blurs, which will give us good timing in the action.

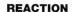

REACTION

This is the effect that follows the action, and it is produced as a consequence of inertia. Remember that according to Newton's third law, each action provokes an equal reaction in the opposite direction.

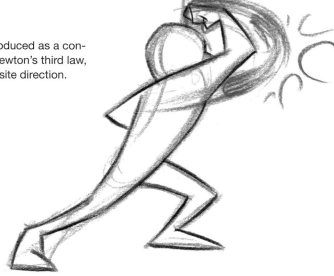

The previous kick or punch gives way to a variety of reactions to the action itself. Due to the impulse and the inertia, the foot or the fist goes beyond its objective once the action has occurred.

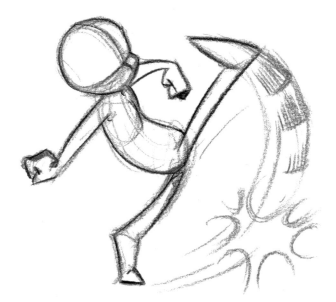

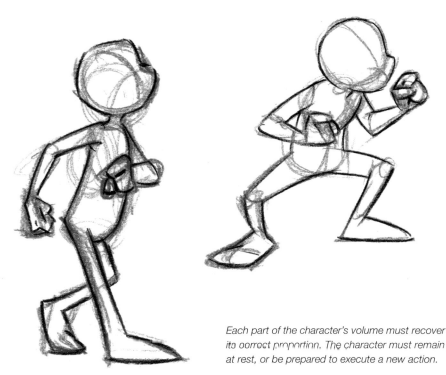

Each part of the character's volume must recover its correct proportion. The character must remain at rest, or be prepared to execute a new action.

RECOVERY

In this last phase of the action, the body finally tends to return to equilibrium, resting, and its natural state after each action, whether to give way to a new action or to remain at rest. During the anticipation and reaction process, we will have distorted the character by applying the necessary squash and stretch effect to exaggerate those key drawings of our animation. Certainly we will have squashed them and stretched them to emphasize each point of the action in such a way that the eye of the viewer is not able to notice anything, even though we have created the desired visual effect. In the recovery phase, everything must return to its place in its correct proportion. For the viewer, the recovery phase should be the only constant visual reference for the character.

During the recovery we also return all the elements that accompany the character in its action to its place: capes, hair, tails, etc. Everything must recover its resting state at its appropriate speed and time.

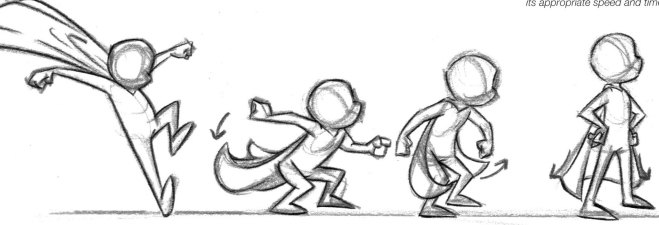

We notice that in real life we anticipate before we execute any action, and that each action in turn generates a reaction.

In animation, exaggerating this process through drawing will not only give realism and credibility to our animations, but it will also help us understand everything that is happening in the scene.

Good animation depends on the correct interaction between these concepts. In fact, we will not always end an animation with a recovery, because at times, different actions

overlap one another in a more or less entangling rhythm. In these cases, the animator produces the necessary combination until he or she obtains the desired results.

More subtle actions, like pointing at something or someone, or grabbing an object, are also accompanied by their corresponding anticipation, reaction, and recovery.

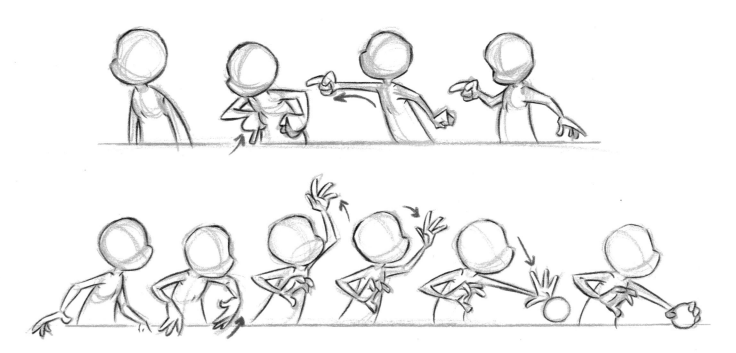

When we apply the anticipation, reaction, and the recovery to the interpretation of a character, we call it the "take." In practice, it is nothing more than an action, but the take, more than explaining what is happening in the scene, tells us how the character reacts to it.

It is therefore one of the most expressive techniques of animation.

The Take
Expressivity in Action

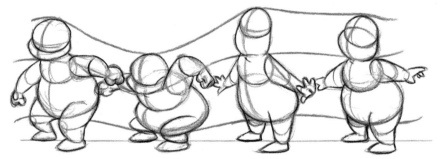

The take creates a "spring effect" that makes the character appear squashed in the anticipation phase and stretched out in the reaction phase. The result is an expressive reaction in the face of some action.

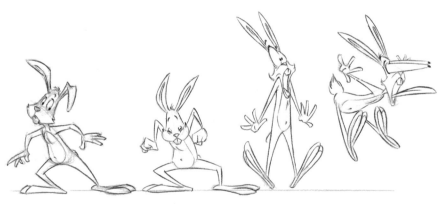

A take can be very subtle and unnoticeable or it can be extremely dynamic. The style of the characters that are being animated and the intention of the creative team determine the style of the take.

The following page illustrates a sample of very common takes applied to different actions: the beginning of a dialogue, a change of expression or attitude, and a turn of the head.

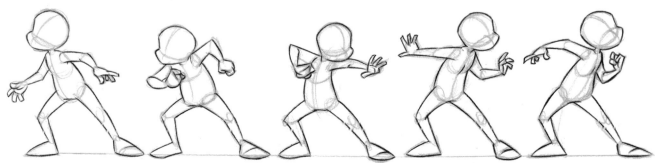

BEGINNING OF THE DIALOGUE

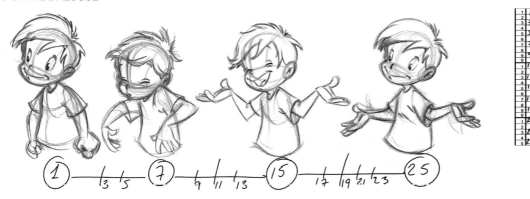

CHANGE OF ATTITUDE OR EXPRESSION

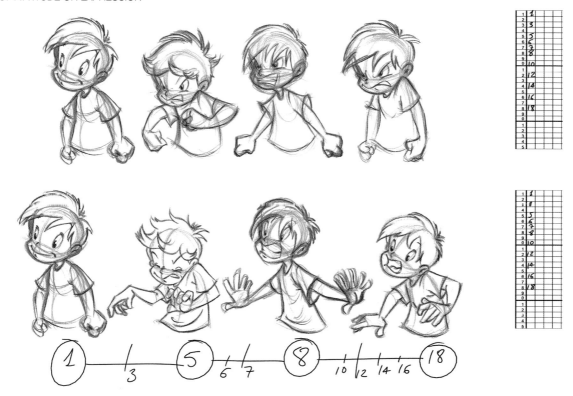

TURN OF THE HEAD

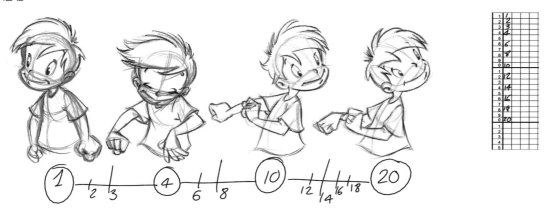

VARIATIONS OF THE FORMULA

We are constantly applying takes to our characters, and this can produce visual monotony. The experienced animator knows how to use the formula in an original way and tries to vary it, to enrich it, and to explore it until he or she achieves greater expressivity for the characters.

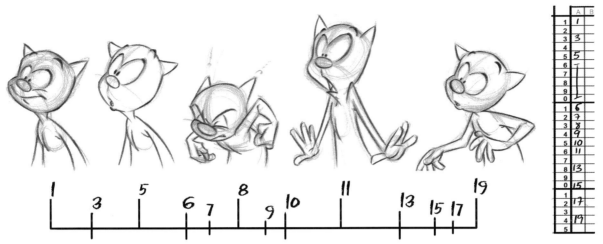

In this take we have added preliminary anticipation to the squashing effect to enhance the audience's expectations and feeling of reaction.

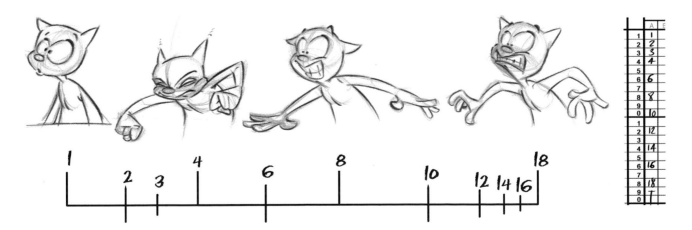

This example changes the recovery of the character. Instead of finishing with the spring effect, we contain in the recovery the emphasis of the expression created by the reaction.

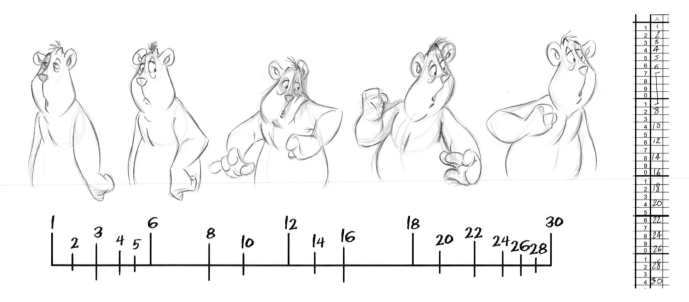

In this more subtle take, we make the character turn by moving it in steps: prepares the action by looking with the eyes, anticipates it by turning the head, reacts initiating the turn with the body, and finally, recovers with the final pose.

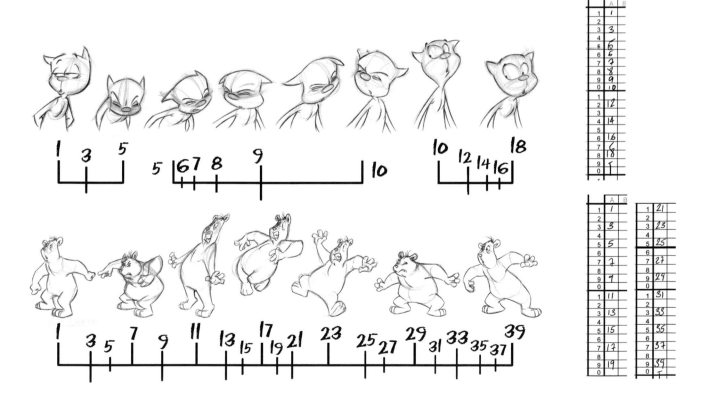

A clear example of a variation is the double take. It consists of forcing the formula, resulting in better expressive anticipation and greater dramatic effectiveness.

The Main Action, the Essential Movement

The most important thing in animation is to distinguish what is most important from that which is secondary, assuming that one element is more vital than the others for expressing the essential parts of the animated story.

The main animation is the one that tells us what happens in the scene. It is the most important movement that generates all other movements and that gives some sense to the action.

Something similar happened in the chapter of the key drawings when we referred to the end drawings of the animation. We proceed similarly by sketching the action of the scene with the extreme drawings, which will define the essence of the movement along the entire shot.

We begin with simple sketches. They must provide good end poses that will serve as the key drawings expressing a clear line of action, a solid silhouette, and a good rhythm of one pose in relation to the next.

We evaluate the overall rhythm so each action moves at the appropriate speed. Possibly, we will work pose by pose so each emphasis of our action is reflected in the movement. At the same time, we continue sketching our exposure sheet with the resulting drawings and creating the corresponding animation graphic between keys with the inbetween drawings that will provide the final rhythm and timing.

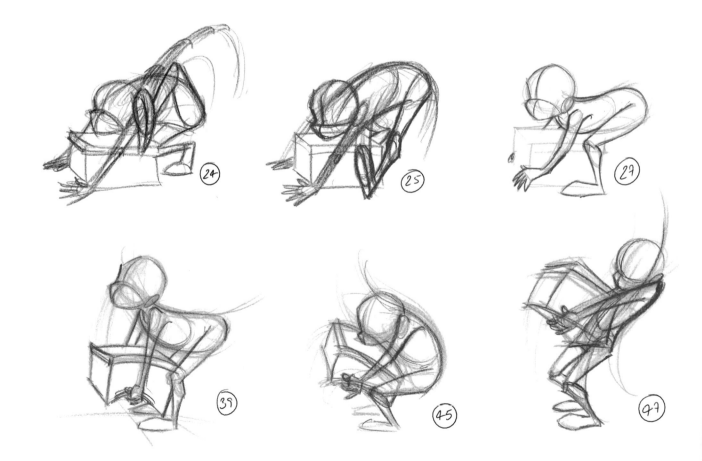

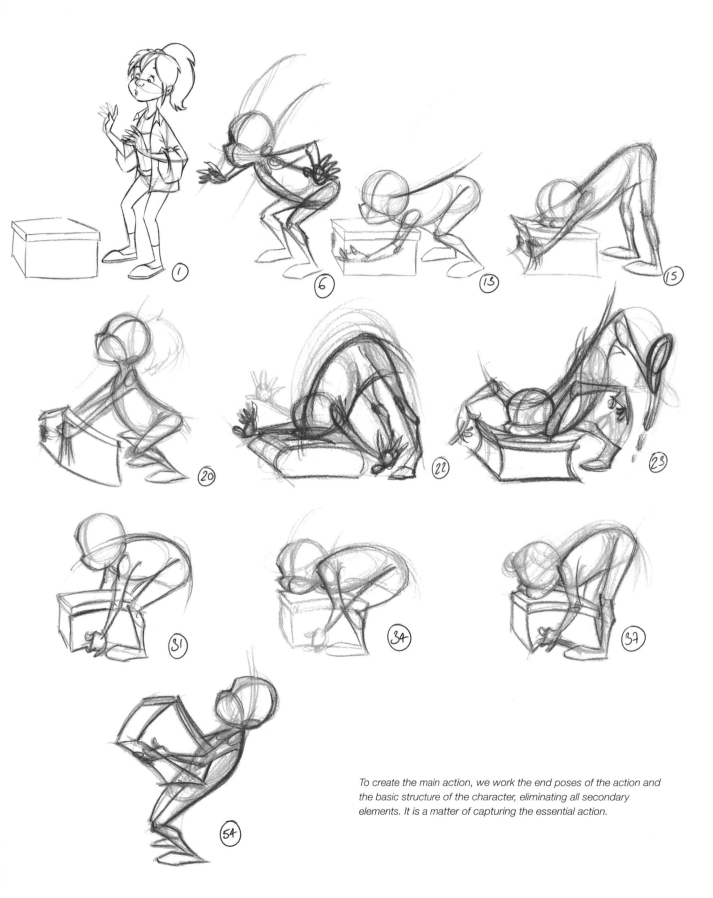

To create the main action, we work the end poses of the action and the basic structure of the character, eliminating all secondary elements. It is a matter of capturing the essential action.

The Secondary Action

Secondary actions are those derived from the main action. They are the result of it and therefore complement the main action, while being dependent on it.

Once the main action is animated, we proceed with the secondary action, but this time we work with continuous animation between one end pose and the next in the main animation. Along with this process, we continue creating the breakdown drawings, which will form new key drawings together with the extreme poses, and they will enrich and define the action.

The secondary action always depends on the main action because while one dictates the forces that govern the motion, the other acts according to those forces and as a reaction to them. The secondary action is neither targeted nor planned by the animator; it is parallel to the main action and it results spontaneously from it.

This is a clear example of the main action and the secondary action. The hand generates the movement and the flag moves as a result of this action.

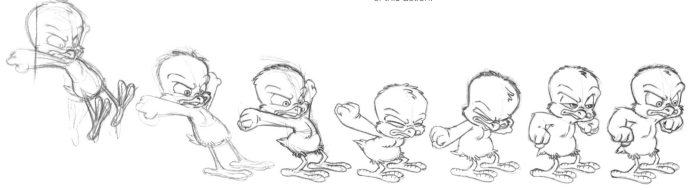

In the animation of a character, its entire body does not move at the same time or stop at the same time. In the example we can see how the feet arrive first while the rest of the body continues falling, the legs continue flexing, and the body arrives next, followed by the head. Immediately after, the arms come in and the head acts as a counterweight to restore the character's pose.

Secondary actions include all the elements that the character carries with it and that are "dragged" by the main action: tails, ears, hair, capes, clothing, etc. All these elements initiate their action as a consequence of the character's main action, stopping at a different speed and rhythm once the character's movement has ended.

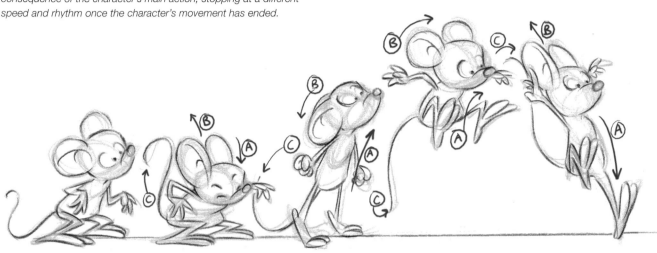

In a previous stage we have created the main animation, concentrating on the essential parts of the movement. Now we retake it to add the secondary actions.

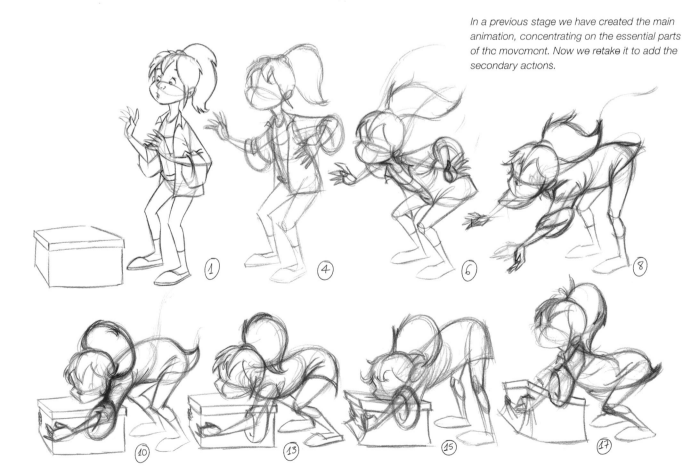

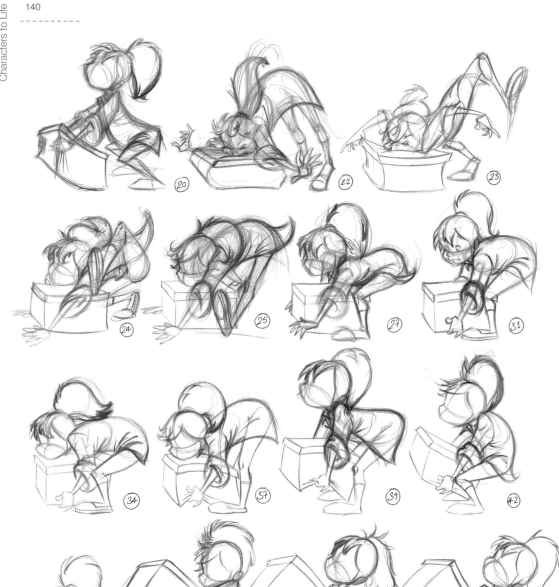

Sometimes the secondary actions also perform main actions, which in turn create new secondary actions. For example: a character is walking while talking and gesticulating its arms at the same time. We are faced with the main action of a character—walking—and as a consequence of it, its arms and head and the rest of the body accompany that main action. At the same time, though, the arms produce voluntary and important gesticulations that can possibly result in new secondary actions in the sleeve of its jacket. The dialogue that continues along the walk is another main action,

accompanied by voluntary movements of the head, which produce secondary actions in the movement of the hair. The animator must be able to organize all the movements so the result is comprehensible for the viewer. The secondary actions have their own laws, and it is necessary to know them to be able to apply them correctly. A secondary action that is not properly resolved, that does not have a good rhythm, or that appears to have a life of its own can ruin a scene. Let's review the following concepts, to learn how to approach secondary actions properly:

FOLLOW THROUGH

This is the follow through movement of any part of the character that results from the main action. As we have learned, the entire character does not begin to move at the same time; there are parts or elements of it that are "dragged" by the main action.

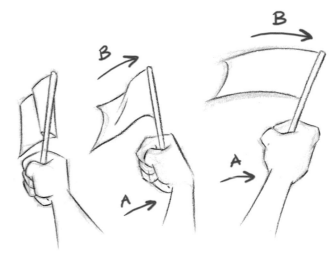

The flag follows the initial movement of the hand in its trajectory.

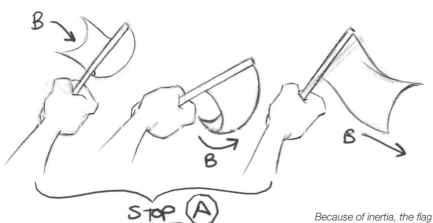

OVERLAPPING ACTION

The parts or the elements that belong to the secondary actions tend to maintain their trajectories through inertia, and they overlap or superimpose over the main action when the latter performs changes in direction or stops.

Because of inertia, the flag continues with its trajectory even after the hand's action has stopped.

MOVING HOLD

Not all the parts of the character have to stop moving at once. Each one moves at its own rhythm and speed until they arrive at a final pose in which all the action stops.

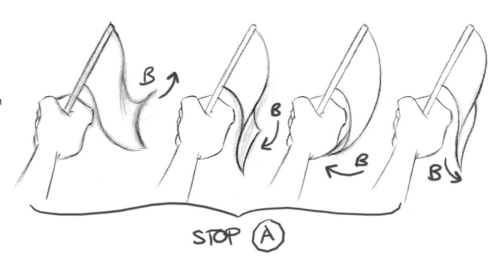

The flag holds its movement until it finally stops.

Arcs: Cadence in the Movement

When we animate our characters, we must make sure that the cadence of their movements is correct, that it flows without being hindered by unexpected movements, and that the movement clearly reflects the action that we want to show.

To achieve this, it will be very helpful to plan the movement by using arcs that define the different trajectories of the actions.

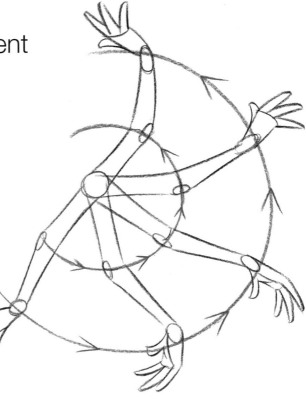

The classic example of an arm in its ascending trajectory shows us how all its parts move along a curved line. This takes place in the part of the arm that generates the movement and in the hand, which is simply projected by the rest of the structure.

Let's go back to the example of the pendulum from the chapter with the key drawings. The trajectory arch marks the importance of the number 3 breakdown drawing, and it is shown as a drawing that signals the change of rhythm of our action.

It is so important that we have even converted it in a key drawing in our animation.

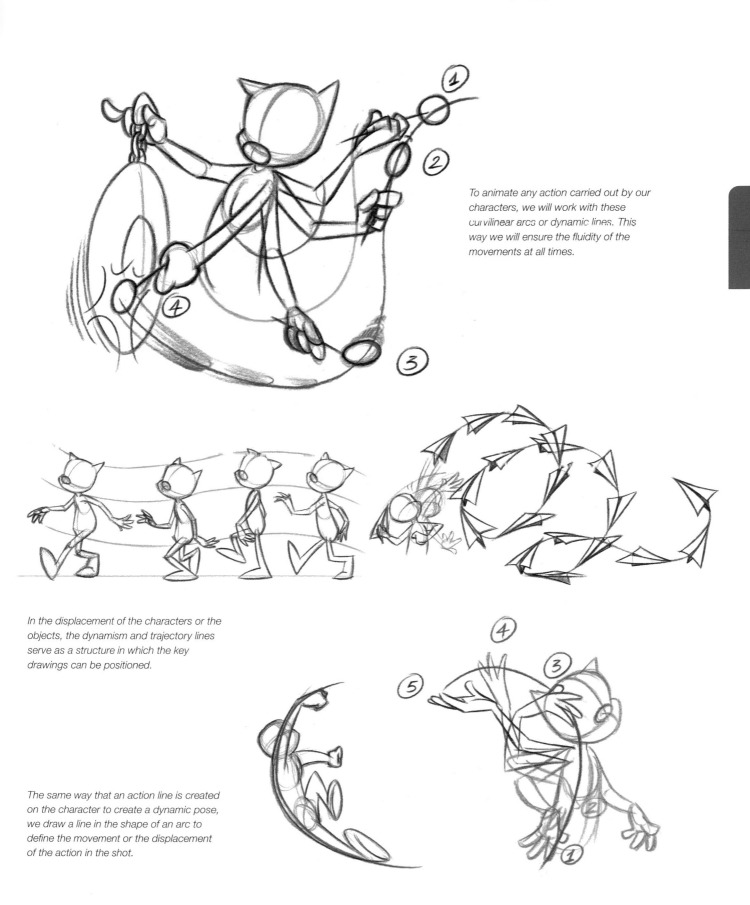

To animate any action carried out by our characters, we will work with these curvilinear arcs or dynamic lines. This way we will ensure the fluidity of the movements at all times.

In the displacement of the characters or the objects, the dynamism and trajectory lines serve as a structure in which the key drawings can be positioned.

The same way that an action line is created on the character to create a dynamic pose, we draw a line in the shape of an arc to define the movement or the displacement of the action in the shot.

When we talk about timing in animation, we are referring to the distribution of time between the key drawings that result from our animation, to the changes in rhythm, to pauses, to the stops in animation, and so forth.

Timing tells us how movement develops and how time is distributed among the poses of the animation. In other words, timing is what gives life and credibility to the character.

Timing: Rhythm in Animation

We must keep many factors in mind when planning timing in animation. The weight of the characters is important because the heavy ones will move slower than the thin ones. The mood sometimes contradicts this factor in such a way that a heavy character that is happy can move more vigorously than one that is thin but depressed. The personality also determines the timing of a character—whether it is clever, astute, silly, extroverted, shy, and so on. We reflect the temperament of each one of them by using the correct timing for their actions.

A stopwatch can tell us how long the different actions executed by our characters last on-screen. It allows us to determine the exact time needed for each one.

With stopwatch in hand, the animator interprets the character's action, which will later be reflected on paper. This is why we say that the true actor of an animation film is the animator himself or herself. This test results in a specific number of seconds and serves as the basis for planning the timing. The ideal approach is to interpret the same action three or four times and to establish an average in seconds of the different results obtained.

By multiplying the final figure by the 24 frames contained in one second, we will get the total frames needed to animate the action.

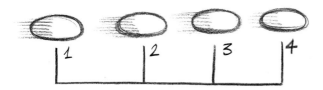

The rhythm of our animation will be marked by the relative distance found between the drawings. The closer the drawings to each other, regardless of whether they are photographed at one or two frames, the slower the action will be. Therefore, if we wish to increase the speed of our actions, we must separate them more in relation to each other. Each action requires specific attention, preliminary study, and a check by line test. The secret for discovering the correct timing for each action is experience and constant trial and error.

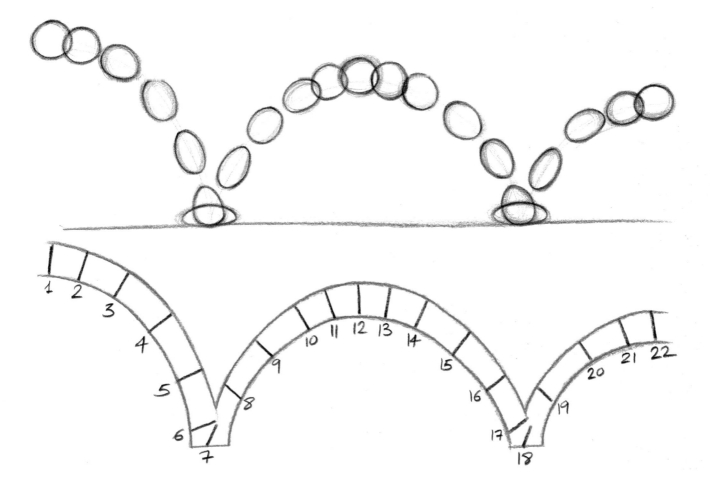

FRAMES PER DRAWING

In previous pages we have indicated that, according to the smoothness required by our animation, we will plan the work "on ones" by using one frame for each drawing, or "on twos" by using two frames for each drawing. In general, the work is done on two frames per drawing because the result on-screen is smooth, and it also requires half the work. However, we will use one frame when a fast animation and extremely smooth movements are needed or when there are camera moves. In any case, the use of one or two frames is also a determining factor for the rhythm of our animation. On occasion, our action will need small pauses, either for starting a new action or to introduce a break that will make the entire action easier for the viewer to understand. In these cases, we will use 6 frames for a single drawing, which is the minimum that the human eye can register as a pause or a brief "silence."

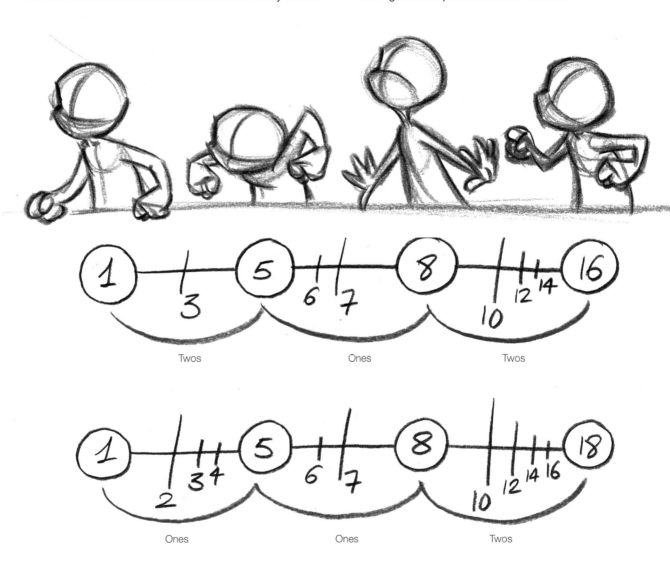

We see how the action can have different timing as a result of the animator's decision to vary the time that certain drawings will remain on screen, as well as the number of inbetweens placed between each key drawing, and the distance between them.

SLOW-IN AND SLOW-OUT

A body does not begin its movements at maximum speed. To acquire speed, a certain length of time is needed, which will depend on the weight of the character or on the force that has been applied to it. In the same way, a body does not stop suddenly either, nor do all its parts stop at the same time; a gradual slow-in brings it back to its resting state. The character and nature of each movement are determined by the combination of the basic slow-out / slow-in options.

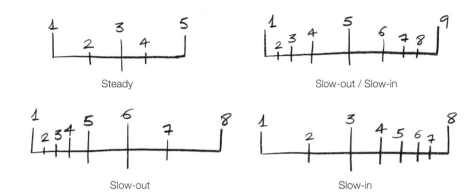

These are some of the more common slow-out and slow-in models. With the timing chart, the animator shows his or her inbetweener assistant the relative distance that exists between the drawings for each action. The key drawings are placed on the long lines at the ends or included in circles, the medium lines correspond to the inbetweens that are done by the inbetweener. The rest are the slow downs.

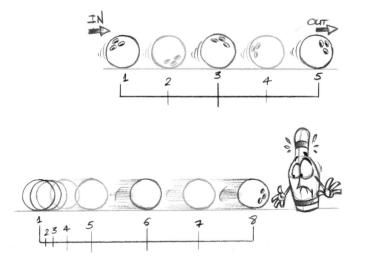

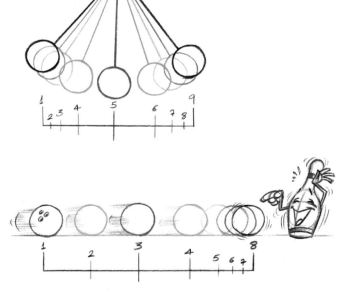

These outlines show how the timing charts, depending on whether they indicate a slow-out or a slow-in, can affect the action on the screen.

This way, we will observe how the timing of one action is divided basically into three concepts that act in unison. They are the following:

- Speed refers to the projection speed of 24 frames per second and to the fact that each frame remains on-screen for an identical amount of time.
- Time is decided by the number of frames that we will need for creating a proper action.
- Rhythm is marked by the slow-out–slow-in or the relative distance between the drawing and the use of one, two, or more frames between the different drawings needed to explain the action.

The distance between the drawings of the action is also expressed in thirds. It all depends on the need that the animator has while planning the rhythm and the speed of the animation.

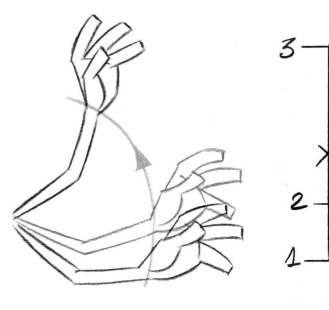

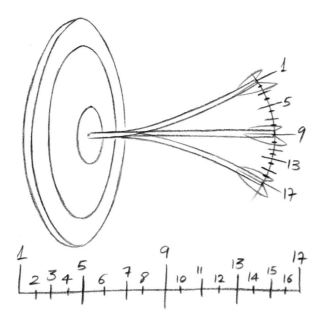

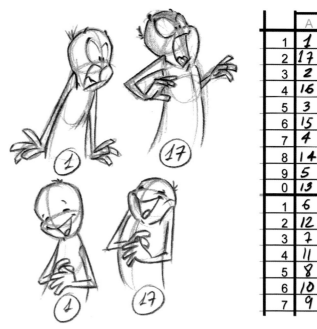

STAGGERING

Timing charts and the relative distance between the drawings can also be used to create movement effects, such as the vibration of a character or of an object

A good combination of drawings on the exposure sheet can create actions that will produce good results on screen.

An arrow that lands on a target, a cry, laughter, a terrified scream, and a situation of maximum effort are all animations that can be created by putting the drawings in the right order on the chart.

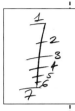

It is important for the timing charts to be clear and not to cause any confusion at any moment. The incorrect interpretation of one of these charts can ruin the proper result of an action.

The animator places his or her timing charts on a margin of the key drawings in a way that will be easy to identify by the members of his team, who must make sure that these notes do not invade the frame prepared for the character's action. The drawing number is usually written on the right hand lower corner.

OTHER FACTORS

There are additional factors that must be kept in mind when planning the correct timing for an action. They have different effects, since some of them do not relate to the direct movement of the character but to external conditions that the animator must control.

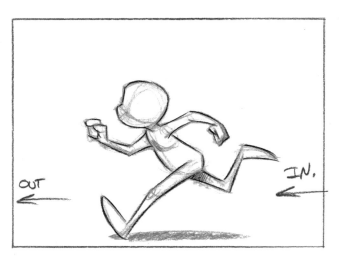 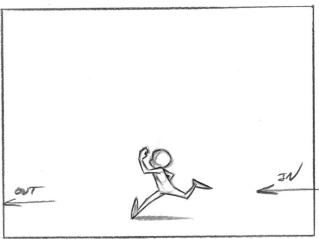

Size Relationship
Between the Character and the Frame

The timing of the scene is affected by the size relationship that exists between the character and the frame in which the action takes place. The movement gives us different times, depending on whether it takes place in a large space with a small character or in a small space with a large character, especially if the character moves from one place to another in the scene at any given time.

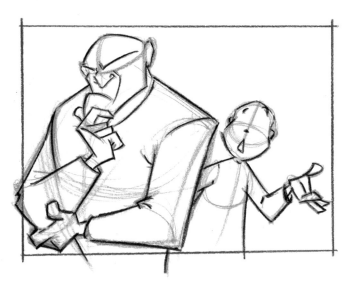

Alternating the Action

Two or more characters can be together in one scene, whether having a dialogue or doing something together.

It is important to make the action of each one of them clear to the viewer by using alternating movements that explain what is happening in the scene at all times. In these cases, the timing of each one of the characters that appears in the shot must be planned separately. Filling up the screen with animation will prevent the actions of the characters from standing out by themselves. The ideal approach is to give each character its time in the scene.

Camera Tracking

Normally, the beginnings, the ends, and the duration of the different movements of the camera are marked on the exposure sheet. We must calculate the timing of the action according to those changes in the movements of the camera, keeping in mind whether there are any changes in the size of the frame and if there are elements or characters that interact during such movement.

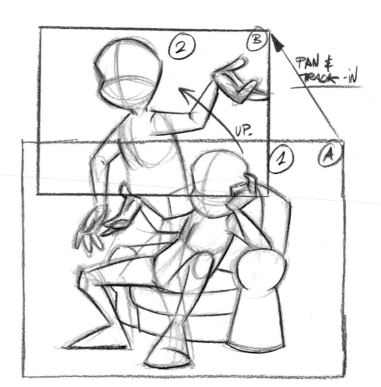

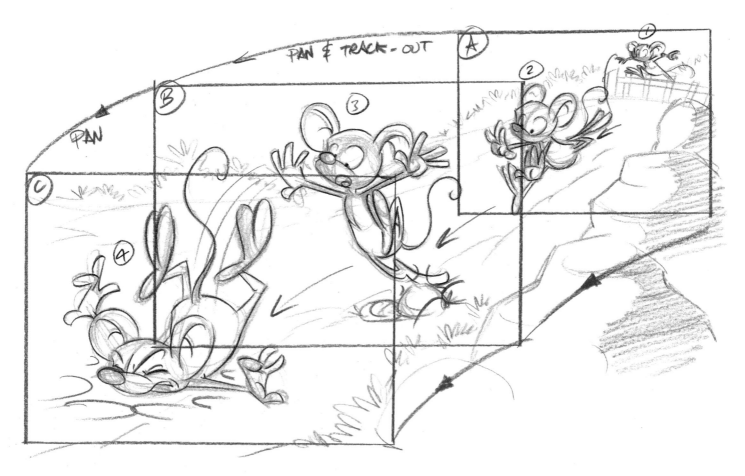

Dialogue in Animation

In animation it is common to work with the prerecorded voices of the characters. The actors do the recitation of the dialogue and the sound engineer transfers this to the exposure sheet using a sound-reading machine that allows him or her to know its length in frames.

The animator has the necessary information on the exposure sheet to know the duration of that dialogue and its syllabic transcription frame by frame. In addition, he or she has more basic material to properly animate the scene, for example: the story and the layout, which show how the action develops and the context in which the dialogue is established, as well as the prerecorded voices of the actors, where the intonation, the volume, the mood, etc., can be appreciated.

This is a standard model of the main forms that the mouth adopts for the different letters. There are other models but they are only guidelines that can be followed by every animator of a specific production. In practice, the animator must get the character's greatest interpretive quality from each dialogue scene.

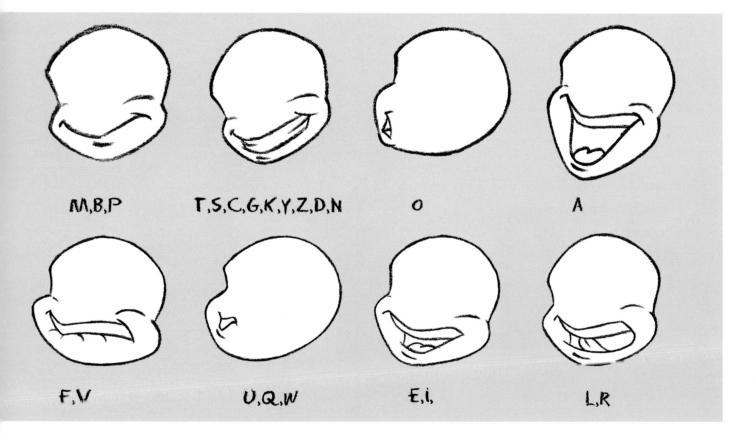

M,B,P T,S,C,G,K,Y,Z,D,N O A

F,V U,Q,W E,i, L,R

The previous model represents only one option; the animator can take maximum advantage of the character by adapting each mouth to his or her special needs. Let's take the mouth for "M, B, P" as a model, and we will observe how special characteristics can be added that better identify it with each one of its distinct phonetic characteristics.

Elasticity is very important in dialogue scenes. The most rigid part of the skull remains practically unchanged, while we can squash or stretch the mouth area to emphasize the character's expression.

The ideal approach is to synchronize the mouth with the rest of the face and the rest of the elements that give it expression: eyes, eyebrows, cheeks, etc. This will enrich the dialogue more than the synchronization of the lips alone.

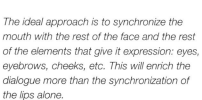

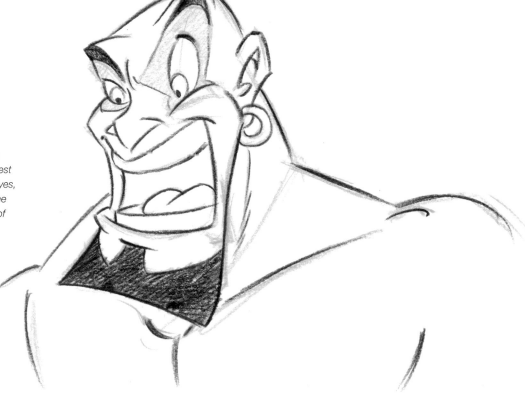

Everything that has been covered so far shows that what really matters in animation is to convey the character's feelings, sensations, life, and expression to the audience. The actors are the ones who will bring us the story, and as such, they must put all their interpretive skills to work to make sure that the story reaches the audience with all its dramatic content.

The dialogue must always be accompanied by good expression, an appropriate pose, and a studied combination of the remaining parts of the body that take part in the dialogue, such as arms, hands, and shoulders, to reinforce its intention.

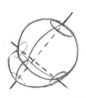

We should make an effort to get three-dimensionality and volume in the expression. Playing with the tilt of the head will emphasize any expression and make it more natural.

In the two examples below, the character says the same words but with a completely different emotional content. In the first one, he reprimands his listener very harshly, while in the second he pleasantly inquires. As we can see, his body's attitude, his gesture, his pose, and his facial expression will help us see clearly the difference between the two forms of dialogue, even though the spoken intonation will obviously be different as well.

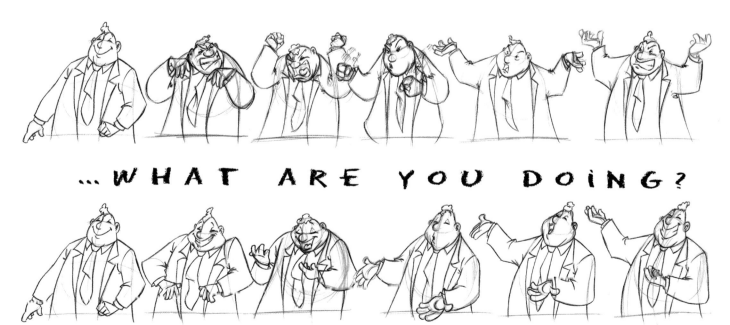

...WHAT ARE YOU DOING?

DIALOGUE IN LIMITED ANIMATION

For television series (and because budgets are very important in that medium) a much more simplified system is used for dialogues. In general, a code of six mouths is used, of which three are the key mouths and the other three are inbetweens that are combined according to the dialogue of the characters.

Six mouths code.

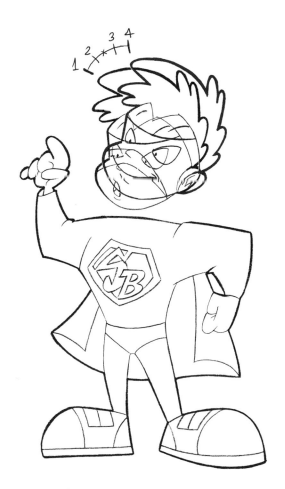

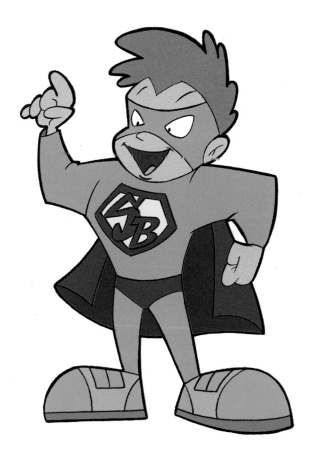

We can separate the face from the rest of the body at different levels. This way, we can avoid drawing the entire character in the dialogue scenes. Also, the mouths are placed at separate levels from the rest of the face.

In general, the work in limited animation is very technical, and to obtain good results it is very important to watch the mouth carefully and to work with the exposure sheet to arrange the different animation levels perfectly.

Finishing the

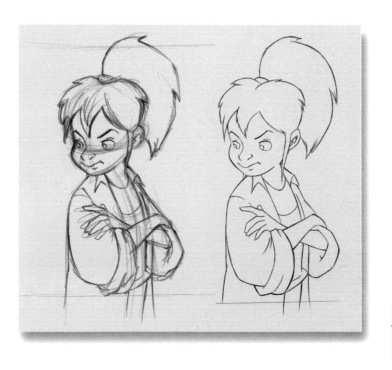

SERGI CÀMARA.
ANIMATION SKETCH AND ITS
CORRESPONDING CLEANUP.

Animation

Animators give life to the scenes

of the movies, while the team of assistants
and inbetweeners review them, adapt them, and polish them, enriching them
with drawings that will make the movements softer and more believable.
In short, this is a group of artists who, under the close watch of the animator,
will take care of each animation scene to produce the most appropriate result
on screen for the proper development of the plot.

The Animation Assistant

This is the artist in charge of making the animator's cleanup drawings. His or her work consists of giving maximum attention to the intention that the animator is trying to convey in the scene, of not changing the rhythm of the action at all, and of placing all the details that correspond to the animated object or character in their place. It is probable that during the process of animating a shot, the animator will forget some detail of the character, such as buttons, pockets, or hair. The assistant must work with the model sheets in front of him or her, know the characters that are being worked on perfectly, and carry out a thorough check of their structure and of all their components.

It is vital for the animation artist to have a good art background. Remember that the animator works with the pose-by-pose method to create a first approach to the action and that he or she will later retake the drawings to proceed with the continuing animation and to add breakdown drawings and secondary actions. It is normal that in this second phase of the process, some of the key drawings come out of their structure and

they get drawn over. In these cases, the assistant must reconstruct the character to restore its proportions and volume, but always respecting the intention of the animator at the time he or she created the movement. The assistant should know how to tell the difference between a deformation created by the animator to convey a stretching or fleeing effect, and the deformation produced by a drawing that is not properly fitted or that it is out of structure.

In his or her sketch, the animator tends to give preference to the movement and cadence of one drawing in relation to another. In this pursuit of giving "life" to the character, details can be forgotten, which the assistant must add; at the same time, the animator's drawing is outlined and detailed, a cleanup drawing created, and all the construction lines eliminated to leave the character perfectly defined.

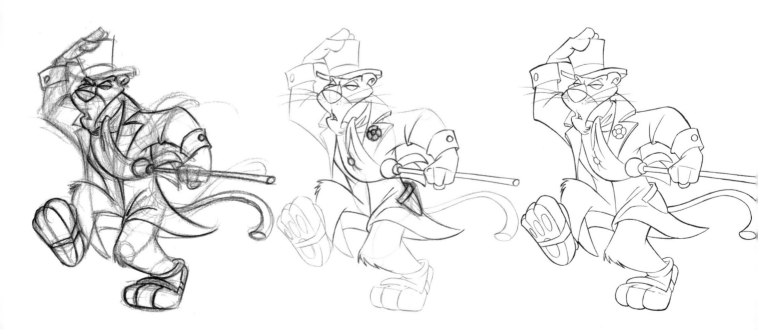

A variable number of assistants work on each film; the most important thing is for the artistic director to the direct the entire team toward a common line style. We must remember that the drawings that are finished by the assistant are the ones that will be colored, filmed, and seen on-screen once the movie is finished. It is vital that all the drawings of the film, regardless of which assistant has finished them, show the same style. As we will see below, there are different line styles, and their use is a function of the type of production (a full-length film, television series, commercials, etc.)

The assistant works on the animator's drawings: reviews their proportions, adds possible missing details, and cleans the construction lines from the drawings.

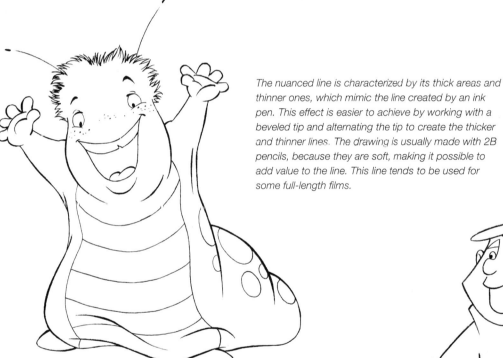

The nuanced line is characterized by its thick areas and thinner ones, which mimic the line created by an ink pen. This effect is easier to achieve by working with a beveled tip and alternating the tip to create the thicker and thinner lines. The drawing is usually made with 2B pencils, because they are soft, making it possible to add value to the line. This line tends to be used for some full-length films.

The uniform line is most commonly used in television series. It is normally made with F pencils and its line is unbroken. The idea is to find a single line style that is easy to replicate by all the assistants who take part in the production.

The fluctuating line consists of a more personal drawing style that is used in commercial work or in shorts. This drawing is done with various materials such as oil pencils, brushes, etc.

The Inbetweener

This is the artist who is in charge of the inbetween drawings that go between key drawing and key drawing and whose purpose is to complete and soften the movement created by the animator's drawings.

The inbetweener creates the drawings that the animator has marked in the timing chart and whose goal is to define the timing of the action by indicating the different accelerations and decelerations, and so on.

Sometimes, the inbetween drawing is considered a "filler" drawing that completes the movement and for which great specialization is not needed; however, the inbetween is more than that.

The professional inbetweener provides "intention" to each of his or her drawings and follows the animator's guidelines, but also collaborates with his or her work to make sure that the action is really interesting to the audience.

There are several questions that this professional must keep in mind; the basic point is that a shot that is inbetweened well will convey the feeling desired by the animator. On the other hand, a shot that is inbetweened incorrectly can make an action unintelligible.

THE INBETWEEN PROCESS

The inbetweener places two of the key drawings on the peg bar of the animation disk and a new paper on top. He or she makes the inbetween drawing by using the light from below to reference the two key drawings, thereby keeping a perfect relationship to the key drawings and maintaining the timing of the action between them.

It is important that the inbetweener construct his or her drawing perfectly to maintain the volume and the structure of the animator's drawing. The line must also be correct, since it is that same person who will make the cleanup drawings of the correct inbetweens, respecting the line established by the team of assistants. The necessary inbetweens for each action are created in a very specific order that the animator will have previously marked in the timing chart, which will accompany each key drawing. In this chart we can see some of the drawings circled or placed at the ends of each timing chart; these are the key drawings.

The drawings marked with longer lines are the first inbetweens, or "breakdown" positions, where the inbetweener must pay special attention to the intention of the action. Then there is a series of drawings indicated with progressively shorter lines that are found between the central inbetween and one of the two key drawings. These drawings are the "eases" or "slow-in" or "slow-out" drawings, since they slow down the action toward one of the key drawings. The inbetweener creates the slower motion by following the order indicated by the length of each line; in this way the necessary smoothness and timing for each action is achieved.

The animator indicates the order in which the inbetweener constructs the drawings. The inbetweener, just like the animator, must organize the drawings for the scene and "flip" them to make sure that they are working so far.

Example A is a conventional timing chart as it appears on the margin of a key drawing sheet to tell the inbetweener which drawings he or she must create.

Example B shows the order of the inbetween process. The first drawing of the inbetweener is number 3 (marked in red as drawing number 1). This is established by taking keys 1 and 7 as reference. The next drawing is number 2, using the key drawing number 1 and its inbetween number 3 as reference, and so on.

Example C constitutes a graphic of the inbetween based on thirds that the animator has planned to make the action more dynamic. The work process is the same; occasionally the inbetweener will make an inbetween drawing that serves as guide to work the thirds with more assurance. This inbetween will only be used as a reference; it will not form part of the final inbetween work.

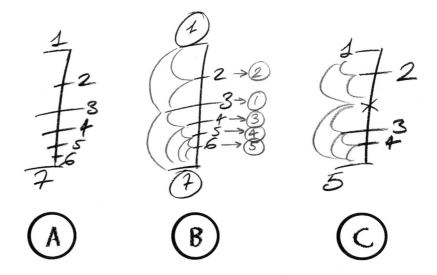

Conventional animation graphic (A), order of inbetween production (B), inbetween graphic based on thirds (C).

The outline shows the production order of the inbetweens and the effect created in each drawing.

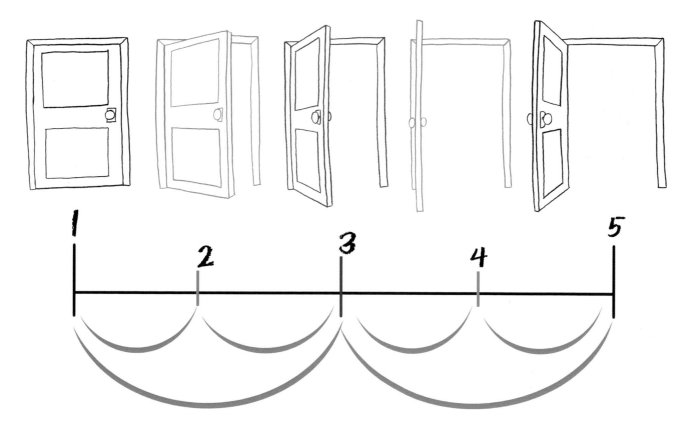

INCORPORATING CURVES

In the section about animation we talked about the "arcs" and the "trajectory lines." The animator plans the movement based on those imaginary lines with the idea of creating cadence in the animation. It is logical to think that the drawings that are to complete such movement follow those same trajectories and, as a consequence, the inbetweener must also work on them.

Inserting inbetweens is based on observation of real life. In the example below, we see the transition from drawing 1 to 5 through three inbetweens established by the animator in the animation graphic. By studying the curves and the trajectories, we will obtain smooth and harmonious results. A "mechanical" inbetween would cause breaks in the action and an annoying stroboscopic effect.

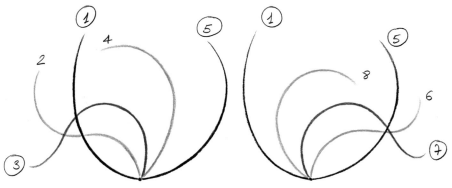

The inbetweener's drawing should not be limited to being "the middle" of the animator's key. In the following graphics we see the way the inbetween is planned following the action's cadence and the correct trajectory in the arc between keys 1, 3, and 5.

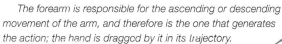

The inbetweener, as well as the animator, will try not to move all the elements at the same time.

The forearm is responsible for the ascending or descending movement of the arm, and therefore is the one that generates the action; the hand is dragged by it in its trajectory.

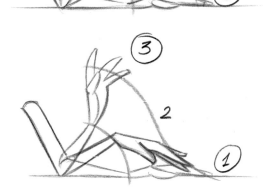

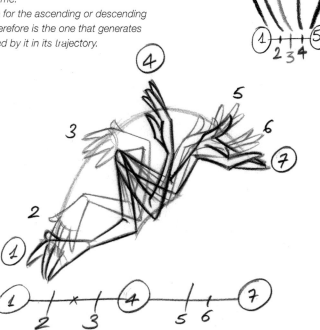

INCORPORATING THE SQUASH AND STRETCH EFFECT

The animator uses this effect to enhance certain phases of his or her animation. The inbetweener must perfectly understand this effect to convey all the necessary intention in his or her drawings. It is very important that the effect applied to the inbetween drawings is in agreement with the intention of the animator. Otherwise, it can happen that an inbetweener who does not understand the true meaning of "squash and stretch" makes errors that will completely ruin the timing created in the scene by the animator. For example, the effect on a character cannot be incorporated as a function of its structure and mass when the take is done the same way as a squashing of an object or a subject on impact. In both cases the elasticity emphasizes the action, but its application is different.

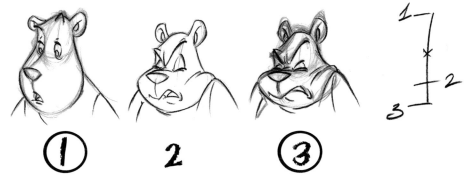

In the anticipation and reaction of a character, the elastic effect is applied gradually in all the inbetweens; however, a ball squashes completely when it hits the ground. In example A, the effect has not been applied correctly in one of the inbetween drawings: the ball is beginning to change its shape before it hits the ground. In example B, the inbetween of the ball maintains its structure and the key drawing is the one that shows the elastic effect. The gradual application of the elastic effect in these inbetweens would make the action very awkward.

BLINKING

The animation characters blink in the same normal situations that an actor or any other person would. In those cases, the blinking movements are quite rapid and probably there will be no more than one inbetween for the closing and one for the opening of the eyelid. However, there are slower blinking motions in which the movement of the eyelid is more intentional. In both cases, the inbetweener must keep in mind that the pupil of the eye and the eyelid move at the same time to prevent the eye from looking white.

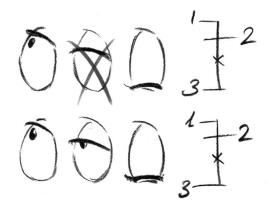

A "direct" inbetween of the blink of an eye of a character should never occur, since this can cause some inbetween drawings of the eye to be completely white. The pupil of the eye always follows the eyelid when it closes and when it opens, and the inbetweener must keep that in mind.

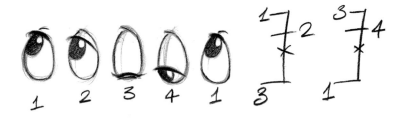

A normal blink of the eye is usually created with one third for the closing and one for the opening; this way, a natural look is achieved.

The Walk: Movement

SERGI CÁMARA.
ANIMATION SKETCH OF THE TELEVISION SERIES "SLURPS," 1997

and Character

Not all characters walk the same way,

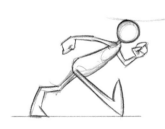

nor does a single character walk the same way all the time. The different situations that occur during the sequence of the story will cause a character to change its attitude or mood, or its energy to decline, or, the opposite, to be full of vitality.

The act of walking is not only useful to move our actors from one side of the screen to the other, it also reveals important traits of their personality, character, intention, and even their weight and size.

A well-studied and appropriate gait for each character is, without a doubt, one more factor that will help us convey all of this to the spectator.

Characteristics of the Gait

Each character has a different way of walking in response to its personality, weight, and size, but its particular way of walking can be altered according to mood, urgency, or intention.

These physical and mental factors influence the walking mode of a subject. In addition to the particular characteristics of each character, there are common ones that we must keep in mind when we plan these animations.

We can begin by constructing the animation of a character in cycles, that is, one that constitutes an endless loop, using and reusing the drawings created for the walk. This will allow us to study in detail how animation develops in a line test before we make the final decisions.

THE STRIDE

We analyze the most important moments of a stride to be clear about what happens each time that the character moves one foot with respect to the other. Something as simple and seemingly mechanical holds the fundamental principles of the animation that we have seen up to now.

The following five drawings explain a complete step, and they are the basis used to understand the most important points of the movement.

In drawing number 1 we can see the stride of the character. At this moment the character is balanced with both feet touching the floor; it shows us the span of the stride and of the arms in exact opposition to the movement of the legs.

Drawing 2 is one of falling. The body bends to the lowest point of the cycle to put all the weight on one leg, freeing up the other to make the shift possible. This pose describes the weight of the character.

Drawing 3 leans the weight of the body on the leg that is resting on the floor and begins a new shift upward. By altering this pose deliberately, we are able to greatly personalize each character's stride.

Drawing 4 represents the highest point of the cycle and the moment in which all the energy is concentrated, ready to face the next step.

Drawing 5 is the opposite of pose 1. The span of the stride and the movement of the arms are identical to those of drawing 1, but the positions of the arms and legs are inverted.

The way a character walks is as important as its pose, structure, type, or expression.

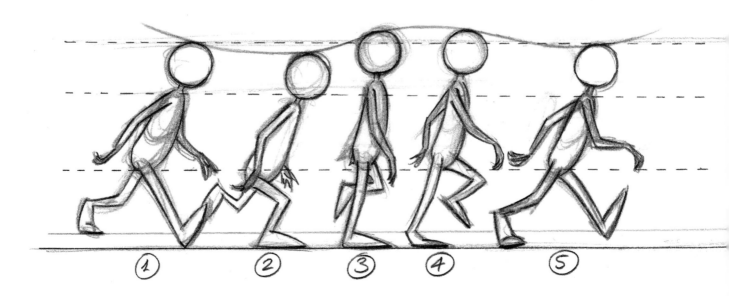

THE RHYTHM

Walking at a normal speed is equivalent to half a second per step, or two steps per second. This means that we use twelve exposures filmed at "ones" to convey the feeling of a stride at this speed, but the rhythm of the step varies, depending on the speed of the character. The following table gives an approximation that is accurate enough.

- 6 frames: very fast stride, practically running
- 8 frames: fast stride, energetic
- 12 frames: normal stride
- 16 frames: strolling
- 20 frames: tired stride, or that of an elderly person
- 24 frames: very slow stride.

A stride at a normal speed in which we have used the previous keys and inserted the necessary drawing, using thirds to achieve the desired rhythm.

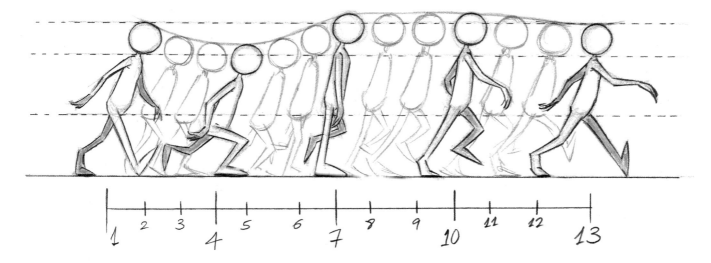

ARCS, AXES, AND PERSPECTIVE

Other common characteristics that must be considered when animating a walk are those that refer to more structural aspects. Arcs mark the movements of the arms, the shift of the body up and down, and describe the trajectory of the legs. The axes show the fluctuation of the shoulders, hips, and inclination of the head counterbalancing the rest of the body. The perspective shows the true nature of the characters transcending two-dimensionality through the construction of good poses.

The basic principle of cadence and arcs is applicable to walking, since everything must shift with grace. Imagine the structure of the character as if it had mechanical joints that described arcs in their movements, conveying an illusion of fluid movement.

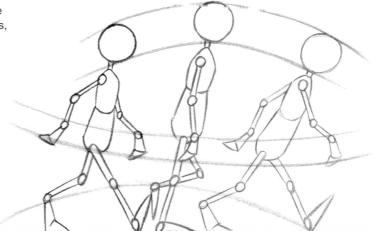

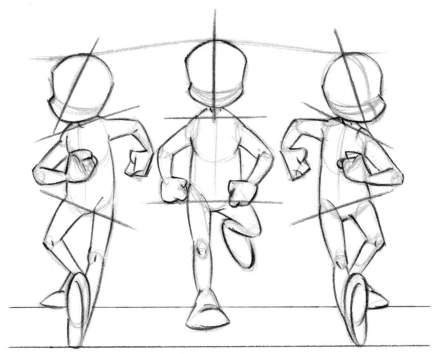

The axes of the shoulders and the hips are opposed to each other, describing a swinging motion. In the same way, the axis of the head accompanies the movement of the rest of the body.

It is important to keep in mind the character's perspective on the ground to achieve greater depth and three-dimensionality while in motion.

KEY DRAWINGS FOR WALKING

To animate a walking cycle we begin with the previous analysis. The key drawings are selected and an order is established so our work creates a way of walking that is appropriate to each character and situation, and at the same time produces a well-structured cycle.

The simplest way is to begin with the two opposite poses in which both feet are touching the ground. The advantage is that the character is in balance and that we are able to decide the size of the stride and the position of the arms as well.

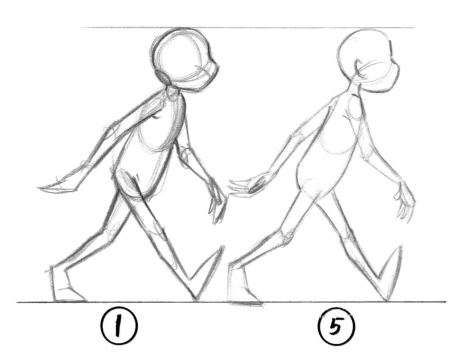

We select drawings 1 and 5 for both ends, since they are the ones that show the maximum span for the stride and for the movement of the arms, in addition to the rotation of the character's torso to one side and the other and the inclination of the head.

The following key drawing is number 3, because this is where the arms are centered with the body to change the direction of their movement opposite the legs. One leg is in full contact with the ground, while the other is in a central position for the next step. The torso and the head also present a central position. This third key drawing of walking constitutes the breakdown drawing; it is the one that allows us to alter the personality of the stride.

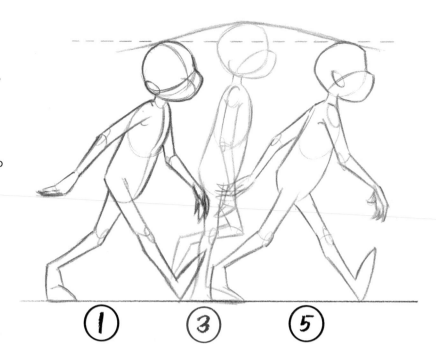

DRAWINGS 2 AND 4: KEYS OR INBETWEENS?

Analyzing everything that we have seen so far, it would be logical to think that drawings 2 and 4 should be the next key drawings to finally establish the cycle of the walk. However, there is a second method to create the cycle, which consists of using drawing 2 and 4 as inbetweens; this way the walk works perfectly well and it reduces the animator's work.

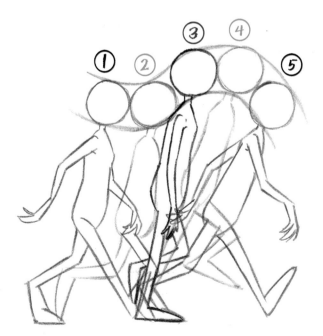

The academic method uses drawings 2 and 4 as new key drawings; this allows a greater capacity for experimentation in the search for different results.

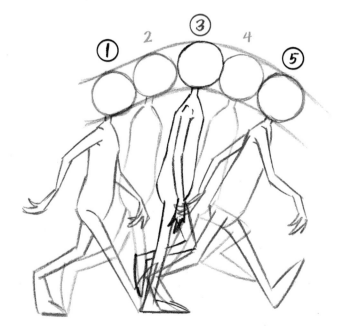

For the alternate method, drawings 2 and 4 are used as inbetweens, between the key poses. It is a matter of trying both systems to observe the difference, and to choose the one that is more suitable for each case.

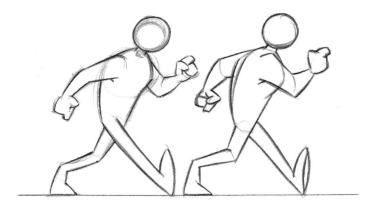

Personality in the Walk

To reinforce individual characters and to give them each a personality, we must study them separately and create a walk that defines them.

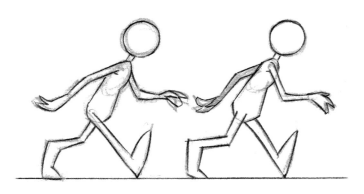

The way a subject walks stems from its pose and its physical and psychological characteristics; therefore, young characters do not move the same way villains do, nor do heroes walk the same way that the most comical characters do. Their different ways of walking tell us as much about them as their expression, their types, their way of moving or talking.

The following factors are the most important ones to keep in mind when giving personality and character to a subject with the way they walk.

KEY DRAWINGS

Key drawings 1 and 5 maintain both feet in contact with the ground. With both key drawings we show the size of the character according to the size of its stride, the distance covered by the swing of its arms, and we provide some new insights into its personality through the attitude of the hands.

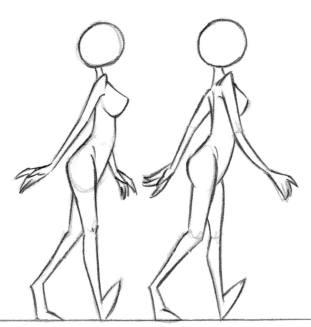

Personality in the walk through key drawings.

BREAKDOWN DRAWING

With drawing 3 we can establish different variations of the mood and the rhythm of a subject's gait.

Once we have a character's walk planned with the two key poses, the decisions that we make with respect to this new key drawing will be important, and they will influence the way a subject walks. We can make our character look dynamic, clumsy, decisive, tired, or reserved by opening or closing the arms and legs more, making it go up and down during the course of the walk, or altering its inclination. All of this, combined with the number of necessary drawings and the desired rhythm for each attitude, can produce very astounding results.

In an animation cycle, the breakdown drawing fulfills the same function as the pendulum seen in the example. It is the one in charge of changing the rhythm and of giving the stride a different characteristic.

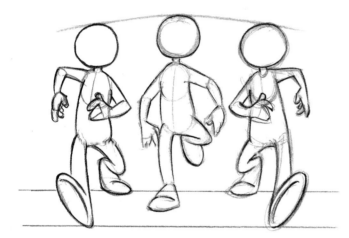

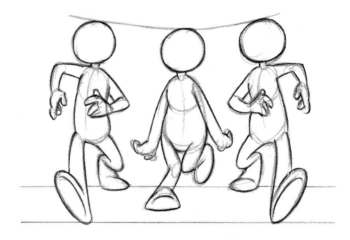

The central drawing is number 3 of our previous key poses; it is the one that marks the basic differences between one way of walking and another.

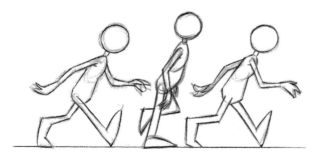

Personality of the walk achieved with the breakdown drawing.

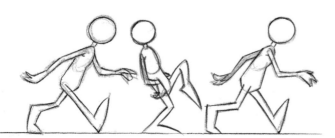

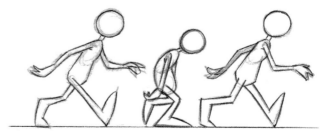

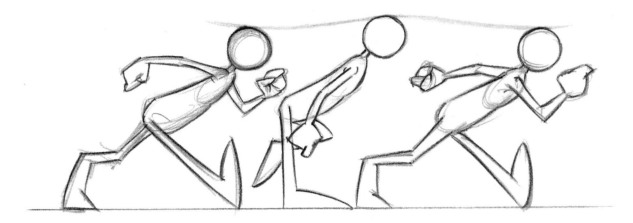

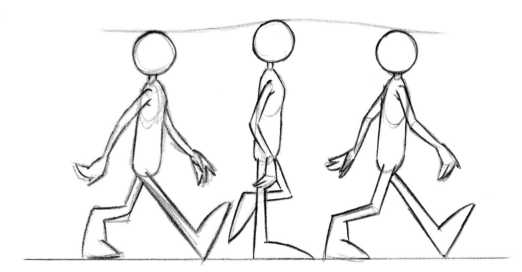

THE INCLINATION

The degree of the walk's inclination is controlled with the character's axis of gravity. Any change to one side or the other shows clear differences in the subject's attitude that can be attributed to the urgency or to the mood. Working this inclination with the three basic poses (1, 3, and 5) is important for maintaining coherence in any moment of the walk.

Personality in the walk achieved with inclination.

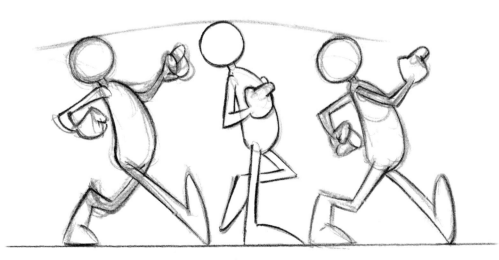

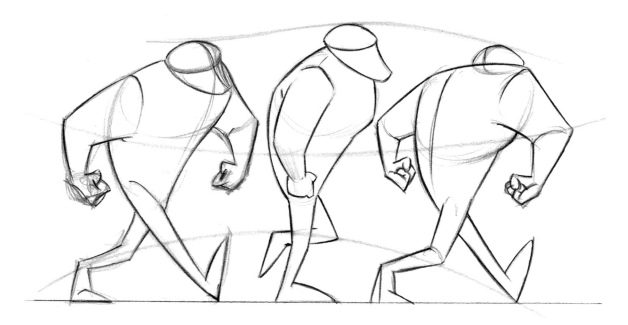

CADENCE

It is very important to highlight the most defining traits of a character when it walks: the way it moves its arms, the arc that defines the movement of its feet, the overall up-and-down motion of its entire body when walking, and so on. The most important thing to define the desired cadence in the walk is to study the different movements as if they were arcs that describe the different parts of its body.

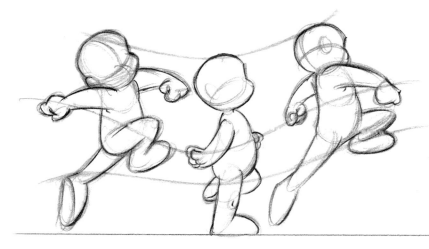

Personality in the walk achieved with cadence.

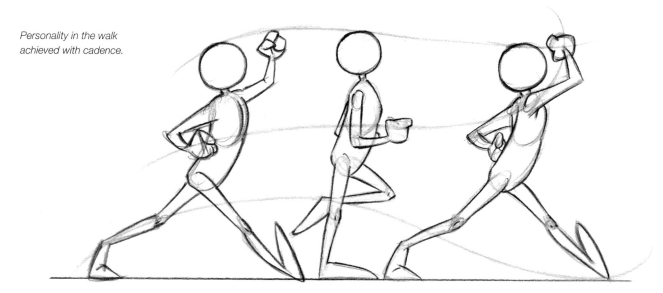

RUNNING

The same principles used for walking are valid for creating running cycles. The only thing that changes are the factors of the inclination and execution of the poses in contact with the ground. The rhythm for running is determined by the speed, and therefore the drawings that we decide to put in between the key drawings are also decisive, but we must remember that around 4 to 8 drawings filmed on "ones" can give a feeling of real speed.

Drawing A shows a key pose in which both feet are touching the floor; this is the drawing for walking.

Drawing B shows greater inclination forward due to the fact that the foot that is touching the ground has greater displacement backward. The other foot is lifted describing the cadence for running and the speed, which is determined by the elevation of that foot in relation to the ground.

Drawing C shows a fast run, with greater inclination of the body and with the position of the foot even higher.

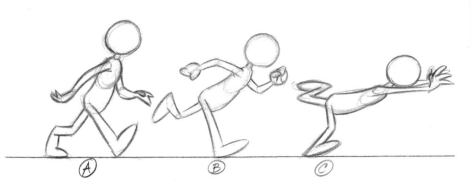

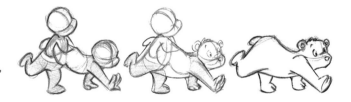

The movement of the arms, the body's inclination, and the form of the stride determine the style of the character's run.

FOUR-LEGGED CHARACTERS

The same principles are applied to create movement in four-legged characters as in two-legged ones. The basic planning consists of imagining that when an animal walks or runs, it is like two people walking or running, one behind the other, and with a slight variation in stride between the two.

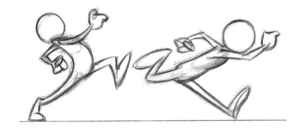

The hind legs in drawings 1 and 2 correspond to the key drawings 1 and 5 that we have seen in the movement of a person. The front legs in drawings 1 and 2 correspond to the key drawing 3 (of breakdown) in the animation of people. It is important to keep in mind this variation in the front and hind legs of an animal in order for the cycles to be effective.

Knowledge of the anatomy of the animal is vital, because not all animal legs are the same; the structure of each one determines the most important differences that must be taken into account to construct the different cycles.

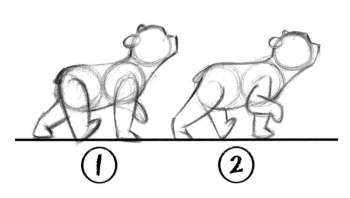

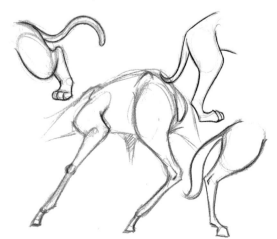

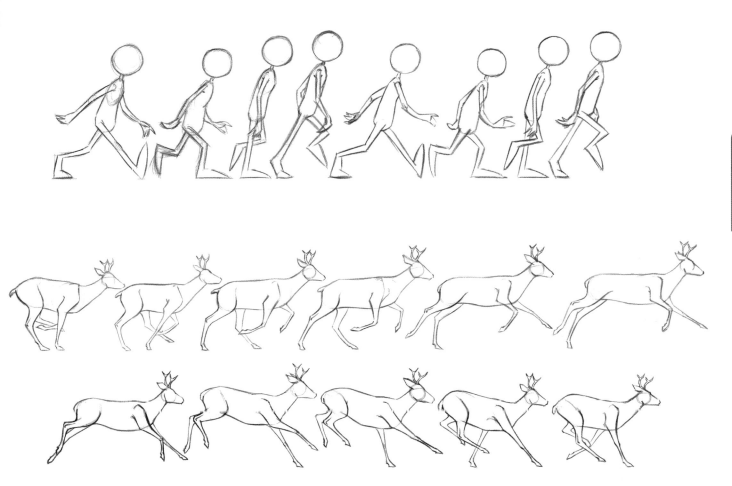

Examples of walking and running cycles in people and in animals. Experimenting with different formulas in these cycles will help us define the character of the subjects.

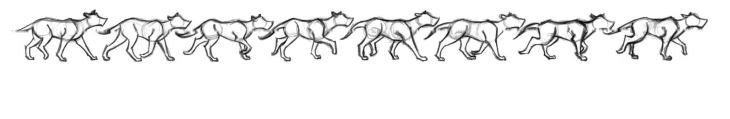

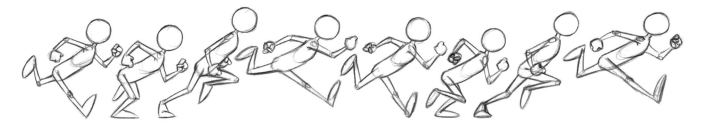

The Finish

"PRODUCERS, EXCEPT FOR THE BIG ONES, ARE THE ONES WHO, SINCE THEY DIDN'T KNOW HOW TO WRITE, THEY DIDN'T KNOW HOW TO DIRECT, THEY DIDN'T KNOW HOW TO ACT, THEY DIDN'T KNOW HOW TO COMPOSE.... ENDED UP BEING IN CHARGE OF EVERYTHING."
Billy Wilder

The Background: Where the Action Takes Place

In traditional animation, the backgrounds tend to be flat and the depth of field is created through layers and multilevel effects. Obviously, the entire process is carried out on a computer, but with the intention of maintaining a classic style.

From pure traditional animation to three-dimensional (3D) animation executed completely on a computer, we can create different combinations, for example, mixing animated characters in 2D with 3D sets, which, at times, produces very interesting results.

We know that it is possible to combine both techniques, but we are going to concentrate on the traditional system of flat backgrounds because they conform to the classical education of an animation professional. At the same time, one can experiment and try to achieve results with computer programs to create 3D images and get the most out of them.

Any technique can be used to create a background. The only premise is the decision of the creative department regarding the aesthetics of the film and the technique used.

Background is a vital element because it tells us a large part of the story. A background is the medium that surrounds the character, the place where the action takes place, and when required by the scene, it serves to transmit the feelings or the mood to the audience. All depends on a rigorous color study in which the importance of the color emphasizes the action on the screen. The stage previous to the final background has been covered in the chapter about layout. Layout artists, following the guidelines of the art director, have created a monochromatic background where they have made all the necessary notes regarding light and shadow. This way, when the background artists begin to color the background, they will do it in a way that becomes part of the overall setting that will constitute a complete sequence.

There are computer programs designed to create animations in the purest traditional style. These programs speed up the coloring of the animations, the filming, the touching up, and the post production, but they maintain the essence of the 2D format. As a result, the backgrounds must be created using classic techniques.

The background layout and its corresponding finished background. The background artists must follow the layout instructions for the creation of the background, which must be supervised by the art director to make sure that all the backgrounds for a single sequence have visual continuity.

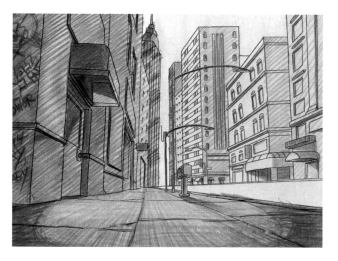

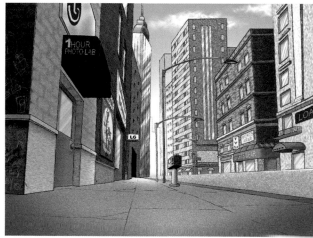

MULTILEVEL BACKGROUNDS

We are able to create the depth of field in our shots thanks to the careful construction of this type of background. These backgrounds consist of several levels where different camera moves can be carried out without intereference from one another; the focus can be set selectively, on any level; and the animation can be inserted between the levels so that the characters can interact with the elements of the background.

Multilevel backgrounds can be panoramic or not, but they always require the use of overlays and underlays.

For the look on-screen to be "natural," it is important to achieve a proper integration of the characters with the backgrounds and effects. It is helpful to plan the finish of each scene before its final creation.

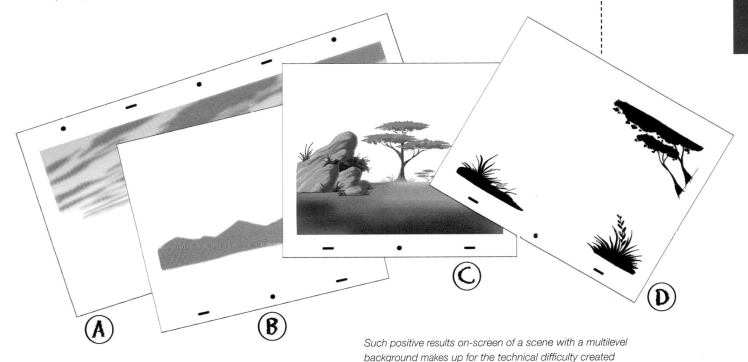

Such positive results on-screen of a scene with a multilevel background makes up for the technical difficulty created by its delicate planning.

The illustration above shows the step-by-step composition of a multilevel scene. The A element is a panoramic background of the sky with clouds, which will be moving horizontally at a very low speed. Element B is an underlay of distant mountains that we have decided to separate from the background setting to create a foggy effect, which will move in the same direction as the clouds in the sky but at a slightly faster speed. Element C is another underlay, and the action of the animation will take place on it. And finally, element D is an overlay of vegetation, which will give depth to the composition that we can even highlight by applying a soft blurry effect.

The illustration on the right shows the scene put together with its corresponding animation.

PANORAMIC BACKGROUNDS

Each background contains two or more views that can have different field sizes. The camera can be moved in them for panning, tracking in or out, rotations, zooms, and so on. The size of these backgrounds can be large, depending on the actions that are to take place in different framings.

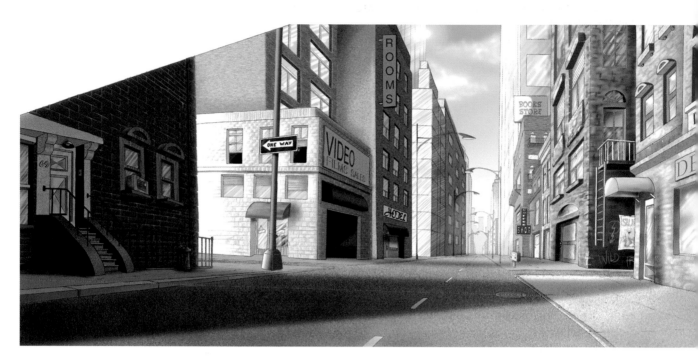

The shape of this scene indicates that it is divided into two views, a medium size one, located on the left and a larger one on the right. The movements on these backgrounds are tracking out and panning. It is an example of a panoramic background with a combination of different camera movements.

Panoramic background that consists of two equal-size views located at the left and the right of the background. The movement is that of a horizontal pan.

DISTORTED BACKGROUNDS

Distorted backgrounds are used to execute sweeping movements of the camera. At the same time they are panoramic backgrounds but with a clear design intention of recreating a shifting and pivoting movement of the camera around its own axis.

These backgrounds convey a feeling of depth. Thanks to the deformation of the drawing combined with the movement of the camera, it appears we are going further into the scene or coming away from it.

The background on the right shows a vertical panoramic view but with changes in the angle of the camera. We start the scene with the lower frame and with a down shot; we move with a vertical sweeping motion to the upper frame to finish with an up shot. The feeling this conveys is not only that of a vertical movement of the camera, but we also make it look as if the camera were changing angles along the way.

In these two frames we see the down shot to up shot effect more clearly achieved in the same scene, thanks to the use of a distorted background.

If we move along this background with a horizontal sweeping motion, alternating tracking-in movements toward the center of the background and tracking-out toward the edges, we will create the feeling of a dizzying movement where the camera enters deeply into the background and then backs out of it.

KEY BACKGROUNDS AND INCIDENTAL BACKGROUNDS

Unless we are referring to an establishing shot, the background never constitutes a work by itself; generally it forms part of a sequence made of various backgrounds showing different points of view and frames of the same area.

The important element when describing the action that takes place in each part of the film is for the viewer to be easily transported to the environment that surrounds each scene. To do this, good scene planning is very important, but no less important is a good background arrangement, where the different camera placements maintain the interest and the visual continuity of the viewer.

The key background for the sequence in a library interior. It is a wide shot where the atmosphere of the scene can be appreciated, as well as the characteristic details and elements, its color, and its lighting, among other things.

If we divide the film into time-space fractions, we will see that each sequence takes place in a different location and in each one of them the shots that tell us the story follow each other.

Regardless of whether they are indoor or outdoor shots, we will observe that some scenes explain the surroundings much better than others; they are usually the wide shots and the general outdoor scenes. These scenes are the ones that for the most part incorporate backgrounds with the greatest amount of information, as long as there are no vital elements for the plot present in some close-up shot.

The background teams of large production companies share the backgrounds for each sequence, in such a way that while some mark the guidelines of these important backgrounds (key backgrounds), the rest maintain the visual continuity of the sequence in the other backgrounds that are needed to complete it (*incidental* backgrounds).

Another shot of the previous key background and incidental background for the same sequence. In the background we observe an opposing point of view from the previous shot, but with the same color quality and identical incidence of light and shadows.

This new point of view is a close-up, and it is located in a low light area of the scene. It is darker and gloomier, but the key background has been the reference for making this incidental one.

THE GRAPHIC STYLE

It is very important that the art director and the creative team agree on an aesthetic style for telling the story. The creative possibilities are endless; however, for a film it is important that all the elements (characters, sets, backgrounds, etc.) belong to the same graphic universe, with the goal of setting a style and captivating the viewer inside that invented world.

Sometimes, the animation formulas and even the narrative language itself can adapt to a specific graphic style. It is not easy to achieve that, but it is without a doubt the way to attain a product that is truly original.

The backgrounds, as well as the rest of the elements or characters that appear in the scene, must share a single graphic universe.

Computer Work

In 2D animation, the computer can take part in many phases of the production and in many different ways. But this form of expression is different from a 3D movie made completely with the help of a computer. We are not talking about the same programs, or the same techniques, although the classic formulas for animation are the same for both media. In 2D animation, the computer replaced the tasks that were previously the result of pure craftsmanship. Also, the development of the different programs available put the art of animation drawing within reach of any talented beginner who had a basic knowledge of computers. The means for the diffusion of audiovisual work also expanded, since in addition to movies and television, films can now be launched on the Internet through image conversion programs that allow them to be viewed on a web page or to be downloaded by any user worldwide. The computer has brought many advantages to the world of animation; for example, the amount of labor has been reduced through the use of technology, producing comparable quality work in less time and at a lower cost. Other advantages are the emergence of 3D as a new universe for expression, which can coexist perfectly with the 2D classical animation, animation with modeling clay, cut outs, and so on.

Below, we are going to cover the use of the computer in a traditional animated film.

CAPTURING IMAGES

The material that we have created for the movie, basically animation and backgrounds, is entered into the computer. In practice, this consists of a large number of drawings, which, once they are loaded onto the hard drive, must be carefully organized so they can be manipulated later.

With the computer we can alter the production chart by switching some drawings with others, creating repetitions, lengthening or shortening pauses, etc., until the desired animation effect is achieved.

There are two basic ways of saving graphics in the computer: by capturing the drawings either with a camera or with a scanner.

The scanner has become the standard way because it allows the loading of all the animation drawings for a scene with automatic commands, maintaining a perfect record of the registration for the different drawings in the same scene. The camera can perhaps be used for a preliminary version of the drawings while they are in the sketch stage to conduct a line test, but once they are in their final form and placed in between, the drawings are usually captured with a scanner. For the backgrounds it all depends on the art technique that is used. If they are made with watercolors, gouache, or ink, the most common approach is to scan them to give them a digital finish, unless the entire background is done directly on the computer.

LINE TEST

Some of the animation programs that are commercially available work with independent modules, that is, each part of the production is generated in one area of the program with its own interface and specific tools. On the other hand, other more intuitive programs show the necessary tools for all the procedures on the screen and you select the ones that are needed to complete the task. Regardless of the system, almost all of them have a section for line test. It is here that we can check the animation in its different stages until the final test is done, after which we proceed with color and effects.

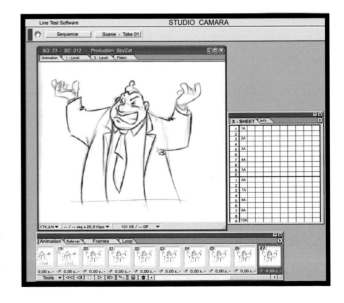

INK AND PAINT

This phase of the work consists of coloring the drawings that form part of our animation. In general, they must be colored one by one and each area filled with a flat color. If greater sophistication is desired because we are working on a project with a more personal color style, our regular program will probably have the tools needed to do that, or we can work with other programs and export files from one area to the other.

In addition to coloring the animation drawings, we can change the color of the line completely or partially, and color the shadows as long as they have been previously animated.

In general, flat colors are used in animation to which effects are added later. The color model serves as a guideline so all the color artists maintain the same color references for the characters.

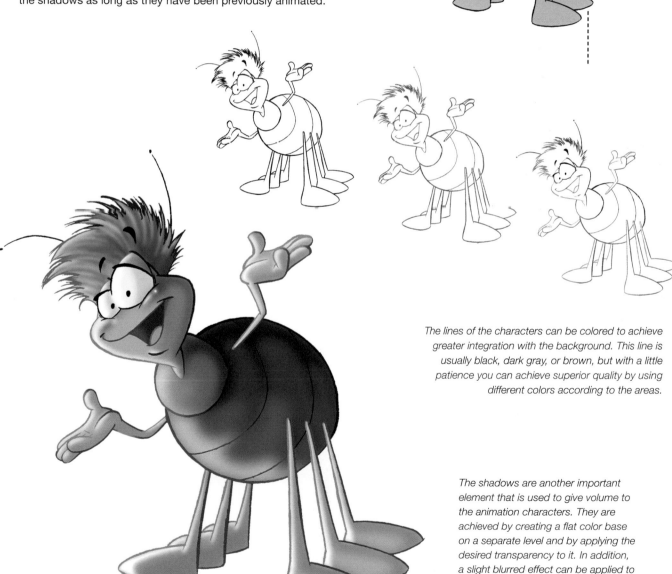

The lines of the characters can be colored to achieve greater integration with the background. This line is usually black, dark gray, or brown, but with a little patience you can achieve superior quality by using different colors according to the areas.

The shadows are another important element that is used to give volume to the animation characters. They are achieved by creating a flat color base on a separate level and by applying the desired transparency to it. In addition, a slight blurred effect can be applied to the shadow layer to achieve greater integration with the scene.

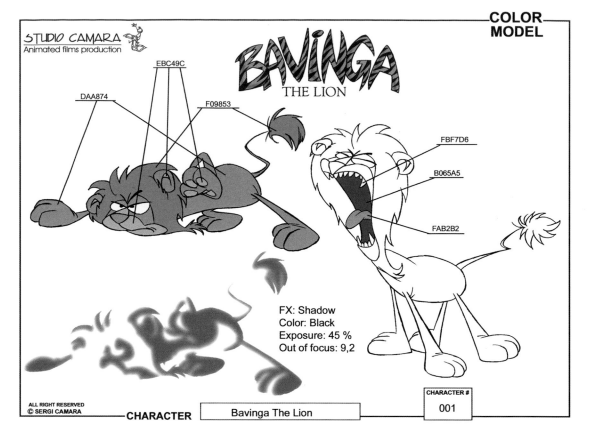

Color models indicate the colors that should be used for each character. It is important to indicate on the model all the parts that belong to each character: the inside of the mouth, shoe soles, etc.

FX: Shadow
Color: Black
Exposure: 45 %
Out of focus: 9,2

ALL RIGHT RESERVED
© SERGI CAMARA

CHARACTER — Bavinga The Lion

CHARACTER #
001

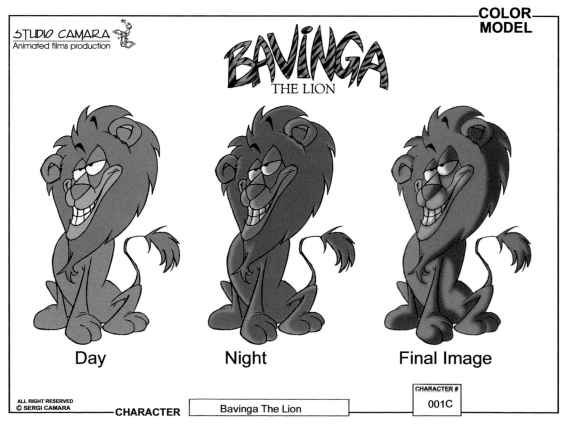

The possible color changes of the character must be shown on the color model to indicate whether the character is indoors, outdoors, in daylight, or at night. It is also recommended to produce a general model showing the final result of the character as it will appear on the screen with its shadows and color lines.

Day · Night · Final Image

ALL RIGHT RESERVED
© SERGI CAMARA

CHARACTER — Bavinga The Lion

CHARACTER #
001C

COMPOSING THE SCENE

It is necessary to select all the materials that belong to the same scene: animation, background, shadows, overlays, underlays, and so on, and to save them together to create a single file. This is also the time to create the camera movements that are required for the scene, if there are any.

The final result is a scene complete with all the necessary components based on the planning of the scene that was done previously. The file needs only to be labeled with its sequence and final scene number and put away and edited later, together with the rest, in the required order.

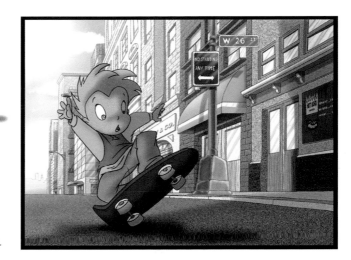

The background, the animation, and the shadows are some of the elements that belong to a finished scene. In the composition phase, they are put together to visualize the entire scene and to create a single file that later will be edited with the others in narrative continuity.

THE FINAL EDITING

There is a final step in the composition once all the scenes of the film have been carefully edited. In this phase, the synchronization of the dialogues, the incidental music, the image, and the sound and visual effects are executed. When all this work is finished, we simply need to transfer the audiovisual product to the required format for distribution and release of the film.

There are many formats, depending on the market that we need to supply and the resolution at which we have produced the work. In general, from the computer we have the option of many possibilities: film, television, Internet, and more.

Some of the formats in which the finished film can finally be shown.

A

Animatic: Storyboard filmed with the correct duration for each shot to get an idea of how the rhythm of the film will develop.

Assistant: Artist who is in charge of cleaning up the animation drawings, while checking the construction and details of each character.

B

Background: (BG) Generic name given to the decorative elements used in an animation movie.

Breakdown: Drawing that marks the change in the action's rhythm and that constitutes a key in animation.

C

Camera stand: An animation stand that is used to film the different scenes. It consists of a movable table to execute the panning movements and a movie camera suspended from a tower.

CGI: Computer generated image.

Clean-up: Key drawing in animation, made using definite lines, from the original sketch.

Concertina (Action): Animations with a very entangled rhythm, where the main and secondary actions constantly overlap and superimpose. Their planning is very complex and usually consists of animations created using the continuous animation method.

Cycle: Animation that can create an endless loop by repeating the filming of a series of drawings in order.

D

Drag: Name given to all the parts of an object or a character that are dragged as a result of the main action and that must be carefully planned by the animator in such way that their action ends at the appropriate speed and rhythm.

E

Ends: Key drawings that mark the action's beginning and end.

Exposure sheet: Guide that indicates all the necessary instructions for the cameraperson (Dope sheet, X-sheet).

F

Field guide: A template that marks the different framing sizes, called "fields," used to film a scene.

Flip: Technique that allows the animator to check if his or her animation works during the work process. It consists of staggering the pieces of paper used to create the animation and to "drop" them strategically at a speed similar to that of the projector.

H

Hook-up: Continuity of action and/or location from one scene to another.

I

Inbetween: A drawing placed between the key drawings made by the animator according to the timing chart, depicting the intermediate stages of an action.

Inbetweener: An artist who makes inbetween drawings.

GI

K
Key: Key drawing.

L
Layout: Drawings of backgrounds, character poses, and camera fields and movements.
Line test: Preliminary film that is made of the artist's drawings in their sketch phase to make sure that they work as intended before they are finalized and placed in between. A more definitive line test is also done when the animation is completed and before the drawings are colored.
Lip-sync: Phonetic deconstruction of a strip of diagloue to ensure the synchronization of the characters' lip movements.

O
Off-screen: (OS) Indication for storyboards and layouts to signal an action that exits the screen or that happens outside of it.
Overlay: (OL) Part of the background located above the animation level.

P
Pan: A panoramic movement of the camera.
Panel: Name used to refer to each individual frame of the storyboard. They are used to make changes to the overall storyboard, to form part of the director's workbook, or can be included in the layout folder to provide information about the specific shot.

Pegbar: A bar that contains pegs with a universal registration system that keeps all the material that has to be filmed in the movie perfectly matched. Bottom pegs: bottom pegs of the animator's disc, which are generally used to create the animation.
Top pegs: upper pegs where the planning of the movement of the background is recorded.

R
Rough: A drawing in its sketch phase.

S
Slow-in: Deceleration planned by the animator in his or her timing charts.
Slow-out: Acceleration planned by the animator in his or her timing charts.
Squash: Effect used in animation for squashing the characters to make smooth, elastic movements.
Squash and Stretch Effect: An effect used in animation to make the characters flexible and to create visual smoothness.
Stagger: Vibration.
Storyboard: Illustration of the script shot by shot with sketches to study the scenes, the duration of each shot, and the visual continuity. It also serves as a preliminary step before editing.
Stretch: Effect used in animation to stretch the characters and to soften their movements using elastic properties.

T
Take: Reaction of an animation character to an event, which can range from very mild to very violent. The constant experimentation and usage of the take by animation artist and producer Tex Avery became part of the personal style of his films.
Timing: This is the rhythm of animation.
Timing chart: A graph of the animation, which is planned by the animation artist using the drawings that will have to be created by the team of inbetweeners and assistants.
Track-in: (Truck-in) Movement of the camera (traveling) towards the subject.
Track-out: (Truck-out) Movement of the camera (traveling) away from the subject.

U
Underlay: (U) A section of the background located below the animation level.

Z
Zip pan: Quick movement of a panning camera.

ossary